KITAJ

David Hockney, 1980

John Ashbery

Joe Shannon

Jane Livingston

Timothy Hyman

Thames and Hudson

KITAJ

Paintings, Drawings, Pastels

with 108 illustrations, 17 in colour

This book was originally published by the Smithsonian Institution in 1981 on the occasion of the retrospective exhibition of R. B. Kitaj's work at the Hirshhorn Museum and Sculpture Garden, Smithsonian Institution, Washington, D.C. It was subsequently expanded and reprinted in 1982 as the catalogue for the retrospective exhibition of Kitaj's work at the Kunsthalle Düsseldorf. In reprinting this catalogue Thames and Hudson gratefully acknowledge the assistance of the Smithsonian Institution and the Kunsthalle Düsseldorf.

Photographic Credits:

Unless otherwise noted, photographs are courtesy of the lender. Numbers in brackets refer to catalogue entries.

Geoffrey Clements [87]
Ralph Kleinhempel [27]
Courtesy of Marlborough Fine Art (London) Ltd.
[7, 8, 10–14, 17–22, 24, 25, 28–33, 36, 37, 39, 41–44, 46–48, 51, 53–57, 59, 61–64, 66, 67, 70–74, 76, 78, 79, 81–86, 88–92, 94, 96, 97, 99, 100, 102–106, 108]
Aida and Bob Mates [65, 68, 69, 75, 77]
Courtesy of Sotheby Parke Bernet (fig. 2)

First published in Great Britain in 1983 by Thames and Hudson Ltd, London

Reprinted 1986

Printed and bound in Great Britain by Balding & Mansell Wisbech

Contents

Acknowledgments

In the sixties, when I first encountered the work of R. B. Kitaj, I was literally struck dumb. I recognized an art that was at once allegorical and depictive, traditional and at the same time thoroughly modernist. Fractured and free-associative as they were, the works were coherent. These rich representations were stirring and even cruel—a true vision of our misbegotten times. Here was an intelligence of gritty courage, wit, and sensitivity. The artist was aiming at our lives and our times, and he hit the bull's eye. I felt exultant and relieved, thinking "It's about time."

In 1978 I suggested to Abram Lerner, director of the Hirshhorn Museum and Sculpture Garden, that we mount a retrospective of this young master. In 1981 we did just that. The exhibition, which traveled to the Cleveland Museum of Art and the Städtische Kunsthalle Düsseldorf, was a huge success.

We were lucky to have John Ashbery, America's first poet, provide a sparkling, insightful essay for the catalog. Jane Livingston, associate director of the Corcoran Gallery of Art, Washington, D.C., added an indispensable contribution to the catalog. Her early cooperation made it possible for the Hirshhorn Museum and Sculpture Garden to undertake the project. Timothy Hyman agreed to include his brilliant exchange with Kitaj.

To our delight, the catalog sold out almost immediately; yet, to our chagrin, we were unable to fulfil the countless requests for catalogs from all over the world. We are thus deeply grateful to Thames and Hudson, Ltd., with special thanks to Nikos Stangos, for agreeing to reprint the catalog, slightly altered but with all the essentials maintained.

1982 J S

Chronology

1932 October 29—Ronald Brooks born to Jeanne Brooks in Cleveland, Ohio. Raised by his Baltimore-born mother, who later became a school teacher. In 1941 she is remarried to Dr. Walter Kitaj, a research chemist from Vienna who had come to America as a refugee.

1937–42 Attends children's classes at Cleveland Museum of Art.

1943 Family moves to Troy, New York. Attends Troy High School (1946–50). He is "always drawing."

1950 Works on a Norwegian cargo ship, traveling to Havana and Mexican ports. Spends one semester at the Cooper Union for the Advancement of Science and Art; studies with, among others, the painter Sydney Delevante, whom Kitaj later describes as "a spellbinding teacher."

1951 Obtains American seaman's papers and works on tankers to Caribbean and Venezuelan ports. Arrives in Europe for the first time. October—studies in Vienna at the Akademie der Bildenden Künste (registered there until July 1954), with Albert Paris von Gütersloh and Fritz Wotruba. Draws from the human figure every day, learns anatomical dissection, and studies the masterpieces at the Louvre, Paris, and Kunsthistorisches Museum, Vienna. Wanders around Europe.

1953 Returns to New York. Joins the National Maritime Union; ships out mainly on South American runs, to Venezuela, Colombia, Brazil, Uruguay, and Argentina. Marries Ohio-born Elsi Roessler, whom he had met in Vienna. Returns to Europe on money saved from seagoing. Paints, draws, and wanders around Europe and North Africa. Spends the winter on the Mediterranean port of Sant Feliu de Guixols in the Catalan region of Spain, where he works on a large allegorical painting (now destroyed). Writes to Ezra Pound, who answers.

1954–56 Ships out of New York as a sailor, for the last time. Conscripted into the United States Army (1955); spends two months in basic training at Fort Dix, New Jersey. Serves as an illustrator in an intelligence section of the Armed Forces Central Europe (Headquarters) at Fontainebleau, working in the great chateau there. Lives with wife in the Seine village of Thoméry, near many sites painted by the Impressionists.

1957 Discharged from the army. Travels to Oxford, England. January—supported by a grant under the G. I. Bill, begins studies at the Ruskin School of Drawing and Fine Art. "I came under the spell (as everyone did) of Edgar Wind, professor of fine art at Oxford." December 24—son, Lem, born.

1959 June—awarded University of Oxford Certificate in Fine Art (C.F.A., Oxon.).

1960 Enters Royal College of Art, London (graduates 1962). During first week begins close, enduring friendship with David Hockney. Spends two years drawing in life rooms. Wins the Arts Council Prize at *Young Contemporaries*, an annual exhibition of student work at RBA Galleries. Meets the American poet Jonathan Williams, who introduces him to post-Pound American poetry.

1961–67 Teaches at Ealing Technical College and Camberwell School of Art and Crafts (September 1961–June 1963); tutors at Slade School of Fine Art, London (fall 1963, spring and summer 1964, fall 1966, spring and summer 1967).

1962	Collaborates briefly with sculptor Eduardo Paolozzi. Through Paolozzi meets Chris Prater, a silkscreen printer with whom Kitaj makes collage-prints during the next decade. Spends summer at Sant Feliu de Guixols (which he has continued to do). Meets Francis Bacon.
1963	First solo exhibition—*R. B. Kitaj: Pictures with Commentary, Pictures without Commentary*—shown at Marlborough New London Gallery (Marlborough has continued to represent him). Tate Gallery, London, buys *Isaac Babel Riding with Budyonny*, 1962.
1964	Adopts a daughter, Dominie Lee Kitaj. Begins "bibliomaniacal book-hunting." Visits Scottish poet Hugh MacDiarmid in Lanark, Scotland. Delivers a slide lecture at Cambridge, Oxford, and London.
1965–66	Visits America, for the first time in nine years, for his first solo exhibition in New York, at Marlborough-Gerson Gallery, from which Alfred H. Barr, Jr., purchases *The Ohio Gang*, 1964 [3], for the Museum of Modern Art. First solo museum exhibition—*R. B. Kitaj: Paintings and Prints*—shown at Los Angeles County Museum of Art. Nationalgalerie, Berlin, buys *Erie Shore*, 1966 [29]. April—makes drawings for *Sports Illustrated* at baseball spring training camps in Florida.
1967	Solo exhibition of drawings and prints shown at Stedelijk Museum, Amsterdam. Leaves London with family to teach for one year as visiting professor at the University of California, Berkeley. Plays "an intensive and very romantic season of league softball in Strawberry Canyon." Forms close friendships with the poet Robert Duncan and the painter Jess Collins. Renews friendship with the poet Robert Creeley in Placitas, New Mexico, and Bolinas, California. Collaborates with Creeley on the first of their two books, *A Sight*. Draws portraits of poets Charles Olson, John Wieners, and Kenneth Rexroth.
1968	Resettles in England. Develops friendships with the artist Jim Dine and his wife, Nancy.
1969	Wife dies. Takes children to California. Works on project for the *Art and Technology* exhibition at Los Angeles County Museum of Art.
1970	Lives in Hollywood and teaches for one year as visiting professor at the University of California, Los Angeles. Begins to compose "epic" Hollywood painting, making preparatory drawings of directors John Ford and Jean Renoir in their homes. Destroys picture "due to lack of heart to continue." Marlborough Fine Art, London, publishes several portfolios of silkscreen prints printed by Chris Prater at Kelpra Studio Ltd., London, including: *First Series: Some Poets; Struggle in the West: The Bombing of London; In Our Time: Covers for a Small Library after the Life for the Most Part*; and *A Day Book* (text by Robert Creeley).
1971	Returns to London with children, living for several months with David Hockney at Powis Terrace. Buys house in London. Meets young American painter, Sandra Fisher, who has just arrived in London. "Painting and drawing slowly begin to come to life again." Begins to see the artist Frank Auerbach over regular suppers in town.
1972	Buys house at Sant Feliu de Guixols and begins to work there from time to time. Begins to study Catalan. Visits the artist Richard Hamilton at Cadaques, Spain.
1975	During a visit to the Petit Palais, Paris, is inspired by Edgar Degas's work and becomes determined to learn to use pastel. Buys first good pastels and, back in London, immedi-

ately begins using them to draw from life. "Encouraged by the daily example and urging of Sandra Fisher."

1976 Organizes *The Human Clay*, a controversial exhibition of figurative drawings and paintings at the Hayward Gallery, London, having bought many of the works for the Arts Council of Great Britain during the previous year.

1977 Stays at Sils Maria in the Lower Engadine, Switzerland, and visits Alberto Giacometti's grave at Stampa. Tate Gallery buys *The Orientalist*, 1976–77 [59]. Scottish National Gallery of Modern Art, Edinburgh, buys *If Not, Not*, 1975–76 [11]. Museum Boymans-van Beuningen, Rotterdam, buys *Moresque*, 1975–76 [56].

1978–79 Returns to the United States, spending a few months as artist-in-residence at Dartmouth College. Summers at Sant Feliu, then spends a year in Greenwich Village, New York. Spends 1978 and 1979 drawing from the human figure and working in pastel. Meets frequently with painters Isabel Bishop, Irving Petlin, and Avigdor Arikha.

1979 First New York exhibition of pastels and drawings shown at Marlborough Gallery. Returns to London.

1980 Spends a year selecting paintings from the National Gallery, London, for an exhibition there called *The Artist's Eye*. Tate Gallery buys *The Rise of Fascism*, 1979–80. British Museum buys pastel triptych *Sides*, 1979. Phaidon Press begins work on the first Kitaj monograph, with text by Lawrence Gowing. First London exhibition of pastels and drawings shown at Marlborough Fine Art.

1982 Moves to Paris for indefinite working period. Elected to the American Institute of Arts and Letters. Honorary Doctorate, University College, London.

Hunger and Love in Their Variations

We lose our way in cities; we get lost in books, lost in thought; we are always looking for meaning in our lives as if we'd know what to do with it once we'd found it. . . . Nothing is straightforward. Reducing complexity is a ruse.[1]
R. B. KITAJ

"Only connect," urged E. M. Forster in *Howards End*; this exhortation was the theme of his novel. A decade later Yeats noted that "Things fall apart; the centre cannot hold," while T. S. Eliot appears to be replying directly to Forster through the persona of a seduced stenographer in *The Waste Land*: "I can connect / Nothing with nothing." By this time the dislocations tried out by other artists before the war had become real, as yet again life imitated art with disastrous results. The world itself, and not just a pictured mandolin and bottle on a table, had become unglued.

Faced with an altered reality, Eliot reacts as though in a stupor. Despite all his craft and scholarship, *The Waste Land* achieves its effect as a collage of hallucinatory, random fragments, "shored against my ruin." Their contiguity is all their meaning, and it is implied that from now on meaning will take into account the randomness and discontinuity of modern experience, that indeed meaning cannot be truthfully defined as anything else. Eliot's succeeding poetry backs away from this unpleasant discovery, or at any rate it appears to, though *Four Quartets* may be just as purposefully chaotic beneath its skin of deliberateness. Yet the gulf had opened up, and art with any serious aspirations toward realism still has to take into account the fact that reality escapes laws of perspective and logic, and does not naturally take the form of a sonnet or a sonata.

It is not unusual to begin a discussion of R. B. Kitaj's work with a mention of Eliot's; Kitaj himself has done so. Questions of politics aside, there are obvious parallels. Both left America in their twenties and brought to Europe a sensibility that was still unknown in the country of their birth but that, surprisingly, took root and flourished in their adopted one. In the work of both, the picturesque is at the service of a deep-seated sense of cultural malaise that seems distinctly European (Kitaj's title *The Autumn of Central Paris* captures it nicely), though presented with a directness that seems distinctly American. Like Whistler, Eliot, and Pound, the crusty gentleman from Ohio plays the role of resident Yankee gadfly in London, warning the locals of the perils of both Americanization and their own imminent stagnation. And, of course, in Kitaj's work, his earlier work at least, the fragmentation and randomness of *The Waste Land* are there, long before he painted it in *If Not, Not*, 1975–76 [11]. His cast of charac-

ters is similar: crude businessmen, prostitutes, neurasthenic fräuleins, ineffectual professors, even a ''Smyrna Greek,'' who is perhaps a relative of ''Mr. Eugenides, the Smyrna merchant.'' If his pictures could, in some cases, be illustrations for Eliot's poetry, the poetry itself often sounds like an approximation of Kitaj's brushwork:

The river sweats
Oil and tar
The barges drift
With the turning tide
Red sails
Wide
To leeward, swing on the heavy spar.[2]

Such a passage is less a description than a miming of a way of seeing wherein objects will clear for a moment and then blur, adjacent phenomena are compressed into a puzzling homogeneity, and clear outline abruptly turns illegible.

In addition, Kitaj is a man for whom modernism flourished and ended earlier in this century: that of Eliot, Pound, Joyce, and Yeats, of Matisse, Picasso, and Mondrian—more radical than anything that has come along since (he would argue) and hallowed by the rich patina of the old masters. In other words, he holds a position that is both conservative and, if his identification of the modern is correct, radical at the same time. The ''strange moment'' he is always saying we live in is not so much strange for him as banal; what is strange is the way Kitaj's appropriation of images and attitudes of the recent past has produced a modernism unlike any other.

It is, fittingly for our late century, a work shot through with oppositions that Kitaj is able to indicate but never quite resolve satisfactorily, which is as it should be: ''Reducing complexity is a ruse.'' (One is reminded of Scriabin's exhortations to the young Boris Pasternak, cited in Pasternak's memoir *Safe Conduct*,[3] to simplify art as much as possible—this from the master of some of the most disturbingly convoluted music ever written: simplicity is the ideal, but complexity is the reality.) First there is Kitaj's situation as a wanderer and expatriate, freighted with memories and attitudes from the homeland in which he had no wish to reside permanently, yet not entirely understood or accepted by his adopted country, eager as it is to welcome artistic refugees from America. As a displaced person, he is well qualified to serve as a spokesman for our century.

A further exemplary contradiction—which, like the others, enriches his work as it seems to short-circuit it—is the conflict between moral and aesthetic concerns. Kitaj has frequently stated his desire to create a democratic art that could be assimilated by a large public, yet there is always something fishy about these protestations. Clearly he has no intention of "painting down" to the public and seems hopeful that he will be allowed to have his patrician cake and let "them" eat it too. The disparity between his intentions and practice has not gone unremarked. "It is excellent that an artist has arrived on the scene whose work shows a profound involvement with the moral issues of our day. What is not yet established is that Kitaj has discovered how to organize his imaginative powers to express this involvement," sniffed a reviewer of Kitaj's 1963 show at the Marlborough New London Gallery;[4] while in 1975 another critic wrote: "Looking at his work one sees a superficial stringing together of images for an elite, growing out of an art for art's sake esthetic. . . . The line he gives us might be all right at a cocktail party but is hardly appropriate to an exhibition catalog when it is so blatantly out of line with his own practices."[5]

Even supposing the existence of a proletarian public conversant with Unity Mitford and Walter Benjamin, not to mention Pound, Joyce, and Bonnard, it is unlikely that Kitaj's work could ever succeed in being populist, for its allusions to figures such as these are so oblique that even intellectuals find them baffling. Besides which (as another Kitaj heckler wrote in *Artforum*), "The fact that not everybody, or even many, care about art (*any* art, not just modern), seems self-evident. . . ."[6] Yet Kitaj's stance, one foot planted in humanistic theorizing, the other in a practice that seems to contradict it, is again symptomatic of modernism. Picasso and Léger were both members of the French Communist Party, to cite but two obvious instances of radical chic. And it is likely that in the case of their work as well as Kitaj's, the *will* to produce art for the people— even if it fell short of its goal and produced an art of extreme sophistication— this intention nevertheless inflected, deflected their work and made it something very different, something far better, than if they had ignored social issues and remained willingly in the fold of self-referential art for art's sake. The failure is an honorable one, and far richer and more involving than success would have been.

Then there is the tension between the extremely fragmented look of Kitaj's early work and the apparently more unified and single-minded character of the late work, particularly the recent pastels. To a reviewer who pointed out the difference between the earlier "collaged" imagery and the later isolated figures, Kitaj replied, "Collage emphasizes *arrangement*, an aesthetic of conjoining, at the expense of depicting, picturing people and aspects of their time on

scorched earth, which was what I always wanted to represent. Arranging a life of forms on a surface will always be the bread and butter of picture-making . . . but the meat and drink?''[7] Finally, there is Kitaj's ambiguous celebration of the figure, where, again, he seems to have taken up a position at a vital crossroads in modern painting.

Certainly there is nothing ambiguous in his statements about painting and drawing the human form. "The notion of a *return* to the figure is just media-talk," he told an interviewer. "For some of us, it's the only art we know. . . . Manet and before, Cézanne, Degas, Picasso, Matisse, Bonnard, Brancusi, Mondrian. . . . were all trained, roughly speaking, in the same way. Over long periods in their youth they gave themselves to the study of the human figure, to that age-old instinct, that instinct I feel in my bones, that we've been talking about, drawing from the human form.''[8] In recent years Kitaj has cleared his stage of extras to concentrate on one or two figures, as in *From London (James Joll and John Golding)*, 1975–77 [13], and *The Orientalist*, 1976–77 [59]. But not until the drawings and pastels in his 1980 London show do we see just how deeply ingrained "in his bones" is the urge to draw the figure. These remarkable pictures scarcely rely at all anymore on effects of decor, on the presence of significant extraneous objects, but zero in on the figure with a new directness. Though the drawing is hardly academic and sometimes bizarrely skewed, for purposes one cannot immediately distinguish (but which need no justification), there is an atmosphere of the studio and a consuming will to "get it right" for the professor who might at any moment peer over one's shoulder.

Yet there is more to Kitaj's figuration than his pious statements might indicate. Note that he slips the names of Brancusi and Mondrian into his list as if they were best known as figurative artists. In the same way, he introduces "nonobjective" rectangles at the center of his *Sorrows of Belgium*, 1965 (Private collection, Paris), letting the war happen in the margins; or enunciates an entirely abstract Mondrianesque composition in *Chelsea Reach (First Version)*, 1969, which is neither homage nor parody but merely Kitaj speaking in another voice—something he is always doing, but seldom so noticeably. One is reminded of late tonal works by Schönberg, such as the Suite for String Orchestra, in which he seems to be saying "I can do that too when I feel like it."

But the spirit of abstraction as well as the letter has always been a foil for Kitaj's acute presentations of the figure. Johns, Rauschenberg, and de Kooning are names he also cites admiringly. Gene Baro has pointed out that the work is "alive to contemporary ideas, to the problems that give rise to Pop Art, to the protean quality of Abstract Expressionism. . . .''[9] This has allowed Kitaj to introduce raw "literature" into his work, a practice that still shocks otherwise open-

minded critics, especially in the sets of silkscreen prints shown at Marlborough in 1970, some of which were merely reproductions of unadorned book covers (*Bud and Sis, Rimes No. 3*) from the library of a most eclectic bibliophile. The all-over picture in which no element matters more than another, as proposed by the Abstract Expressionists and disconcertingly reformulated by the Pop artists, has perhaps helped Kitaj to come to certain conclusions about the surface of a picture. Sometimes he lets it take the form of a grid, as in the 1963 silkscreen *Photography and Philosophy*, in which a row of photographs taken in 1941 of heads of Russian prisoners of war is balanced with a group of six portrait drawings. More important, it has helped him to develop a surface that is different every time, in which his figures have their being—a sort of magma or "scorched earth," like the hellish swamp in which fragmentary people, animals, and objects float in *If Not, Not*: a landscape not devoid of picturesqueness, but whose mountaintop in the background is crowned not with a castle but with the "gate of death" at Birkenau-Auschwitz. One whiffs an era's bad breath. This ground cannot be characterized, as it varies from picture to picture, but it is always there, even in the recent figure drawings, as a medium in which the figures can be most themselves. If it accomplishes this best by self-effacement, it does so; if, on the other hand, it can best serve the figure by overpowering it (*Ninth Street under Snow*, 1979 [87]), it will do that too.

What I have been saying is that at every key point Kitaj seems to be occupying a place from which divergent paths rush off to different destinations. I have neglected to say until now that this is precisely what for me constitutes his greatness. As often as Kitaj the grouch proclaims the need for a narrow new approach to the figure, as often is he undercut by Kitaj the philosopher, the hedonist, or any of the artist's other Mabuse-like disguises. A spirit of genuine contradiction, fertile in its implications, thrives in the work, though not in the discussions of it between Kitaj and his critics. ("I'm an old sea-dog. Some reviewers seem to choke on my awful personality."[10]) Gene Baro enumerates further anomalies: "The way in which silhouettes become masses and masses become transparencies in some of his paintings is part of Kitaj's *stable world of change* [my italics—the oxymoron is the triggering mechanism of his work]. . . . Threats of disorder are contained to be exhibited. . . . Disparities are stabilized, or at least can be seen arrested in instability; an act of synthesis has taken place, and a personal impulse has yielded an impersonal meaning (which the viewer translates once again for the self)."[11]

And then there is Kitaj's often quoted but ill-understood comment (he was discussing the silkscreen prints, but the statement has implications for all his work): "SOME BOOKS HAVE PICTURES AND SOME PICTURES HAVE

BOOKS." Those who dismiss Kitaj for his "literary" qualities (actually one of his major and most daring innovations) have perhaps taken this to mean that the picture has a libretto, that it is in fact a kind of illustration after all. But to conclude this is to ignore Kitaj's passionate explorations of literature—twentieth-century literature and poetry in particular. Nowadays few painters are literary scholars and even fewer are "bookish" in Kitaj's jackdaw way (which allows Walter Benjamin to coexist on the same bookshelf with Bub and Sis). And those who are probably don't think of it as an ingredient of their art—painting, as we know, being merely areas of color arranged on a flat surface.

It wasn't always this way. The English aesthetician and art collector Richard Payne Knight expressed a general view current in the late eighteenth century when he wrote in his *Analytical Inquiry into the Principles of Taste* (1805): "The means . . . which sculpture and painting have of expressing the energies and affections of the mind are so much more limited, than those of poetry, that their comparative influence upon the passions is small; . . . and when more is attempted, it never approaches to that of poetry. The artist being not only confined to one point of time, but to the mere exterior expressions of feature and gesture. . . ."[12]

Poetry can "put a girdle round the earth in forty minutes." Its stock of idea-images is endless, yet they are visible only to the mind's eye. For some these are the highest categories of imagery, yet poetry will never have the weight and inevitability of painting or sculpture, limited though their scope may be by comparison. How wonderful it would be if a painter could unite the inexhaustibility of poetry with the concreteness of painting. Kitaj, I think, comes closer than any other contemporary, and he does so not because he is painting ideas, but because he is constantly scrutinizing all the chief indicators—poetry, pictures, politics, sex, the attitudes of people he sees, and the auras of situations they bring with them—in an effort to decode the cryptogram of the world.

Of many examples I select one that is for me one of Kitaj's most haunting scenarios, the 1974 pastel *Study for the World's Body* [8]. Again a title from Kitaj's bookshelf intrudes—John Crowe Ransom's 1938 elaboration of "the new criticism" wherein, as in this picture, we are shown that "the object is perceptually or physically remarkable."[13] What we see is a couple embracing in what is apparently an empty house: a light socket with no bulb hangs from the ceiling, a coathanger hangs from a nail in the bare wall. The uncurtained window admits light but frames no view; it is partially blocked by an ominous black rectangular shape whose position in space is ambiguous—is it standing next to the couple or behind them, against the window? They have just been disturbed, apparently; the man, who has his back to the viewer, is turning around

to look at something that the woman, retaining him with a white hand on his shoulder, gazes at too. Perhaps there is danger; perhaps it was only a creak in the floorboards. The characters of both are sharply indicated—these are specific people, not allegorical lovers: the man's nose is long and pointed, yet his air of intellectual alertness renders him almost handsome. The woman's face is perhaps excessively round and broad, but her expression of delicate apprehension is beautiful too. They are an unforgettable modern couple—sophisticated to the point of paranoia, perhaps, but able to deal with the world which made them turn out this way; more than a match no doubt for the unnamed thing that has just entered their lives, yet vulnerable and touching, almost pathetic, in their strength. Beautiful because exemplary. One thinks of Auden's "A Bride in the 30's":

Summoned by such a music from our time
Such images to audience come
As vanity cannot dispel nor bless;
Hunger and love in their variations . . .

Such is Kitaj, the chronicler not of our "strange moment" but of how it feels to be living it.

1. R. B. Kitaj, "A Return to London," *London Magazine*, n.s. 19 (February 1980): 25.

2. "The Waste Land," in T. S. Eliot, *The Complete Poems and Plays, 1909–1950* (New York: Harcourt, Brace and Co., 1952), p. 45.

3. Boris Pasternak, *Safe Conduct: An Autobiography and Other Writings* (New York: New Directions, 1958), p. 24.

4. Edwin Mullins, "Other Exhibitions," *Apollo* 77 (March 1963): 231.

5. Gerald Nordland, "Los Angeles Newsletter," *Art International* 19 (December 20, 1975): 34.

6. David Simpson, "Letters [to the Editor]," *Artforum* 14 (November 1975): 8.

7. Kitaj, "Return to London," p. 15.

8. James Faure Walker, "R. B. Kitaj Interviewed by James Faure Walker," *Artscribe*, no. 5 (February 1977), p. 4.

9. Gene Baro, "The British Scene: Hockney and Kitaj," *Arts Magazine* 38 (May–June 1964): 100.

10. Letter to Joe Shannon, June 1981.

11. Baro, "British Scene," p. 100.

12. Quoted in Andrew Wilton, *Turner and the Sublime* (London: British Museum Publications for Art Gallery of Ontario, Yale Center for British Art, and Trustees of the British Museum, 1980), p. 15.

13. Quoted in Malcolm Bradbury, Eric Mottram, and Jean Franco, eds., *The Penguin Companion to American Literature* (Harmondsworth, England: Penguin Books, 1971), p. 213.

The Allegorists: Kitaj and the Viewer

JOE SHANNON

For experiencing art is experiencing, among other things, that others have existed as we exist. JOHN FOWLES, 1970

Georges Hugnet once noted about the French proto-Surrealist Lautréamont that "his contribution [was] more intellectual and moral than formal."[1] A similar comment could be made regarding R. B. Kitaj. This is not to slight Kitaj's formal achievements—a large portion of this essay will, in fact, be devoted to those attainments, with emphasis on his singular draftsmanship. Rather, it is simply to acknowledge that it is Kitaj's use of content and subject matter—the illustrational aspects of picture-making[2]—that has separated him from the pack and placed him among the leaders of resurgent figuration.

It is these illustrational works, in which Kitaj presents his idiosyncratic vision of our frayed and puzzling times, that are Kitaj's major, lasting accomplishments. No artist, not even Picasso, has been better able to convey with figuration the social texture of our grim and messy century. Kitaj's best works don't spell out specific events so much as create an atmosphere of social calamity. These works are visualizations of human life, engaging man's issues as worthy images. In them, Kitaj maintains the same ethical and moral commitment that he grants his loved ones, his friends, his nation (nations), and his planet.

Unlike many of the old Dadaists, Kitaj has never tried to "humiliate" art, despite his love for the ironic. From the beginning he intended to uphold art, to wield it as a civilized instrument of reform, or, at the very least, to use it to cast a little light into the corners of our shrouded brains. His subjects are almost always urban; Kitaj has a Baudelairian love for the city and considers himself a city watcher—a city witness. The time of his mythic city is the late 1920s to the early '40s, a period rushing toward the unspeakable crimes of the Nazi thugs. Even the works set in more recent years have an air that suggests that woeful era.

Urgently seeking social significance, Kitaj has probed the human condition allegorically as well as empirically, using complex and difficult imagery that compels us to peer beneath the surface for meanings. According to Walter Benjamin's theory of allegory, "any person, any object, any relationship can mean absolutely anything else."[3] On some level—whether psychological, or, as Benjamin says, ontological—allegorical potential is emitted from all things. It is for us, the "readers," to allegorize:

If the object becomes allegorical under the gaze of melancholy, if melancholy causes life to flow out of it and it remains behind dead, but eternally secure, then it is exposed to the allegorist, it is unconditionally in his power. That is to say it is now quite incapable of

emanating any meaning or significance of its own; *such significance as it has, it acquires from the allegorist* [my emphasis].[4]

Thus, even an artwork of the "literal," empirical kind, whose "objecthood" (in the Greenbergian sense) is supposedly nonreferential and hermetically sealed, can, with the right "reader" or "allegorist," become much more than a mere object presence. The viewer (melancholy or not) unconsciously has an "allegorical desire, a desire *for* allegory, that is implicit in the idea of structure itself. . . . Psychoanalytically . . . the movement of allegory, like the dreamwork, enacts a wish that determines its progress. . . ."[5]

The allegory is created by both viewer and artist. Kitaj offers in his work an unfolding of metaphor and illusion; he designs the imagery to urge directions the viewer should take as allegorist; he is a provocateur of meanings. At the same time, "Allegorical imagery is appropriated imagery; the allegorist does not invent images but confiscates them. He lays claim to the culturally significant, poses as its interpreter."[6] Or, as Kitaj commented, "You can't make a mark on a canvas that's not redolent of something you know outside the painting."[7] He has said, "I came out of Surrealism"[8]—yes, but he builds his art on the visual poetics of humanity's plight and uses any free-associated subject matter that he might bring forward from that plight to make his message clear. By contrast, similar material, when perceived by an old-line Surrealist, might have been used "automatically" to make works emphasizing the juxtapositions of madness, works that the viewer would be more likely to see as disjunctive and irrational.

Kitaj has stated that he would like to do visually what modern poetry has done verbally—to make works as difficult, as multileveled, as tough, and as full of human purport as a work by T. S. Eliot or Ezra Pound.[9] This desire can help explain some underpinnings of Kitaj's approach. Poetry is to prose narration as mannerism (subjective stylization) or abstraction (reduced depiction) is to naturalism. Poetry, like modern painting, draws attention to itself—its form is as important as what it says. And poetry, like mannerism, distances reality at the same time it invokes it. But, unlike much modern painting, poetry has a train of thought. The spiritual poetics in a Suprematist painting by Kazimir Malevich, for example, may have satisfied Malevich, but the painting has no train of thought—any allegory to be had must be "read in" by the viewer.

Kitaj is an impure modernist, alternately embracing and discarding modernist canons. His illustrative streak is the bedrock "impurity" of his great strength (the "pure" modernist Donald Judd once sarcastically compared his work to that of the Symbolist Franz von Stuck[10]). Kitaj is an equally impure traditionalist: even now, during his most naturalistic period, his abstractionist side consist-

ently contradicts his powerful depictive impulses, but this also is a strength, keeping as it does his visual vocabulary "readable" to our modernist sensibilities.

This impure modernist and impure traditionalist makes every effort to wake us up, to yank us out of last year's skin, out of our investments, our complacency, and to set us down on his searching path. By the mid-1960s, when his work reached full power, that path was as meandering as that of any twentieth-century artist. Keep in mind that Kitaj is a restless eclectic. In the 1950s, especially, he was constantly shifting from traditional concerns of handiwork and depiction to modernist issues of reduction. I won't be speaking much here of this classic modernist streak, his abstractionist side—works like *Isaac Babel Riding with Budyonny*, 1962 (Tate Gallery, London); *An Untitled Romance*, 1961 (location undetermined); *Reflections on Violence*, 1962 [27]; and *Halcyon Days*, 1964 (Museum Boymans-van Beuningen, Rotterdam); or odd jokes like *Chelsea Reach (First Version)*, 1969 (destroyed). In my view these are just diverting blips in the cardiogram of his career. He has persisted in experimenting with such nondepictive visions. In 1969 it was the conceptual *Lives of the Engineers* series (Collection of the artist), then came the neo-Cubism of *Dashiell Hammett* (Tony Reichardt, London) in 1970, and he continued more recently with the polyformed *Hugh Lane* of 1972 (Private collection, Switzerland) and *The Third Department (A Teste Study)*, 1970–77 [40].

My job, as I see it, is to trace the development of Kitaj's oeuvre by examining certain key illustrational works. I will stick to what could be perceived by a viewer alone in the gallery, standing before the works with only his own teeming associations and not privy to Kitaj's stated intentions. In discussing the following works I will focus on the evolution of important elements in Kitaj's draftsmanship:

Erasmus, 1958 [20]
Nietzsche's Moustache, 1962 [25]
Good News for Incunabulists, 1962 [1]
Where the Railroad Leaves the Sea, 1964 [2]

His content and subject matter will be considered in:
The Ohio Gang, 1964 [3]
Juan de la Cruz, 1967 [5]
The Autumn of Central Paris (After Walter Benjamin), 1972–74 [6]
To Live in Peace (The Singers), 1973–77 [12]

Finally, I will return to the latest changes and advances in Kitaj's drawing by studying *The Yellow Hat*, 1980 [17], then will conclude with a discussion of two

of his recent paintings: *If Not, Not*, 1975–76 [11], and *Smyrna Greek (Nikos)*, 1976–77 [10].

What follows will, I hope, illuminate why these dry, vigorous icons are able to move us so.

Erasmus
1958 [20]

Kitaj has said that *Erasmus* was his first good work,[11] and its mordant humor and energy do foreshadow his later power. The paint is applied loosely, expressionistically, with a de Kooning-like vigor. We may see whimsy in these action-painted cartoons; yet there is also an underlying darkness that intimates aberration, an image of idiot laughter suggestive of besmeared Jiminy Crickets or Francis Bacon's gasping frogmouths. Such oppositions persist throughout Kitaj's work.

The goony, vacuous cartoon head in the square at bottom right is akin to such later characters as the ghostly sodomizer in *Juan de la Cruz*. Childishly drawn, it expresses a gravely ironic contemplation even in its innocence. The Cheshire-cat smile of the central head in the top row clearly prefigures Kitaj's later simplicity of line. It is, however, the profile of the bland Everyman in the very center that reveals the rudiments of Kitaj's severe "forced" style, which later became evident in the tongue-biting deliberateness and economy with which he delineated the menacing "Primo" in the center panel of *Junta,* 1962 [24]; the reporter in *Good News for Incunabulists* [1]; and the doctor and nurse in *Erie Shore*, 1966 [29].

The grid arrangement in *Erasmus* is not unusual for Kitaj; until recently, he used that device repeatedly. Such paneling, as well as the related techniques of montaging and collaging, has been around since the teens, favored by artists from Picasso, Raoul Hausmann, Hannah Hoch, Kurt Schwitters, and Max Ernst to such present-day adherents of imagic gridding as Robert Rauschenberg, Larry Rivers, Jasper Johns, and Kitaj himself. Beyond the formal aspects of this Mondrian-like strategy of composition, the panels provide imagists like Kitaj and others with nonillusionistic breaks. Such delineated spaces can be used to convey comparison and variation, as in *Erasmus,* or to give the instant of a painting a duration (for narrative or didactic purposes) by making the eye move from panel to panel, unfolding ideas. In purely pictorial terms, interplay occurs between the surface orientation of the frames of the grid and the images of varying degrees of illusion within.

In works related to *Erasmus*, but more rooted in narration, Kitaj experimented with giving imagic material *voice* by using the "document"; the readymade image (taken from such diverse sources as magazines, newspapers, movie stills); the deadpan didactic phrase (e.g., "Chicagoism of the Soul"[12]); the provocative juxtaposition. These experiments are, to my mind, most successful in his prints.[13]

Nietzsche's Moustache 1962 [25]

It was Kitaj's improvisatory response to his "first marks" in *Nietzsche's Moustache* that determined the ingenious nature of his style and imagery. Every artist is familiar with those exploratory strokes, dots, and doodles that I call "first marks." Depending on the artist, and depending on what he is trying to accomplish, these marks are generally used not to depict but to locate. Here will be the feet ⌣, ⌣ here will be the head ∫ ⌐. If the artist is using a "one-shot" medium—making, for example, a contour drawing in pen and india ink—then first marks are made more carefully and may, in fact, be depictive from the start. But in a changeable medium like oil or pastel, first marks can be, and usually are, exploratory—meandering notations recalling the "automatic" scrawl of a Surrealist like Matta or an abstractionist like Cy Twombly.

Timothy Hyman has aptly said that viewing a work by Kitaj gives him the "sense of a mind roving."[14] No matter what Kitaj's original conception of *Nietzsche's Moustache* may have been, it was changed dramatically by his willingness to be led "a-roving" by the possibilities he saw in the first marks.

An abstractionist makes first marks in a process of finding non-referential, picture-building shapes (you might call this an art response); a traditionalist makes first marks as a step toward depicting a viewed motif (you might call this a nature response). Both are striving for truth, but of a different kind. Kitaj's way falls in between the two. He shows us that even when the depictive process is reduced—abstracted—the process of allegory can be in full swing, thus:

(1) social ideas, as well as pictorial ones, can be carried by the fragmented personages in *Nietzsche's Moustache;*

(2) unlikely as it seems, evocations of sentiment and feeling can be intensified by these abstract factors;

(3) the studied use of illustrative elements in concert with purely pictorial factors can stimulate a viewer's own free associations, releasing the allegorist within him.

So, although not depictive in the traditional sense, *Nietzsche's Moustache* nonetheless can evoke associations in the viewer as vividly as a more explicitly rendered figurative scene. In it Kitaj has created a comedic, interacting quartet that has personality, both antic and sad. He has done this subtly, with gestural implications of content, by smudging a hat, by capturing a stance, by distortion—in other words, by the formalization of first marks. The face of the slouching figure at right is scrubbed out and extended (arbitrarily, abstractly) to the female's shoulder at his left. This is a magical and pregnant connection. The figure to her left, almost headless beneath his boater, has a structure like a house sketched within the heavy outline of his distorted and solitary leg. The figure at far left, more energetic than his loitering companions, is caught in stop action, lunging to his right.

These disjointed and fragmented sketches—predepictive or postdepictive (depending on which side of the modernist fence you stand on) provide seeds of allegorical meanings based on the feelings to be found in this atmosphere of clownish gravity. Our response is partly shaped by the subconscious connection we make between *Nietzsche's Moustache* and cartooning or other popular styles of distortion. This relationship to cartooning reflects an "anything-goes" mode—derived from Art Brut, children's book illustrations, and drawings by children, as well as from cartooning—that was part of the pervasive hip vision shared in the early 1960s by some of the so-called English Pop figures such as David Hockney and Allen Jones, as well as by Kitaj and a few others.

With *Nietzsche's Moustache*, Kitaj shows us the myriad opportunities for allegory made possible by his idiosyncratic selection from all the first marks available to him. These selections, both abstracted and depictive, shape the nature of the emotions and ideas the viewer gets from the work.

Good News for Incunabulists
1962 [1]

Good News for Incunabulists leads to Kitaj's most coherent subject pictures, such as *Where the Railroad Leaves the Sea* and *The Ohio Gang*. Because of their twentieth-century social message, these paintings make a kind of history painting for our time. They are certainly not "history paintings" in the traditional commemorative sense, like such grandiose celebrations as Jacques-Louis David's *Oath of the Horatii*, 1785 (Musée du Louvre, Paris), or Diego Velázquez's *Surrender of Breda*, 1635 (Museo del Prado, Madrid). Instead, these works by Kitaj commemorate the grim, ambiguous, unfocused quality of contemporary events. The players in Kitaj's strangely dramatic and tautly psychological theater of images are the nameless who commit the crimes, hold the jobs, sign the papers, practice the vices, or end up the victims at Auschwitz and Babi Yar. Though disjointed and fragmented, these compositions are profound reflections of our bitter history. These tensely intellectual illustrations are as epic and "historical" in their own way as the best history paintings of the past.

In formal terms, the figures in *Good News for Incunabulists* are fewer and larger in relation to the format; the background elements are massed to provide a backdrop and compositional unity. This contrasts with Kitaj's more fragmented and abstracted works—such as the previously mentioned "modernist asides": *Reflections on Violence* and *Halcyon Days*. In *Good News for Incunabulists* elements are abruptly montaged: see the woman's head at upper left or the configuration of abstract lines at lower left (like a Mondrian painting from the teens). The scaled-down Chaplinesque witness in the lower left-hand corner represents another plane of allusion, like a subplot, provoking questions and

providing clues. Such homunculi are visual footnotes to Kitaj's paintings, either appearing in natural-scale relationships, like the figures at the top of the stairs in *Walter Lippmann*, 1966 [4], or in unnatural relationships, like the (RED!) worker digging at the bottom of *The Autumn of Central Paris (After Walter Benjamin)*, who appears again (now white) in *Pacific Coast Highway (Across the Pacific)*, 1973 [47].

The left arm of the newsman in *Good News for Incunabulists* is a typical example of Kitaj's utilization of first marks. Two quick, distorted outlines carry the shoulder and arm off the canvas; a few swift and rough dragging strokes form the hand that redirects the limb back into the picture. This drawing, combined with the placement and angle of the head, conveys urgency—*emergency*.

Where the Railroad Leaves the Sea 1964 [2]

In this painting, along with *Apotheosis of Groundlessness*, 1964 (Cincinnati Art Museum), Kitaj first uses de Chiricoesque perspective as a surrealistic metaphor for time and distance, breaking the picture plane to engage the possibilities of illusionistic space. Prior to these paintings Kitaj had usually emphasized the flatness of the picture plane by gridding, by patterning, by abstracting key factors, by switching scales, and by montaging or collaging.

Where the Railroad Leaves the Sea and *Apotheosis of Groundlessness* evoke a lonesome silence, especially the latter, with its shadowless, unpeopled warehouse in which bright structures seem to float just above the floor. There is a spirit of anti-virtuosity in the way the angular forms are stiffly and laboriously painted to give a dry, graphic appearance. This is a grieving picture, as is *Where the Railroad Leaves the Sea*. Here the setting is a train station, whose soaring girdered roof ends raggedly, like exposed bones pointing toward the unseen sea. The embracing couple sit alone at a counter, preparing to part (there is too much sadness about them for this to be a greeting). An urban melancholy pervades, a heartbreaking existential loneliness.

Where the Railroad Leaves the Sea is composed symmetrically. Kitaj the cool modernist flanks the couple with colorful Picabia-like structures, mechanical "guardians." Kitaj the romantic throws us into deep time-space, with the receding ruin of the roof creating a setting that is surreal and disquieting.

The masterly drawing of the two figures shows Kitaj's disregard of strictly depictive concerns and his exploitation of the opportunities for invention suggested by first marks. He never limits himself to simple rendering; he is too much a man of his times not to respond to accident or to a recognition of shapes formed by memory of past art, his own and others. Kitaj is as much interested in drawing as independent entity—or, better yet, in drawing as a decisive act of variation—as he is in drawing as responsive depiction.

The verve, the mysterious power here belie the sparseness and flatness of the overall delivery. Consider the man's monstrous head, his Auschwitz hairline, his face scarred by the squiggling overlays. His brain leaks strokes and smudges that hover behind his head like thoughts, their forms implying a mouth, a talker, a ghostly personage. Little attempt has been made to model internally; color is simply scrubbed inside the contours. The man's disconnected right arm and hand firmly grasp his companion's shoulder as he urgently plants his kiss. Kitaj severed the arm for reasons of design—if it were continuous, the gesture would be groping and awkward; with it cut, the embrace remains imperative and elegant.

The image is almost diagrammatic; yet, despite its economies, it rivets the viewer's attention, stirring sympathetic emotions that come from recognition. The painting summons up scenes of farewell from numerous movies of the 1930s and '40s, and recalls with special poignancy the situation of the Jews, who were separated forever from family and friends by crimes beyond human understanding.

The Ohio Gang
1964 [3]

The Ohio Gang is Kitaj's first epic subject picture, and the first that has the mien of a "history painting" in almost a traditional sense. Not that it illustrates any specific event of the past; rather, it epitomizes an entire era. *Where the Railroad Leaves the Sea* is a sad and intimate vision reflecting larger social issues. *The Ohio Gang* is grander, more mythic, more complicated and mysterious (we can almost hear strains of *The Threepenny Opera*[15]), establishing an air of social portentousness and dire historical significance that is basic to Kitaj's world view.

The grim and grimy decadence that pervades *The Ohio Gang* must trigger in our minds unavoidable memories of the gangsterlike atmosphere attending the rise of Nazism in Germany. The spirit of the picture recalls that of George Grosz's savage caricatures of the 1920s or of German realism in general during that period. Composed in a constructivist manner, the painting has no real perspective except what is suggested by the placement and relative sizes of the figures. That is enough to establish ample illusional space for this strange assemblage to enact whatever it is that has brought them together.

This work always brings to my mind Picasso's great etching *Minotauromachy*, 1935 (fig. 1). I am not sure that there is any direct relationship, but I do sense a similar moral intent in the works: both are about good and evil. In the Kitaj there is more evil than good; the good has been all but vanquished. Picasso's print reveals a personal neoclassicism composed of very subjective images: mediterranean and darkly poetical. Kitaj's painting is also darkly poetical,

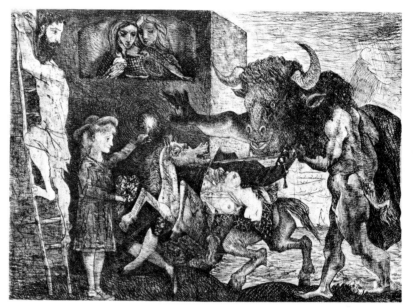

but how different! There is no neoclassicism here (except in the drawing of the nude); there is, instead, a very real citified terror. It is as if the gentle, intrepid little girl in the Picasso had grown into Kitaj's graceful and nonchalant nude, a jaded, hedonistic moll. In the Picasso, the child holds a candle toward the beast of darkness; in the Kitaj, the painting's only ''light'' (the swivel lamp is dead) is the pallor of the nude's flesh, and the gangster sitting before her is no Minotaur of strength and gloomy purpose, only a third-rate poseur, a plotting Mack-the-Knife. Where Picasso's mythic content portends dangerous but heroic events, *The Ohio Gang* augurs petty thievery, venereal disease, and murder. It's as if Kitaj sees the first symptoms of a dying culture in a plague of small-change robbery and schemes of graft or vice, with his mythic seething city its nutritive medium, its giant petri dish.

We see the gangster warm his long-fingered hands over the beautifully drawn moll, his head a smart example of Kitaj's play with first marks. Delicately ambiguous, his face appears both in a dominant three-quarter view and a pug-like profile. Behind the couple, a figure pours down from a disjointed head that rests on the sill of an opening. To the right of these figures stands an oddly undressed slattern, an evil handmaiden who transmits a syphilitic physicality, an effigy of Kitaj's brand of burning metropolitan sex. A mutant, a CPA with tits, kneels in a pram being pushed by a madly grinning nurse. She is an explosion of marks (first as well as formalized)—a virtual wreckage of visual improvisation. Above her a tiny pithecanthropus strides toward escape.

The Ohio Gang is one of those images, like *Minotauromachy*, that is so replete with possibilities that historians will be trying to unravel its enigmas for years. This we do know, that it is about our times, about viciousness and exploitation, about license and perverted porcine appetites. Nor is there any doubt where Kitaj stands in this moral quagmire, just as there was no doubt where Picasso stood or Grosz or Max Beckmann, with works just as damning.

Juan de la Cruz
1967 [5]

A message picture that summarizes much of Kitaj's social and didactic intent, *Juan de la Cruz* reflects the keenness of the artist's mind and the richness of his visual imagination. It comes close to realizing Kitaj's implausible dream of a populist art: his work at last had "got a job."[16] *Juan de la Cruz* shows Kitaj's human concern and mocking humor, as well as his most skillful manner in draftsmanship, composition, and color. His drawing had become a distinctive amalgam of power and grace—at once deliberate and aleatory. Someone once said that modernism is a den to which there are no returning footprints; if so, then romanticism is a den with ever-returning footprints. With Kitaj, there is an underlying romanticism combined with a thoroughly hip understanding of human folly.

If there is a more biting revelation of the ragged ups and downs of the 1960s—that time of soaring liberalism, misguided liberal excesses, and cultural short-circuiting—I haven't seen it. *Juan de la Cruz* is a souvenir of the futile insanities of the Vietnam War, that symptom of the time's unstable multiplicity. Kitaj the impure modernist, the impure traditionalist, and especially Kitaj the powerful illustrator, displays all his wares in this work.

The beautiful Juan gazes out, appraisingly and slightly hostile. No more than twenty-two, he is already very much a person to be reckoned with: a helicopter pilot, a sergeant, a man of rank. His head is a rich monochromatic brown, painted in an anti-painterly way, looking like a one-color proof for an offset litho. Within the nervously delicate drawing, his jacket is done in typically flat, scrubbed tones (Kitaj rarely bothered with interior modeling in those days). Blue sleeves and collar, brown bodice: decorative, nondepictive color choices almost Fauve-like in their lushness. On his breast is the name tag "Cross"—a tart irony, obviously intended, since Kitaj's title tells us his real name is Juan de la Cruz.[17]

To Juan's right is the nude figure of a woman, back arched for sex, rendered in unstylish lines like the drawings in matchbooks and Charles Atlas ads. Ghosting over the waiting woman (and obviously a product of first marks) is a descendant from Kitaj's *Erasmus*—a comic-strip balloon prepared for coupling. To the left are scratched marks like glyphs of war: X = barbed wire, X = can-

celed, X = wrong. Outside the helicopter door, a pirate watches the sodomized woman walk the plank.

The interchange between the decorative and the sadistic, the playful and the lethal is almost unbearable. Juan, a draftee from a canceled life—facing his own death; this beautiful youth kills. We see here a pirate's war, woeful and misbegotten; if the helicopter was its machine, then Juan de la Cruz and his kind were its flesh—its red meat.

The Autumn of Central Paris (After Walter Benjamin) 1972–74 [6]

Kitaj's wife died in 1969, and it was not until 1972 that he fully returned to his work, again savoring ideas from art and from nature. It was then he began to draw from life, *intensely*. He played with ideas from a child's drawings of Batman and Superman, making them into two gigantic paintings [42, 43]. He also continued to make some of the century's most evocative subject pictures, such as *Arcades (After Walter Benjamin)*, 1972–74 [41], and the masterful *The Autumn of Central Paris (After Walter Benjamin)*.

Benjamin is Kitaj's hero; he is to Kitaj what Apollo was to Titian, what Marat was to David. Benjamin is Kitaj's soul brother, a German Jewish intellectual who committed suicide in Paris in October 1940, after an unsuccessful attempt to flee the Nazis. Like Kitaj, he was a city walker, a city witness, a flaneur. He wrote brilliantly on a variety of subjects, from book collecting to opera; there are especially memorable essays on Kafka and Baudelaire. Starcrossed and out of kilter, he described himself as having come "into the world under the sign of Saturn—the star of the slowest revolution, the planet of detours and delays. . . ."[18] Susan Sontag says that he had "the taste for allegory, Surrealist shock effects, discontinuous utterance, the sense of historical catastrophe."[19] The same could be said of Kitaj and Kitaj's work.

A tumbling, classical composition of monumental scale and presence, *The Autumn of Central Paris (After Walter Benjamin)* has a kind of seventeenth-century authority. The story, whatever it may be, operates on several levels. There is the central group, drawn with wit and bite, who are surely discussing matters of life and death. There is the subplot of the little red worker brandishing a pickaxe, perhaps an allusion to Benjamin's politics. There is the pensive woman in the semicircle gazing out to the left; she seems bereaved, but may simply be waiting for someone. Still, she thickens the possibilities—as does the jigsaw puzzle of fragmented and overlapping figures ascending to the upper left corner. These multiple images are the visual equivalent of spinning the radio dial: a few words of a newscast, a whisper of passion from a drama, a squawk of music, a sermon, a song, a voice—silence. Like those fractured, evocative sounds, Kitaj's interlocking figures suggest both presence and absence, con-

nection and separation, tumult and order, triggering in us a desire to know more of what lies beneath—we desire allegory. There are magical passages of great beauty, moments of rare sunshine: the woman at the table on the far right, the strolling man played against the bright sky in the deep distance. Nonetheless, Kitaj never allows us to forget the nature of our world—the angst remains.

To Live in Peace (The Singers) 1973–77 [12]

In the mid-1960s Kitaj could never have made this painting; even now it makes me blink in disbelief. It is surprising, just as it was surprising for Goya to do both the tapestry cartoons and *Los Caprichos*. Stylistically, of course, it is Kitaj's in every way. But in terms of content, where is the grim Kitaj of historical catastrophe? Here we have an almost Renoir-like politeness—in fact, this is as close to Renoir's *Luncheon of the Boating Party*, 1881 (Phillips Collection, Washington, D.C.), as Kitaj will ever get. The painting is as light and musical as its theme. What is more loving and wholesome than a family meal on a dazzling day by the sea? And to sing together, why that's positively genteel.

How unabashedly intense is the singer on the right, how delicately (almost orientally) is she drawn, how appropriate her posture. The duet is completed by the enthusiastic man in the center, hands on lapels, head thrown back, mouth open in full cry. Kitaj evokes empathy for this friendly genre group by playing on the viewer's recognition of human types and human situations. There is very little traditional depictive detail, very little inner modeling, yet the scene breathes life. It is Kitaj's genius that he can convey complex concepts of life and living by these scrubs of color and graceful distortions.

In 1974 Kitaj began a series of pastels that was, in many ways, to alter the course of his art. Enthusiasm for this traditional technique led him (the impure modernist and impure traditionalist) to a firmer grip on history and artistic precedent. The pastels were a continuation of his renewed interest in drawing that had started in 1972. Seeing the exhibition of Degas pastels at the Petit Palais in 1975 reinforced this enterprise, as did the relative ease with which he took to the medium. Like Degas, Kitaj had complained that oil painting was too slow, that his output was too small. Taking up pastels changed that for both artists. Kitaj found it to be a rapid medium and one compatible with his great eclecticism of style and subject.

By mid-decade Kitaj was in a revisionist humor that led him to judge his earlier work very critically, saying, in fact, that he considered much of it "puerile."[20] He sought a certain pedigree, wanting to join a line that leads back to the Renaissance and earlier. He believed that figuration was the visual language of humanity and that modernism—especially formalism—had reached a dead end.

But Kitaj cannot escape the fact that he is an artist of the mid-twentieth century. In my opinion his greatest skill does not lie in approaches, such as naturalism and realism, that are comparatively unmannered. His strengths are his modernism, his mannerism, his restless impurity, his eclecticism. He brings a unique vision to figurative depiction—an improvisatory flair for responding to first marks.

When an artist, any artist, attempts to change in ways unnatural to his basic gift, the danger is that each undertaking will be overworked, undermining its freshness and spontaneity; the artist thus risks atrophy of his essential vision. Kitaj is aware of these risks, hence the big thing, the courageous thing, is that in mid-life he would tackle so significant a change.

His remarkable successes with this aspect, evidenced by the works to be discussed here, show not only his skill but his *nerve*, and his Raphaelesque malleability and willingness to learn.[21] It is stimulating to contemplate where these achievements, combined with his improvisatory instincts, might lead him in the future.

Not surprisingly, it is the works from nature—especially the nudes, which reflect Kitaj's new emphasis on rendering forms with sensual weight—that show most clearly his effort to link up with tradition, to make an art consistent with his polemic. *Marynka*, 1979 [82] and *Marynka Smoking*, 1980 [92], are strong, rather straightforward depictions, while others convey a steamy sexuality, as evident in the casual sprawl of the prostitute in *Femme du Peuple I*, 1974. *Marynka and Janet*, 1979 [84], a sly, wiry drawing of two women embracing, has some of the piquant underworld quality of Toulouse-Lautrec's gouaches and oils of lesbians, but obviously Kitaj's bemused couple is more convivial. With *Marynka on Her Stomach*, 1979 [83], Kitaj puts muscle and chunky flesh on the bones of our notions of sex. Like another powerhouse, Gustave Courbet, he models great volumes of thigh and rump, making us aware of their dynamism as symbols of raw, earthy life. This is not to say that Kitaj has abandoned anxiety: in *After Rodin*, 1980 [99], we are brought up short by similar volumes, confronted by a headless creature on the autopsy table; threats of mutilation assail us, while ancient fears are stirred by the frontal view of the woundlike genitals and the beheading (which, after all, results in the ultimate impotence).

The Yellow Hat 1980 [17] This is a simple composition, similar to Degas's lounging nudes of the early 1880s (see fig. 2). A nude is lying on a couch, her head cropped at the eye and nose by the edge of the paper, her right ankle resting on her left knee—her legs are spread. The fingers of her left hand caress her genitals. *The Yellow Hat* shares with Kitaj's other nudes a fleshy, unusually sculptural volume of breath and blood. Its colors are interesting, but there is something of the pharmacy about them, a poisonous quality; note the orange leaking behind the leg,

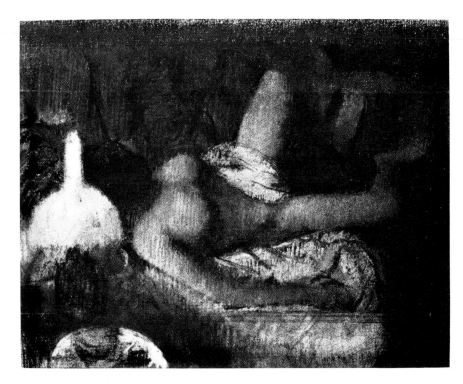

and the yellow hat against the rusty head. The facial expression is neutral, neither asleep nor aroused.

A note may be appropriate here about Kitaj's many views of sex. In the 1960s, mostly with images of females, he showed us the Groszian side of sex—the dangerous, slightly criminal pleasures, but also the fathomless mystery. The woman in *Where the Railroad Leaves the Sea*, nude from the waist up (or wearing a transparent blouse), can be interpreted either as sexy or vulnerable—by exposing her breasts Kitaj again asks us to speculate, to "read in." The slattern in *The Ohio Gang* sports her breast-baring harness as carnal equipment; in *Erie Shore* the pugnacious blond nurse reveals a dark pennant of pubic hair beneath her miniskirt. The brightly constructivist woman in *Synchromy with F.B.—General of Hot Desire*, 1968 [33], thrusts her pelvis forward to flaunt her gaping genitals.

I cannot think of any male sexual subjects in Kitaj's work before the 1970s; there may have been some, but certainly no penises. In the 1970s suddenly that is changed: in *Communist and Socialist*, 1975 (Collection of the artist) [50]; *His Hour*, 1975 (Mr. and Mrs. Gene Corman, Beverly Hills, California); *This Knot of Life*, 1975 (Collection of the artist); *The Rash Act*, 1976 (Collection of the artist); and others. With the exception of the drawing series from the male

model done during his stay in New York and pastels such as *Actor (Richard)*, 1979 [91]; *Sides*, 1979 (British Museum, London); and a few others like *David*, 1979–80 (Collection of the artist), and *Quentin*, 1979 [85], Kitaj's other work from the nude has been of the female.

The emphasis in the previously mentioned works is not merely on sexual physiology but on sexual acts; there is a big difference. Many artists of the past have done work of this kind, but it is little known and rarely shown. Kitaj, by introducing these issues publicly, advocates that the potent biological and social mysteries symbolized by the sexual encounter can be as enriching to a painter's subject matter as to a writer's. There has been some censure of Kitaj for exhibiting these works, but unlike Egon Schiele, to whose work he is indebted, Kitaj has not been imprisoned for them. Some of these works unforgettably expand the pictorial range of the sexual encounter. *This Knot of Life*, for instance, is an enigmatic work whose setting is the hallway, a favorite locale for Kitaj's vignettes, just as voyeurism is a social activity that he often portrays, as in *His Hour*, with its Goebbels-like central character.

What is Kitaj telling us with these eye-riveting portrayals of sex? Does he feel that sex of this kind is just another example of humanity's self-destructive indifference or exploitiveness? Are these revelations a mockery of the gentle possibilities of sex—a perversion of *love*? Yes, for surely "sex is an exchange of pleasures, of needs; *love* is giving without return. . . . This is the quintessence the great alchemy of sex is for; and every adultery adulterates it, every infidelity betrays it, every cruelty clouds it."[22]

As we have seen, many of the pastels are done from nature—from the model—but many are not. When it comes to picture-making and to trying something different—when Kitaj has an itch, he scratches. He uses classical plays on first marks in *Bather (Tousled Hair)*, 1978 [69], while the deliberate "tongue-biting" Kitaj reappears with the bent-iron outlines of *Therese*, 1978 (Mr. and Mrs. Michael Blankfort, Los Angeles). The most ambitious pastels are the nightmarish *Sighs from Hell*, 1979 [9], and *The Rise of Fascism*, 1979–80 (Tate Gallery, London), which carry forward Kitaj's exploration of history's major crime.

Just as Degas's example led Kitaj to do the powerful pastel nudes, so is his influence present in *Washing Cork (Ramon)*, 1978 [14], bringing to mind the older artist's stolid, strong-limbed ironers or the trapped resignation of Raphael Soyer's garment workers, also derived from Degas. Kitaj's selection of lines from his first marks softens the figure's distorted contour. The scale of this gentle presence in relationship to the page gives the figure an added immediacy and weight.

If Not, Not
1975–76 [11]

Despite all the time and effort he has recently expended on his drawing, Kitaj has not abandoned painting. Before concluding this study, two monumental works—*If Not, Not* and *Smyrna Greek (Nikos)*—demand mention: these paintings sum up much that is crucial to Kitaj's vision. Like *Land of Lakes*, 1975–77 [55], its sister painting from the other side of hell, *If Not, Not* differs greatly from Kitaj's earlier subject pictures. It has a ''primitive'' Bruegel-like vista and a deep distance scale to its figures, in contrast to the ''classic'' Caravaggesque close-up groupings of, say, *The Ohio Gang* or *The Autumn of Central Paris (After Walter Benjamin)*. It creates the same world's-end fantasia beneath a sky of hellfire black and orange as Bruegel's *The Triumph of Death*, c. 1560–62 (fig. 3). This wretched twentieth-century landscape is strewn with the broken and the dead. One of the main players crawls in from the right; bandaged and wounded, he carries a bag that is probably full of explosives, for surely he is a terrorist (or patriot, for what does it matter to the flesh to be exploded?). The figure at the lower left relates to a subsequent painting, *The Jew, Etc.*, 1976 [60]—another lonesome image, in which a small distressed gentleman (note the hearing aid on both figures) flees by train.

Smyrna Greek (Nikos)
1976–77 [10]

A sense of conspiracy infuses many of the human transactions in Kitaj's paintings, whether manifested by the shady group in *The Ohio Gang* or by the ambiguous exchange between the young woman and the mysterious man in

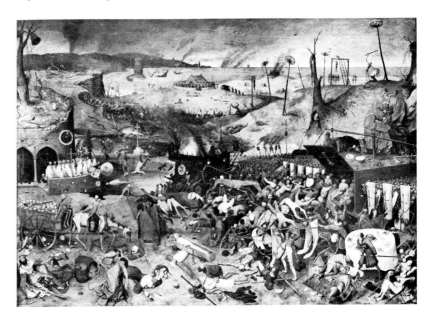

Fig. 3
Pieter Bruegel (Flemish, c. 1525–1569)
The Triumph of Death, *1560–62*
Grisaille on panel,
117.2 × 161.9 (46⅛ × 63¾)
Museo del Prado, Madrid

trench coat on the apartment landing in *Walter Lippmann*. Kitaj the allegorist asks us, like Benjamin's melancholy allegorist, to fix our gaze on what is behind the surface of *Smyrna Greek (Nikos)* and attempt to "read" the lives of the figures represented. Is the bespectacled man in the trench coat a revolutionary theorist? A lonely intellectual? Maybe a Walter Benjamin seeking comfort from this very professional girl? Why can't he look at her? Why is he so worried? or so sad? Who is the man descending the stairs? An assassin? Whatever. In *Smyrna Greek (Nikos)* the deal has been closed—the human interchange is about to begin and it is rife with implications.

There is always a certain amount of "reading in" when one is trying to understand a complex painting. A work may offer clues and possibilities, but we must complete these half-truths with insights formed by our own pasts. If we are to make any sense of the image before us, we must try to reconcile it with our personal memories and experiences. But to be sensitive and competent "readers" (allegorists) we must recognize as well that the power of the image lies also in its mystery; subjectively there is much we can *see* without fully understanding. In looking at Kitaj's work the most important thing is not that we understand what he shows us, but that what he shows us forces us in turn to see the visions within ourselves, visions of our shared humanity. Once again, Georges Hugnet's praise for Lautréamont applies aptly to Kitaj, the allegorist:

He brought into question the role of spirituality, of morality, all human laws . . . he threw into the night of humanity a dazzling light which fell on shame and agony. . . . full of the most astounding images, he tried to deliver man from his illusory obsessions; throwing all notions of good and evil into the scales, he marked on the dial the hollowness of human justice.[23]

1. Quoted in "A Note on Lautréamont," in *Maldoror (Les Chants de Maldoror),* trans. Guy Wernham (Mt. Vernon, N.Y.: Golden Eagle Press, 1943?), p. x.

2. *Content,* according to Erwin Panofsky, reflects ". . . the basic attitude of a nation, a period, a class, a religious or philosophical persuasion—all this unconsciously qualified by one personality and condensed into one work." (Erwin Panofsky, *Meaning in the Visual Arts* [Garden City, N.Y.: Doubleday & Co., Doubleday Anchor Books, 1955], p. 14.)

 Subject matter is the representation of ". . . natural objects such as human beings, animals, plants, houses, tools and so forth; by identifying their mutual relations as events; and by perceiving such expressional qualities as the mournful character of a pose or gesture, or the homelike and peaceful atmosphere of an interior." (Ibid., p. 28.)

 Illustration is the artist's means of communication when he is "preoccupied with the purpose of conveying ideas and feelings by means of his own visual images. . . ." (Bernard Berenson, *The Italian Painters of the Renaissance* [Cleveland and New York: World Publishing Co., Meridian Books, 1963], p. 186.)

3. Walter Benjamin, *Origins of Germanic Tragic Drama,* trans. John Osborne (London: NLB, 1977), p. 175.

4. Ibid., pp. 183–84.

5. Joel Fineman, "The Structure of Allegorical Desire," *October* (Spring 1980): 48.

6. Craig Owens, "The Allegorical Impulse: Toward a Theory of Postmodernism," *October* (Spring 1980): 69.

7. *Time*, February 19, 1965, p. 72.

8. Conversation with the author in Barcelona, Spain, August 1978.

9. Conversation with the author in New York, winter 1979.

10. Donald Judd, "In the Galleries," *Arts Magazine* 39 (March 1965): 62.

11. "... *Erasmus* ... is the first painting of any interest I made in England." Quoted in Maurice Tuchman, *R. B. Kitaj: Paintings and Prints,* exhibition catalog (Los Angeles: Los Angeles County Museum of Art, 1965), n.p.

12. From the painting *The Perils of Revisionism,* 1963.

13. Although Kitaj's prints are a major part of his oeuvre, after much soul-searching and a recognition of our space limitations, we decided that for this exhibition it would suffice to concentrate on the paintings and drawings. We also believe there are plans for major exhibitions of his prints by other institutions.

14. Timothy Hyman, "R. B. Kitaj: Avatar of Ezra," *London Magazine* (August-September 1977): 57.

15. Although *The Threepenny Opera* was written five years before the rise of Hitler, it predicts the gangsterish atmosphere attending his ascendancy. In *The Resistible Rise of Arturo Ui* (1941), Bertolt Brecht draws direct parallels between gangsters and the fascists.

16. "... I would like it [art] to get a job. I would like it to *do* more useful tasks than it's been doing. I would like it to subvert the outstanding prescriptions for what it ought to be. I don't like the smell of art for art's sake. I'm guilty of many of art's sins." Quoted in Tuchman, *R. B. Kitaj: Paintings and Prints*, n.p.

17. The title of this painting most likely refers to John de Yepas, called John of the Cross, a Spanish Carmelite friar of the sixteenth century who was severely persecuted for his reform efforts. An important poet, he wrote *The Dark Night of the Soul*, among other works.

18. Quoted in Susan Sontag, "The Last Intellectual," *New York Review of Books*, October 12, 1978, p. 75.

19. Ibid.

20. Undated letter to the author, postmarked June 16, 1978.

21. Berenson once noted, "Ever ready to learn, Raphael passed from influence to influence. At whose feet did he not sit?" (Berenson, *The Italian Painters*, p. 210.) Because of Picasso's restless, protean ways, Berenson was later to compare him with Raphael. Kitaj is at least as restless as these two; in fact, the young Picasso is an obvious and omnipresent influence on Kitaj. Degas's presence is felt in the recent pastels, and over the years Kitaj has also been compared to a variety of other artists. Obviously, he also is ever ready to learn.

22. John Fowles, *The Aristos* (New York: New American Library, Signet Book, 1970), p. 175.

23. Quoted in "A Note on Lautréamont," p. x.

R. B. Kitaj
in the
Larger Picture

JANE LIVINGSTON

The artist in our society has lost his traditional roles both as immediate cultural arbiter and as ethical leader and social participant. Within modernism an essential gratuitousness inheres in painting and poetry as perhaps never before in American or even in British or French history. In this era we uncomplainingly invest in the work of art the power to constitute the sole vessel of the human personality that shaped it; we ask of the artist neither that he state his positions in relation to his own art, nor that he exemplify in his behavior any particular belief. It can hardly be accidental that biographies of the modernists often are rather arid, or even when provocative, go unread. Modernism—and especially one of its cults, the primacy of the physical object itself, "in its own objecthood"—has wanted to gloss over the issue of the life of the author as a directly conditioning factor in the final "quality" of the objects he conceives and executes.

I am not simply referring to a condition of healthy anonymity in relation to the art works produced in our era. Nor do I here address the well-known contemporary phenomenon of the so-called personality cult à la Rauschenberg or Warhol, which, while fascinating in its import, is a separate matter. Implicit in the current aesthetic value system is an abjuring of testament and responsibility that has finally to be confronted. And, indeed, we begin to sense that this state of affairs proves intolerable to a few contemporary painters and sculptors and photographers. The apostates from the religion of objecthood are now becoming increasingly vociferous; in the 1960s they were virtually mute.

One artist in our century personified an exception to this tendency—I refer, of course, to Picasso. Picasso simply refused to acknowledge this worship of personal moral separatism and the existential art/life duality; his prodigiously complex appetitive and gregarious *modus vivendi* was inextricably bound up with what he produced at every phase in his career, and we cannot truly know his great works without taking into account many factors of the man's life and times. There is another major, more recent, exception to my premise. R. B. Kitaj's way of engaging the world beyond the objects he produces is Picasso-esque in its urge to include layers of history and culture, though it is not as much a matter of asserting action and ego as it is an insistence upon continually questioning his own activity, and others' responses to it. Kitaj has become a kind of figure *sui generis*, an artist whose production is accompanied always by a cutting discourse with himself, and with us.

Kitaj is certainly first a traditional practitioner of painting and drawing: these are his means of both temperamental synthesis and ultimate psychic expression. And it is with these means that he has invented his own creative attitude; he continues to evolve radically as painter and draftsman, from the (often de-

35

spairingly) literate to the viscerally profound. The recent major drawings contain a quality of utter clarity, a clearness born not of sanguine acceptance and naturalistic description, but of the anguish of experiential identification, and of the painfully specific. The images lie like spirits in their material. Empowering his objects as if with spoken words, Kitaj injects authentic life into his work, seemingly out of sheer hard practice, exercise, and preparation.

But apart from his identity as an artist, he is also an ethical polemicist of considerable sophistication. He is at least a desultory participant in England's journalistic/intellectual climate; among his friends he exteriorizes his personal spiritual development by seeking to articulate visually and verbally the meaning of what it is we all do in the guise of art. His quest is carried out almost in a spirit of civic duty. Whether or not he fully knows it, Kitaj will not be content to separate his life with all its tribulations and celebrations from whatever it is he achieves on the canvas. The point is this: that to be so unrelentingly *conscious*, so in tune with both the psychic enablements and the obstacles that comprise one's endeavor as a painter, is to be committed to an idea of the ''artist'' that is simply outmoded.

Kitaj reflects upon Edgar Degas's nature as an activist, an artist who had authentic genius and organized exhibitions and entered into the official culture of his day. The spirit in which Kitaj engages in the visual art polemic is reminiscent of Degas, or even more of Gustave Courbet, perhaps the greatest self-reflective/political painter of his century. But it is important to establish that in Kitaj's case the publicly rhetorical aspect of his production is not necessarily willed; it is almost in the nature of an involuntary, spasmodic force in his life. It is appended to his higher function. He does *not* court public exposure or solicit dialogue, though he restlessly seeks intellectual engagement. Paradoxically he needs solitude, retreat, freedom from public scrutiny, probably more urgently than other contemporary artists. Kitaj is a shy, even incipiently terrified, venturer into the realm of solitary painting and its life—yet he hungers after social discourse.

In the realm of Kitaj's affinities to earlier figures, one includes Paul Cézanne, in his fullness of historic awareness; the passionately articulate Vincent van Gogh; the apologist/provocateur André Breton. These organic temperamental bonds to predecessors, and the paucity of contemporary counterparts, heighten our sense of Kitaj's being enisled, almost stranded in his own time. We simply cannot invoke equals among his chronological peers in his domain of expressed consciousness. And yet he is deeply of our time. He is necessarily unlike his precursors by virtue of his context. It may be in large part Kitaj's instinct for involvement with the politics of the aesthetic existence that has determined his

decision to live in London rather than in his native United States. He escaped the macho psychology of rebellious independence, the almost aggressively anti-verbal personality, of the American Abstract Expressionists, which was to be replaced by another sort of silence in the next generation. Kitaj's contemporaries and youngers in the United States tend to take refuge either in mysticism or in a sort of secular worship of deep stylishness, that tough hipness that contains its own set of commandments. The idols of American artists since the late 1940s have certainly been anything but literary: first, Freud, Jung, and the psychoanalytic model; second, existentialism and its sense of alienation and necessary disequilibrium; and third, the dynamism of technological progress. Literature is the enemy in this constellation of desires and beliefs. To few living artists could it occur, as it has to Kitaj, to reflect upon an idea such as the ramifications of the industrial revolution, its deep cultural importance and mythic overtones; instead they gravitate to a sporadic excavation of postmanufacturing attitudes. They are often most interested, whether or not they know it, in statistics and in ephemera.

I am characterizing what R. B. Kitaj is *not* about. This seems the surest way to place him in the large historic context, and he seems to need to be placed. What he is about is literary tradition, poetry, and *criticism* in its deepest sense. The possibility for a useful social criticism as it was practiced in the eighteenth and nineteenth centuries—specifically, for a visual expression that can literally hold to the light our values and accomplishments—seems to Kitaj a notion very much to be considered, even in the face of a virtually unanimous rejection of such a possibility by our important artists in every other style. It is in this spirit of critique that he is drawn to Walter Benjamin and to Hannah Arendt, and, ultimately, to Alexander Solzhenitsyn. It seems no wonder that Kitaj is not living here when we reflect that even the little intense discourse practiced in the 1960s in New York with and about artists has disappeared from American art; it does survive to some extent in England. Here in our very freedom we seem to have become muzzled, or at best monologic.

One of Kitaj's persistent themes is the difficulty of political freedom: he is continually aware of the disparity between our "fat western privilege" and the Gulag-haunted societies of repression: "I've taken up this freedom of ours to do what we like and I should like to keep trying to define myself, not out of self-importance, but in the Sartrean sense of not wishing to have other people define me for fear of acting in bad faith."[1] The artist's second underlying theme, appearing again and again alongside this fascination with "our nutty freedoms and their discontents," is an awareness of history: "So, does one get inside history as leftists (and formalists) try to do classically or can one

make history by confounding it? I tend toward the latter in trepidation. One of my preparations has been to draw the human form very seriously for the past few years . . . very exhilarating." (Kitaj often strikes a note of rueful self-doubt, tempered by humor and hope. And so do his paintings and drawings, even, or especially, those of women.)

And there is an overarching insistence on critique: "My life of mistakes will protect me from the moralist heaven. I am a most flawed person and artist, and those personality flaws find their way into my dubious pictures. I do think art, 'imaging,' has something to do with a higher morality . . . Matisse in that glorious quotation expressing his 'almost religious awe towards life.' I want to address my modernist colleagues in this respect: Modernism is very dear to me. Modernism and Fascism have been sworn enemies. Modernism and Stalinism have been traditional enemies. This enmity, presided over by Auschwitz and Gulag, is a central issue of consequence in my lifetime . . . not as central, for me, as the murder of the European Jews, but related to that catastrophe."

Many months ago, at a formative state in my thinking about Kitaj, I halfway wanted to characterize him as an "academic" holding to an "old-fashioned moral absolutism." Since then, my own perceptions of his understanding of history, and of the peculiarly self-aware quality of his achievement, have become vastly enriched through both contact and reflection. What could look like a tenaciously classical and schooled quality in the draftsmanship has become for me a phenomenon that is truly radical, *immediate* in its character, a presence accomplished through the most intense severing of reliance on technique or formula. I see now that as Kitaj evolves as an artist, so does the depth of his work. The directness of Kitaj's confrontation with the condition itself of humanity makes him the most extreme rarity in our culture, in which the artist has so often either worshiped himself in the narcissist mode or exalted himself more vicariously through identification with fashion and taste. Kitaj is a reminder to our American selves that other old aesthetic realities might still have meaning and usefulness.

1. All statements by R. B. Kitaj are quoted from correspondence with the author, 1980–81.

A Return to London

R. B. KITAJ *replies to some questions put to him by Timothy Hyman about recent developments in his work, his upbringing in Cleveland, his time in Vienna, and such subjects as the political and sexual implications of his art.*

Your earlier collaged imagery seemed equivalent to a view of the world as fragmentary, cinematic. Has your view changed?

Collage emphasizes *arrangement*, an aesthetic of conjoining, at the expense of depicting, picturing people and aspects of their time on scorched earth, which was what I always wanted to represent. Arranging a life of forms on a surface will always be the bread and butter of picture-making . . . but the meat and drink? We are talking, of course, about our old friends form and content. The whole meal will be my redemption if I can fix it. Collaging seems banal to me now. I am saying that I cannot conceive any more of art as some kind of game without rules as Duchamp did or *art as such* as Greenberg terms it. Both these modern aspects of art will make themselves felt but I want much more for the thing. Dissipation in youth and a Redemption in aging—not untried before.

Do you have any explanations for this change in yourself? In your own personal life? In your changing enthusiasms in art? Or in some wider public events?

First of all, time is running out and I'm addicted to temporal salvation. I'm impatient, as Pound said his countrymen are. I became convinced that in the early years of this century, Cézanne, Degas, Munch, Matisse, and Picasso were conducting some of the *last* fire and brimstone into the representation, the eternal reinvention of human forms. There seems to have been a serious interruption in that connecting vision of a newer and older mode of representation which always appeared to me as if through a glass darkly. The survivors I so admired (Balthus, Giacometti, Bacon) seemed mannered but they were the Keepers of the Flame. I wondered what the next Giotto, the next Caravaggio would look like. I came to feel that I had loitered long enough on the edges of the modernist Pale of Settlement, like those Messiah-Watchers of old. Life is too short. (Schopenhauer said life is like a child's shirt—short and beshitted!) So I guess I heard the Call of the Wild. For me, forward (not back!) to drawing the human form every day; that *natural* passage (so it seems to me) toward the other shore—the delineation of the face and fortunes and torments of us all. Some day there will be painters whose skills and imagination will be *seen to be done* by many, many people unversed in the half-baked philosophical double talk in which our very difficult twentieth-century art is smothered. You know, buried in the controversial argument about art appealing to more people, to a wider public, etc., lies a truth at *least* as powerful and authentic as the undeniable truth buried in the defence of art for art's sake! "My hand in the fire," as Brancusi used to say. Anyway, heresies and orthodoxies will always be changing places.

But isn't there a sacrifice made in the recent work—aren't you getting much less in?

No way! You're not talking to the Rev. Donald Judd! You know me . . . I always want to get *too* much in and one of the delicious consequences of our austere modernity is that one can be driven like a lunatic into a dream of amplitude. That's what I meant by my own youthful impatience. These last seventy years have been *so strange*, so breathtaking, so deathly, so *revisionist* . . . in art and in life. Time now to recollect in some tranquillity. That's for me, now, a recollection in art, an overview of bad times and some good moments. For two years now I've only been drawing, with mixed results, most often the single face or body on sheets of paper. When you get it right, as a handful of men have, you get the whole world in, like Degas, Dürer, and Hokusai did. Then you can do *anything*. When you get the whole world into a representation of a human form, as Hokusai did, you also *let* the whole world in and the art becomes more *social*. I can hear the distinguished opposition braying at me like they do in the House of Commons.

Don't you feel your wish for a deeper or more "real" art may be very hard to reconcile with the immaculate and designed character of your surface?

I happen now to be "disturbing" paint much more than I used to . . . but I'm just spreading my wings . . . trying to learn more about painting and about those legendary moments when contents and methods are supposed to marry. I'm not too sure they *have* to marry all the time . . . but I don't want to go into all that just now. To answer your question: in the terms of my own life and its present needs, the Mona Lisa is more profound, more "real," more timely, less dated, more "social," better colored, maybe more forward-looking, than almost *any* picture I can think of since Cézanne put his brushes down in 1906. What in holy hell is wrong with immaculate and designed surfaces? Just because *I* haven't done it too well doesn't foreclose a "careful" method! The early Netherlandish and German painters, most of the best Italians, the East Asians, the redoubtable Ingres, Vermeer, all produced immaculate surfaces and I daresay no one *designed* his surface much better than Matisse could. I know what you mean though. Sometimes I think artistic "unity" can be a sham and that discontinuity is more profoundly attractive. I've heard it said that allegory provides that kind of corrective to art, presenting itself as more fragmented.

I would like to say, in passing, that I have always feared and mistrusted the, what shall I call it, "gestural detachment" which was introduced as a *component* of much modernist painting in the early years of this century . . . the kind of elegant, thrown away brushing the French went in for and which was taken up with a vengeance by expressionists and later abstractionists. I have envied its usage in the grand, detached brushstroking of Matisse and Picasso, as if they couldn't care less how much their brush slipped about—so grand was their conception (which it often was)—and I really think that gestural license

doomed a lot of later art until it hit bottom in an international tachist style. agree with Greenberg that tachism was the lowest point art ever reached. When art became reduced to automatic brushstroking it was doomed because, to use an inexact analogy from verse, it wouldn't *scan* anymore, its structure and "correctness" could no longer be felt or tested by most intelligent people and almost everyone lost interest except for the inevitable artistic gauleiters and fortune-tellers who know everything there is to know about art. I'm not talking about abstraction, but about licentious brushing. Right now, smooth old Mona Lisa seems more *radical* to me than Hans Hoffman or Josef Beuys . . . and my dictionary tells me that radical means the most advanced view of reform on *democratic* lines . . . which is also to say, not elitist. Painterly brushwork can be wonderful but it has also become a token, an amulet for the *me* generation of expressionists.

Can I ask you about your earliest experiences of art, in Ohio or elsewhere in the USA?

There are some people who don't like museums because they think of them as tombs, or something negative. I've always loved them. They are to me lighthouses of utopianism and social well-being. As a child, I lived nearby one of the best American museums (Cleveland) and my early years were brightened by that great place. My people were enlightened working people and those depression years are a distant blend in my memory of a kind of Studs Lonigan street boyhood (laced with left political fragrance . . . Some of my mother's friends went off to fight in Spain), and the silent luxury of those grand museum rooms. Certain pictures will stay with me forever. A Bassano banquet, a Greco Holy Family, Picasso's *La Vie* of 1903 (which I still look at once a week in a book), Albert Ryder's *Death Rides a Pale Horse*, and George Bellows's superb boxing epic, *Stag at Sharkey's* . . . I lived in that place and took my first art lessons in their children's classes. I remember drawing from the Greek statues and I even remember the names of the instructors and how encouraging they were.

It seems to me the recent work has made clearer your links with Vienna. Can you say a little about the period you studied there?

1952 . . . *very* Third Man! Vienna was bombed out, spent and bleak. I attended the Art Academy where Schiele had been a student. I worked in the studios of Professor Albert Paris von Gütersloh. There's a good portrait of Gütersloh as a young man by his friend Schiele. He was one of those morbid Viennese Surrealists not unlike Burra. You couldn't keep warm so I was always at the train station going somewhere—hiking in Salzkammergut, down to the sea at Fiume and Trieste. Very youthful Russian troopers were everywhere with acne and sten guns examining papers. I read a lot in cafés that are now gone with the

wind and ran in a louche pack of students who lived and loved in romantic attics. Kafka and Joycean exile meant more to me then than the gorgeous Bruegels and Velázquezes in the great Hapsburg collection. But I was drawing every day from models, rosy with cold, who were meticulously posed early in the morning (even to the placement of the joints of fingers). Gütersloh worked in his own adjoining studio, very grand with samovars and tapestries. He came to bless his students once a week or so. I was more "influenced" by a man who was my closest friend at that time. He was an American painter named Frederic Leighborne Sprague. Fred was at least twenty years older than me, an ex-officer living on the G.I. Bill. He was the black sheep of a rich Back Bay family and had spent his youth burning the candle at both ends. His Redemption was upon him and he lived for two things: Roman Catholicism and Art. He hooked me on his version of the art and *almost* converted me to his Church. He got me as far as weekly private sessions with one of the loveliest men I've ever come across, Monsignor Ungar, a leading Roman Catholic scholar in Vienna. (I painted a little portrait of Ungar.) Believe it or not, I could thrive on contention in those days; not the timid soul I am today, and I really fought for my immoralism against that regular dosage of received wisdom. As to the art, Fred Sprague led me through the unexplored backwaters of Mittel Europa. Schiele and Klimt were almost unknown outside Austria then. And, as is so often the case (like the circle around Picasso in Barcelona), there was a fabled wider circle of artists who are not exported even now, like Max Oppenheim, the very interesting Richard Gerstl, Arnold Schönberg (as a painter), and the odd types teaching at the Academy like Herbert Boeckl whose form of undigestible figurative Cubism would seem now like a classical instance. Sprague and I would visit rural monasteries where he executed murals from time to time and we would touch on the lives of those modest men and come away in an aura. In Vienna, although he had very little money, he somehow found Schubert's elegant old rooms to rent in the medieval Annagasse and it was there we argued art and anarchy. To this day, I still mix some colors the way he did. He looked like Francis X. Bushman and had silver hair down to his shoulders.

Do you think something of the self-conscious decadence, and the stylized character, of artists like Klimt or Schiele may then have entered your bloodstream?

Some, I suppose.

Your early experiences of wandering—as a seaman, etc.—seem to link up with recent work about Jews, travelers, exiles . . .

Rembrandt advised his pupils never to travel . . . *not even to Italy!* I'm tempted by that advice but I do have to visit foreign cities from time to time because of work I have in mind to do. I am now wandering more than I ever have inside myself instead of abroad. I also think that representing the human form entails

wandering across its geography in a never finite reverie of learning. It's a world to enter again. This seems to be a period of retrenchment and recollection rather than the real thing. Someone said that the work of memory collapses time and that will be seen as a fitting tribute to still picture-making. The issues of progress in painting, of traditions, iconoclasm, and dialectic can be circumscribed in the imaginative memory which collapses time. I mean to practice an art of *straying*, though; not to stay in my room forever, if only because like aged Degas, if you keep moving through the streets you may ward off death. So one prowls forbidding streets and back in one's room the mind wanders, thoughts stray, and the actual work becomes a concentrated act of will which collects experience, and in a sense, freezes the passages of time and all the wandering in a little still world, the painting on an easel. But then the picture may begin to wander long beyond the moment of its appearance and, I like to think, its life will depend on whether it communicates experience that no one will ever have again in the same way.

Have you come to feel your Jewish birth more significantly? Do you identify yourself as an American? (A Russian? A Jew?) Or do you feel you've become strongly Anglicanized and Europeanized?

Yes, all that stuff! In recent years I guess I feel more of a Jew, after an agnostic upbringing. I'm not a *believer* and I'll always be a suspicious reader but a central condition for me has been the murder of the European Jews. Churchill wrote, "This is probably the greatest and most horrible crime ever committed in the whole history of the world. . . ." (I would say that Black Slavery was a match for it.) Out of that maelstrom I've begun a meditation on historical *Remembrance* and its attendant senses of exile and survival. And now the agony of the Palestinian Diaspora confounds the historical Jewish agonies and those two battered peoples embrace in a deathly lock step. I intend to confront these impossible things in an art because some day, when I'm chased limping down a road looking back at a burning city, I want the slight satisfaction that I couldn't make an art that didn't confess human frailty, fear, mediocrity, and the banality of evil as clear presence in art-life.

American, yes, very much so . . . Russian, yes, a part of me is Russian; *twenty millions* butchered in my lifetime by one set of madmen and I don't know how many millions by Stalinists. The stench is palpable. But, if I don't come to a rotten end, I think I'll live and die here, under English skies, where, like Jimmy Whistler at the end of his life, I hope, "I don't have a close enemy left in London."

What were the factors that made you set off to lecture in 1966? Did you ever consider publishing that lecture?

Clem Greenberg and Ken Noland came to supper at my house in Dulwich. The conversation was so stimulating, I remember I couldn't sleep that night. The next morning I began to write the lecture. The reason I never allowed it to be published is because it was too obscure. If I were to write one now, it would be much clearer.

How does a picture usually come about? Do you often begin with a title? Do you make many preparations before you begin painting? Do you often have to change them radically once they've begun?

I want to enjoy (or suffer) a kind of art-life which makes wider demands on my capacities, skills, and imagination. I have been greatly challenged by the *protean* masters . . . Degas, Picasso, Matisse to name only the most recent three who seemed to have been able to achieve so much across lines other artists feared to tread. I can't bring myself to make some stylistic corner of art my own and so I'm anxious to treat and practice widely. The answer to those questions of yours is that all things are possible.

I feel like Hopper did when he used to say he was torn between painting the "facts" and improvising. I carry themes in my mind for years before I will try to compose them . . . I've got themes that will last me now till I die. I said that to a well-known painter in New York. He said, "How boring!" His dedication to spontaneity was touching. To me it was a failure of imagination. Like Degas said of himself, I'm the least spontaneous of men.

I've been mulling for years the possibility of representing the Jewish Tragedy under the Nazis. Arising out of that, I want to try and pretend in another picture, a poetic reconciliation between Arab and Jew. Formalists will laugh at that, but the ancients believed in what has been called the *type-coining power* of art, and so do I. Types, figures were invented which embodied emotional states saturated with "reality." Prototypes in classical art resolved an antithesis between naturalism and idealism. Artists *can* coin examples of social well-being (Matisse wanted that). If artists can apotheosize persons, principles, and practices, they should also have the power to bear witness to unhappiness by coining a remembrance of it. There is a Negro Tragedy, a Black unhappiness I have felt deeply all my life which I've also begun to treat, haltingly.

These impossible themes are very grand and form themselves slowly in a nervous intercourse with other subjects and the regular practice of direct drawing from people. I am quite taken with the idea that forbidding events in the world can be taken up by a person like myself, who may never have experienced those events, except in the mind, and in a quiet room filled with English daylight, pretend to mark the passage of a horror or of a fantasy. Kafka wrote a very funny book called *Amerika*, all about my country, which he had never visited. In his grand style Tolstoy wrote maybe the greatest novel ever written, about wars which were waged thirty years before he was born.

Two crazy polarities introduced by modernism are that you can do everything (Picasso, Matisse) and that you must stick to a tight (stylistic) corner. I prefer the first craziness to the much safer second one. The first craziness is not taught in our schools too well.

The painting you've called If Not, Not *was in fact about* The Waste Land. *Why not make this clear in your title? (Viz. Bacon's triptych, "Inspired by T. S. Eliot's Poem* Sweeney Agonistes").

Why didn't Eliot make *his* subject clear? The subjects of *The Waste Land* are not at all cleared up in the bloody notes, let alone the title. There are two hundred books since 1922 pretending to tell us what Eliot meant in *The Waste Land*. Bacon is a poor model for straightforward meaning. So is abstraction. In spite of all the explanations of abstraction (or maybe because of them), I've always thought that abstract art deserves as much iconographical spadework as any other *difficult* art and that it is no less "literary" on that account. I promise to supply some notes for *If Not, Not* when I can get around to it. Meanwhile, you can take it that the picture was "inspired" by *The Waste Land* and by some other wonderful things. In a stream of consciousness such as a phantasmagorical picture reflects, I wouldn't wish to pretend to a consistent guide (the Eliot poem) conducting me through the work. I still like Pound's distinction between sign and symbol: a sign doesn't exhaust its references as quickly as a symbol does. My tendency has been far too oblique for sure . . . and as you know, I've been working to reform myself. Maybe I'm just an old recediviste and I'll never strike a right balance between what Mallarmé called sense and sonority. Even if I do, I don't wish to forsake human complexity at all. The idea that you can get *lost* in a picture seems very life-like because we all get very lost in our emotional, worldly lives. I remember getting lost in Fontainebleau forest. We lose our way in cities; we get lost in books, lost in thought; we are always looking for meaning in our lives as if we'd know what to do with it once we'd found it. *Meaning* in Mondrian is not all clear to me. His work is like a wonderful maze, isn't it? Benjamin said it takes *practice* to get lost. I don't envy art which pretends to be seamless, unadulterated, and without meaning outside itself. Nothing is straightforward. Reducing complexity is a ruse.

Much of your work has an implicit or explicit political content. Can you outline your political formation/position?

I *feel* like a socialist. The compassionate idealistic socialism I grew up with was and still seems a splendid thing, not as a set of received ideas, but only when and if a man or woman could be transformed by compassion. Pascal said the sole object of Scripture is charity . . . of course, in its noblest sense that's like socialism. Especially now when there are a hundred armed camps calling themselves socialist. Each morning newspaper brings fresh reports of struggle and killing between "Socialists." I can only believe in particular (flawed) people I

read about or even meet with . . . never know-it-all "socialists" who appear to be embittered fools or evil or lacking compassion and imagination. Now, what does that have to do with art? The question is *so* large there will never be any final answer . . . but, the possibility of a compassionate art *does* exercise me and I am challenged when I'm told it won't fly. I *am* moved and challenged when Auden says: no metaphor can express a real historical unhappiness . . . to which Solzhenitsyn replies, " . . . If words are not about real things and do not cause things to happen, what is the good of them?" I'd like to try, not only to do Cézanne and Degas over again after Surrealism, but after Auschwitz, after Gulag (et al.). Some of us need a post-Auschwitz art even more than a postpainterly art.

So, as you say, my pictures have contained some political content, but I do have a more distinct vision now of what a more *social* art can be. I won't spell it out for fear of losing my weak grasp of it but more social would seem to mean more understanding of and responsive to the passage of people in our world. It *is* an age-old mystery how a lonely person acting out of much self-interest in a room away from the crowd can hope to serve a greater good, but that has been the way of it in religion and socialism and art.

You often treat of sex in your work, but almost always as a kind of moralist (it seems to me). To take two current projects of yours, do you think Auschwitz *and* Frankfurt Brothel *are two sides of the same coin?*

Well, I don't feel like a moralist. Many of us may have both a moralist and an immoralist at work inside ourselves. On which side of which coin such things lie confounds me. Your question is far too difficult and interesting and complicated to answer here too well. There is not exactly an Auschwitz plan, but, as I said, a work "about" the murder of the European Jews. Brothel life has attracted fellow Sleepwalkers like Baudelaire, Degas, Picasso, Proust, Benjamin, Morandi (believe it or not), to its hellish sighs at the heart of decaying cities, whose very streets would offer up victims to the death transports. I wish I could accomplish some sizzling little pictures . . . like unusual emblems which have a *searing* quality in the sense that they leave a mark in the body like a tattoo; pictures which can leave a mark in the mind . . . maybe not quite Auden's impossible metaphor for a historical unhappiness, but an emblematic *remembrance* of horror and banality. Greenberg wrote that Picasso had *failed* to do just that in his painting called *Charnelhouse* (stacked bodies in the camps). But, let me tell you, no one can convince me that the *subject* of a picture cannot instigate its formal achievement. In fact, I believe that the *personality* of an artist swallows so-called "aesthetic criteria" as such personality *subsumes* form and content. Conrad says somewhere that truth and men are forgotten except by those who believed the truth and loved the men. *That* kind of powerful faith *can* be confessed in art. As to *why* some of us are drawn to hellish

themes and others wish only to witness the sublime, I can't presume to know. You may as well ask about fascism and prostitution in Picasso's life because both were familiar conditions he engaged in his art. Your question has great interest for me and its implications will follow me into the fog.

Do you feel any regret at having become involved in the polemic that followed The Human Clay exhibition you organized?

Yes and no. Artists are not "supposed" to go public too much but I have never been afraid to live a life of mistakes. Even Degas, when he was younger, was an avid organizer of exhibitions and other artists. Of course there is a hermit in each of us and that balance legislates our "engagements" . . . I also like to think that the public (social, engaged) impulses and the private needs can come together in our art. Among all peoples, there are those who are incapable of listening to opinion or argument off the beaten track, not consonant with their own ideology. So it is among people who care about art. I am not one of them. I want to say something now which is very important to me: Modernism is dear to me. Fascism and Modernism are enemies. Fascism is *my* enemy. The enemies of my enemies are my friends (this is not foolproof). On that principle, Modernism is my friend. It cannot be otherwise . . . we are bound in friendship. There *are*, however, some reforms, some reformations, even some revolutions which will enrich our artistic lives from time to time. I think the last revolution was when the idea was introduced that you didn't *have* to depict people and things in the visible world anymore. *That* idea is my definition of Modernism. So, ideally, that polemic you ask about should be an argument among friends but it rarely is because it is still so difficult for people to admit, with William Blake, "As a man is, so he sees."

Do you think you may have come home to London now for good?

Yes.

Reprinted from *London Magazine*, February 1980.

Good News for Incunabulists, 1962
Oil on canvas, 152.4 × 152.4 cm
Waddington Galleries, London

2 **Where the Railroad Leaves the Sea,** 1964
Oil on canvas, 121.9 × 152.5 (48 × 60)
Marlborough Fine Art (London) Ltd.

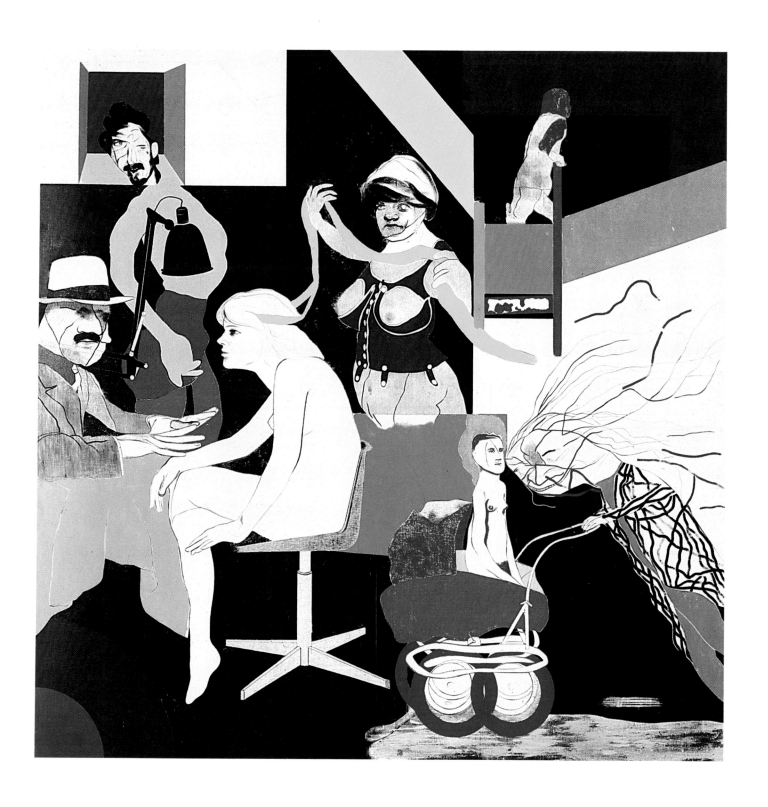

The Ohio Gang, 1964
Oil and crayon on canvas, 183.1 × 183.5 (72⅛ × 72¼)
The Museum of Modern Art, New York
Philip Johnson Fund, 1965

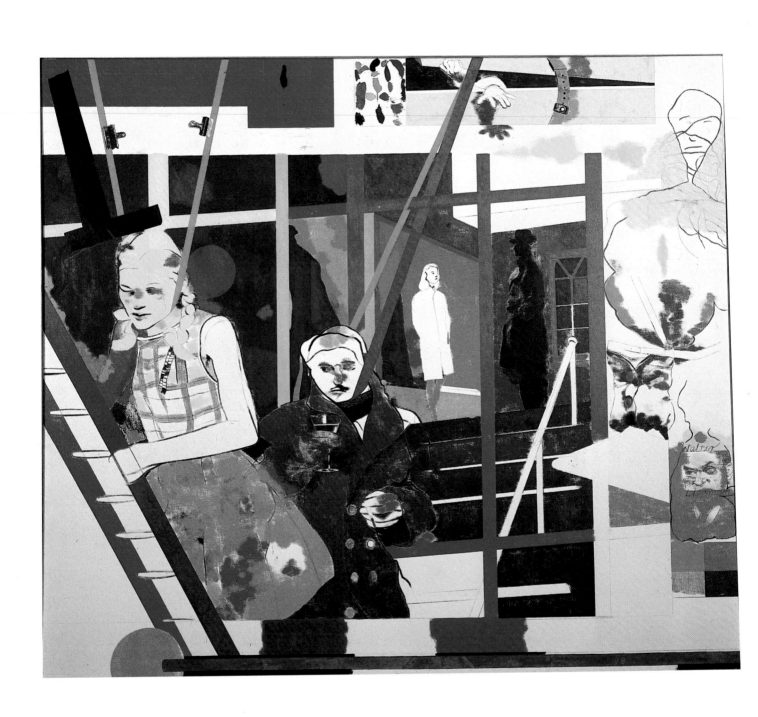

4 **Walter Lippmann,** 1966
Oil on canvas, 183 × 213.4 (72 × 84)
Albright-Knox Art Gallery, Buffalo, New York
Gift of Seymour H. Knox, 1967

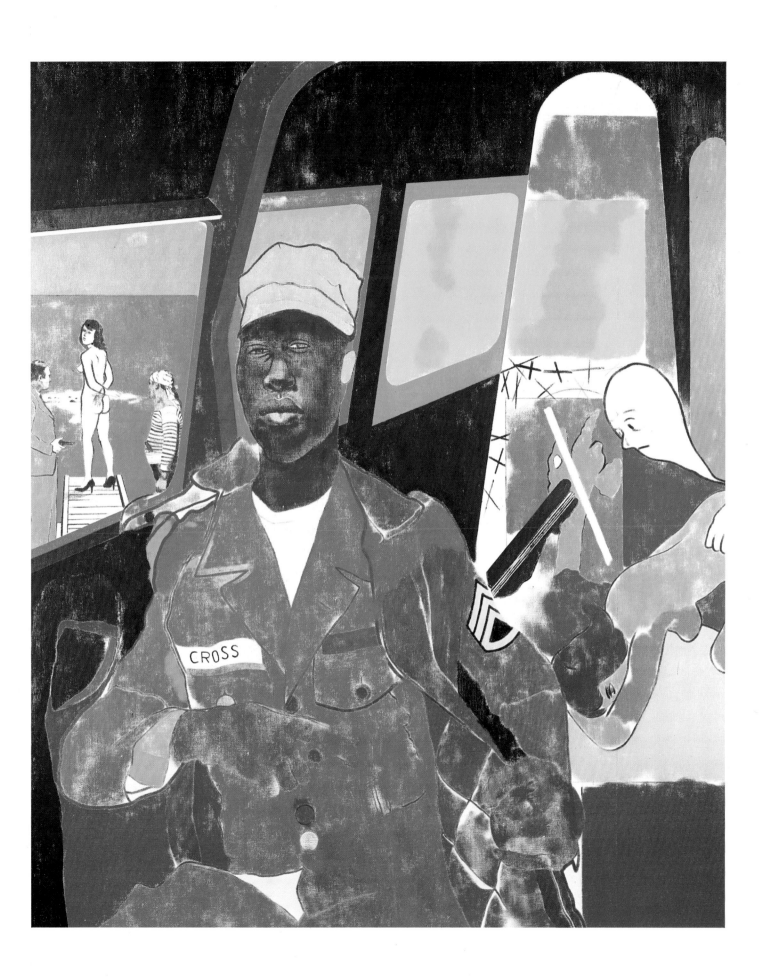

Juan de la Cruz, 1967
Oil on canvas, 183 × 152.4 (72 × 60)
Private collection

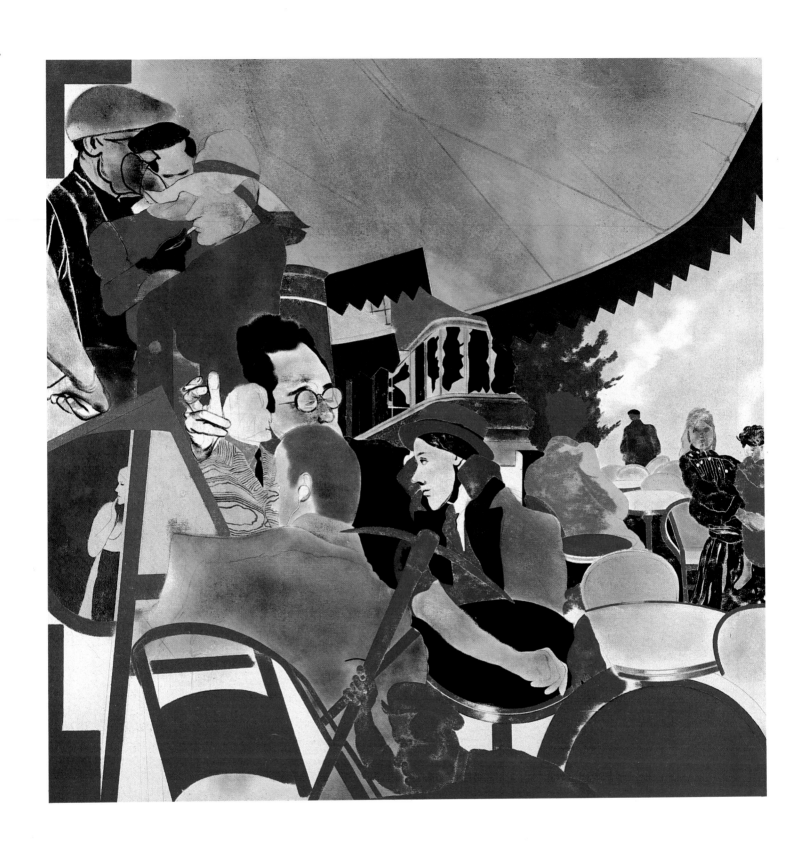

6 **The Autumn of Central Paris (After Walter Benjamin),** 1972–74
Oil on canvas, 152.4 × 152.4 (60 × 60)
Private collection

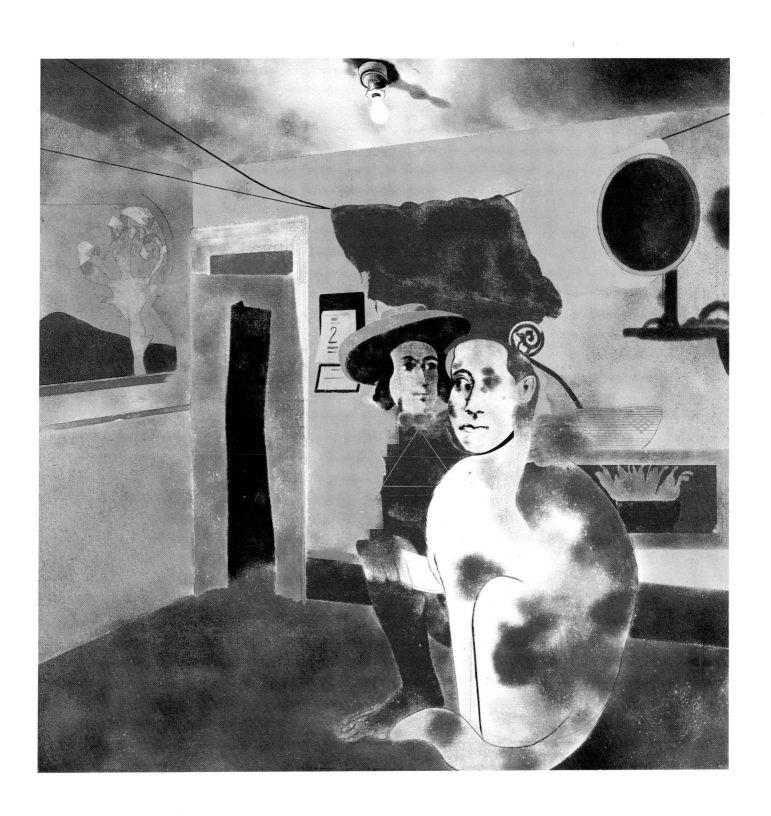

7 **Man of the Woods and the Cat of the Mountains,** 1973
Oil on canvas, 152.4 × 152.4 (60 × 60)
The Trustees of the Tate Gallery, London

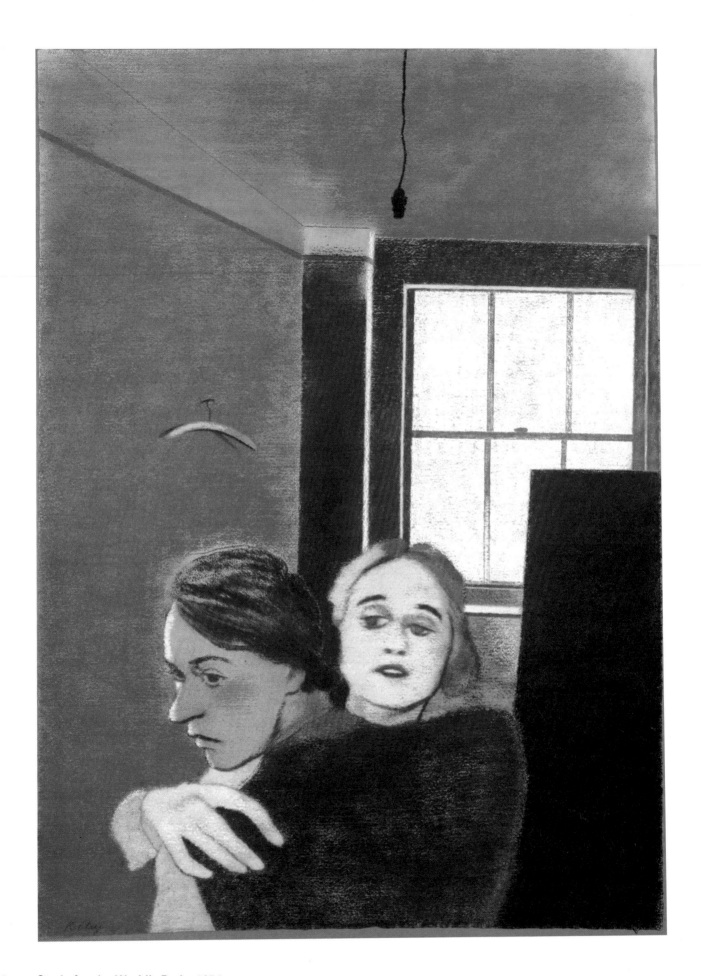

8 **Study for the World's Body,** 1974
Pastel on paper, 76.2 × 50.8 (30 × 20)
Private collection

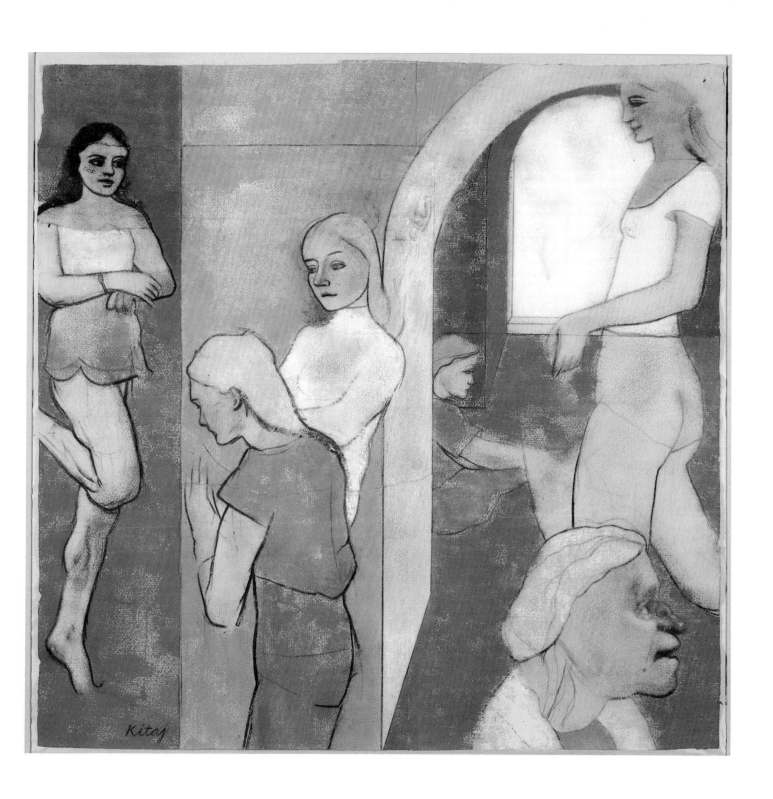

Sighs from Hell, 1979
Pastel and charcoal on paper, 97.8 × 100.3 (38½ × 39½)
Private collection

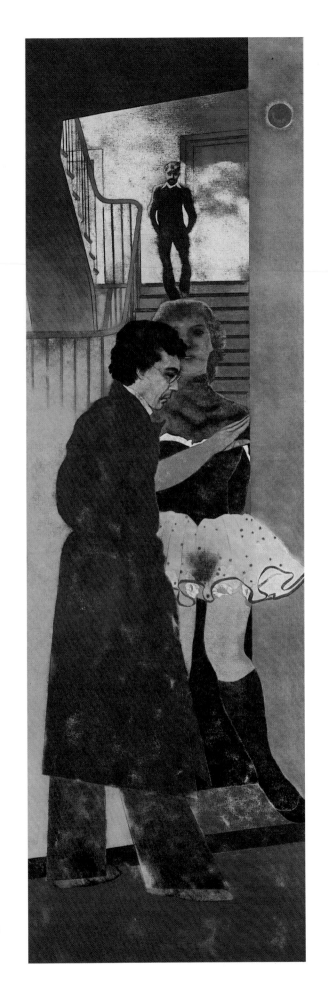

10 **Smyrna Greek (Nikos),** 1976–77
Oil on canvas, 244 × 76.2 (96 × 30)
Collection Thyssen-Bornemisza,
Castagnola-Lugano, Switzerland

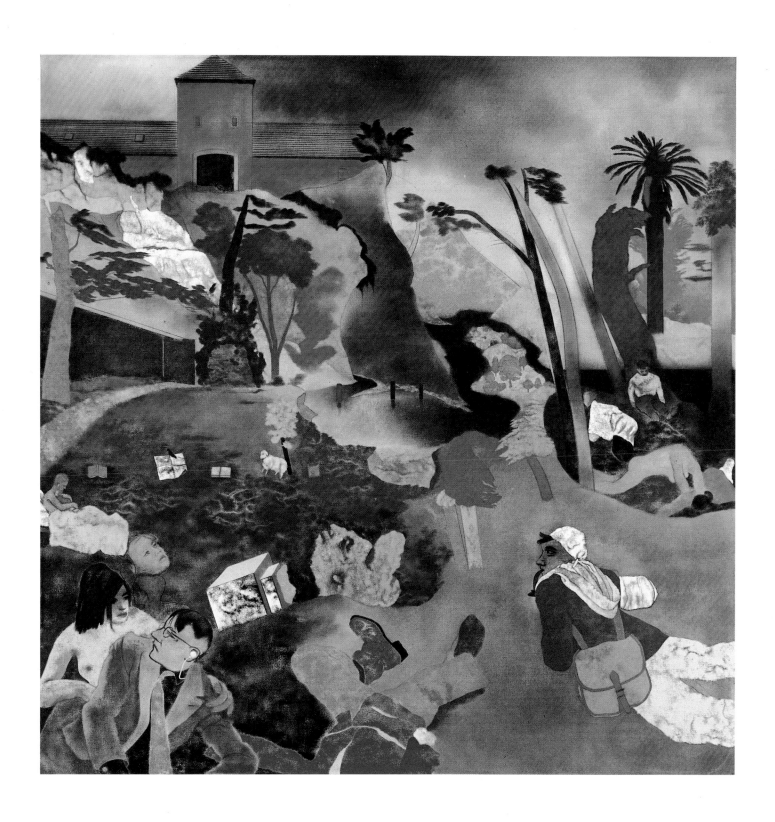

1 **If Not, Not,** 1975–76
Oil on canvas, 152.4 × 152.4 (60 × 60)
Scottish National Gallery of Modern Art, Edinburgh

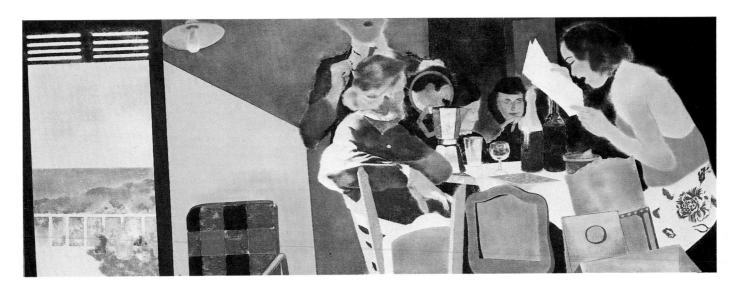

12 **To Live in Peace (The Singers),** 1973–77
Oil on canvas, 76.2 × 213.4 (30 × 84)
Private collection

13 **From London (James Joll and John Golding),** 1975–77
Oil on canvas, 152.4 × 244 (60 × 96)
Private collection

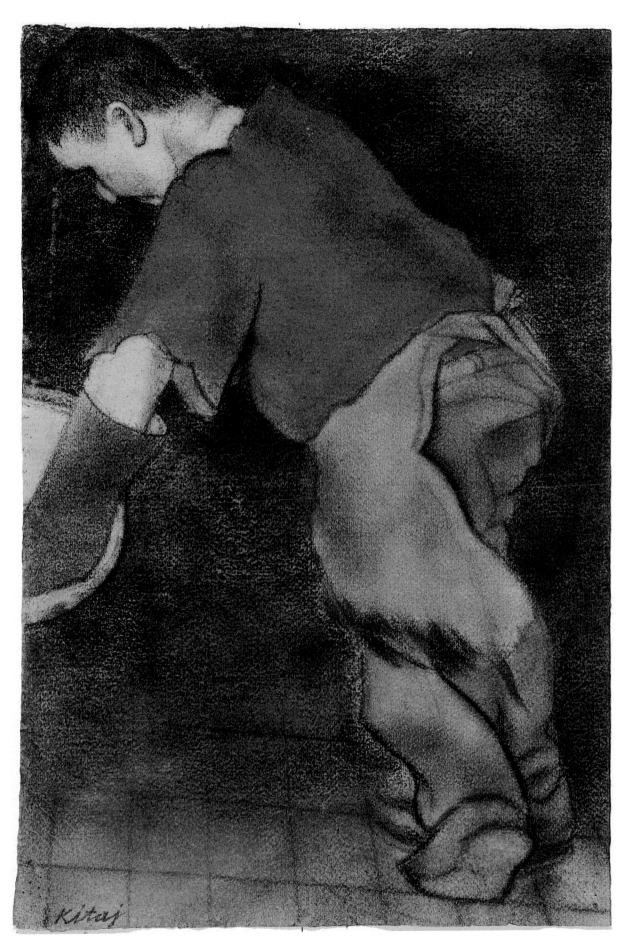

14 **Washing Cork (Ramon),** 1978
Pastel on paper, 55.9 × 38.1 (22 × 15)
The American Can Company, Greenwich, Connecticut

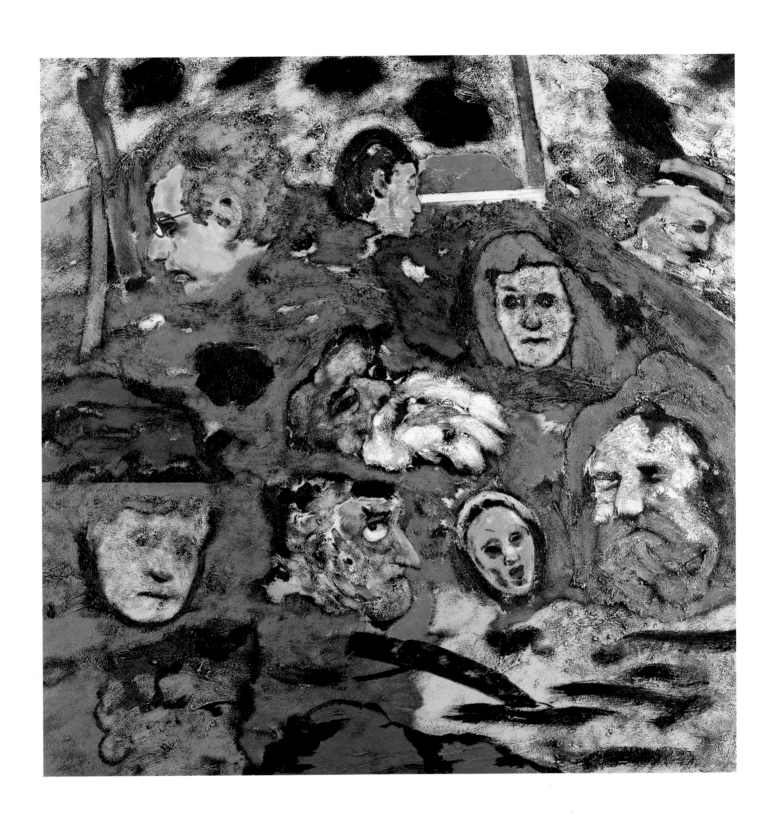

15 **Rock Garden (The Nation),** 1981
Oil on canvas, 122 × 122 cm
Marlborough Fine Art (London) Ltd.

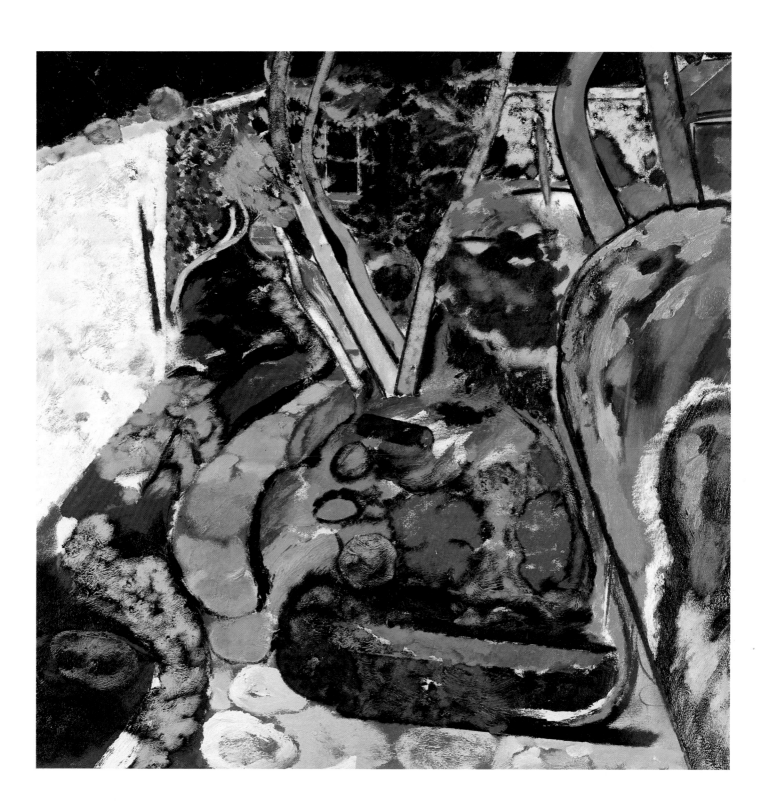

The Garden, 1981
Oil on canvas, 122 × 122 cm
Cleveland Museum of Art

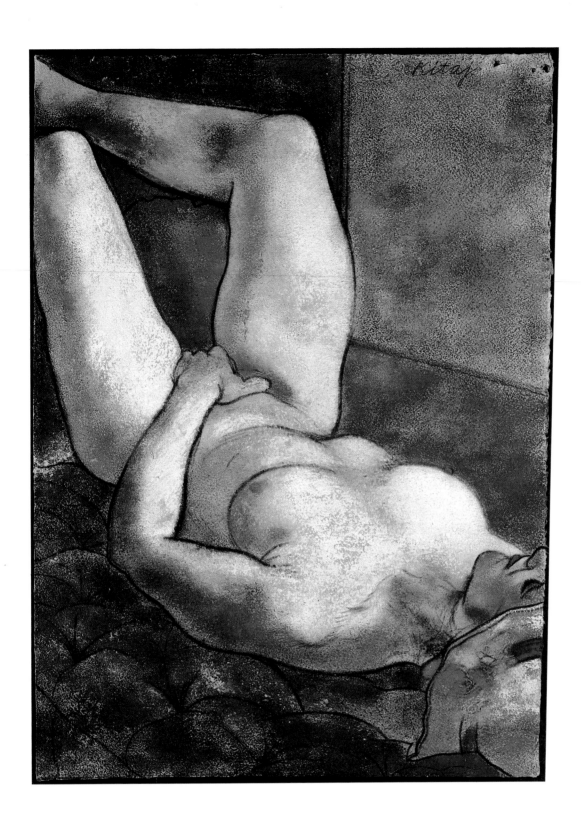

17 **The Yellow Hat,** 1980
Pastel and charcoal on paper, 77.5 × 57.8 (30½ × 22¾)
Collection of the artist, London

Monochrome Plates

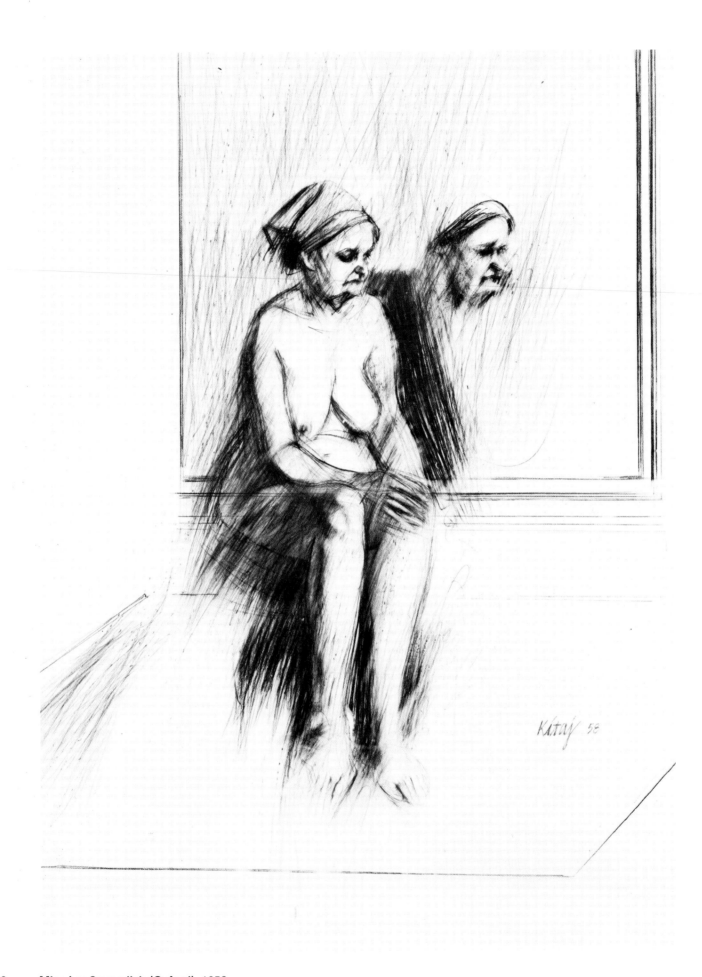

18 **Miss Ivy Cavendish (Oxford),** 1958
Pencil on paper, 53.3 × 41.6 (21 × 16⅜)
Collection of the artist, London

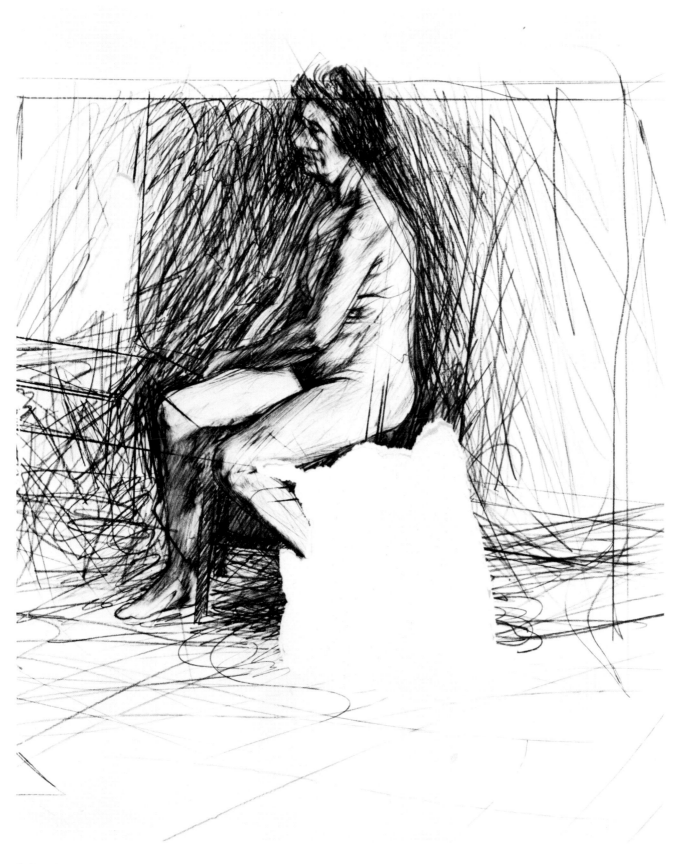

19 **Ashmolean Drawing (Oxford),** 1958
Pencil on paper, 53.3 × 41.6 (21 × 16⅜)
Collection of the artist, London

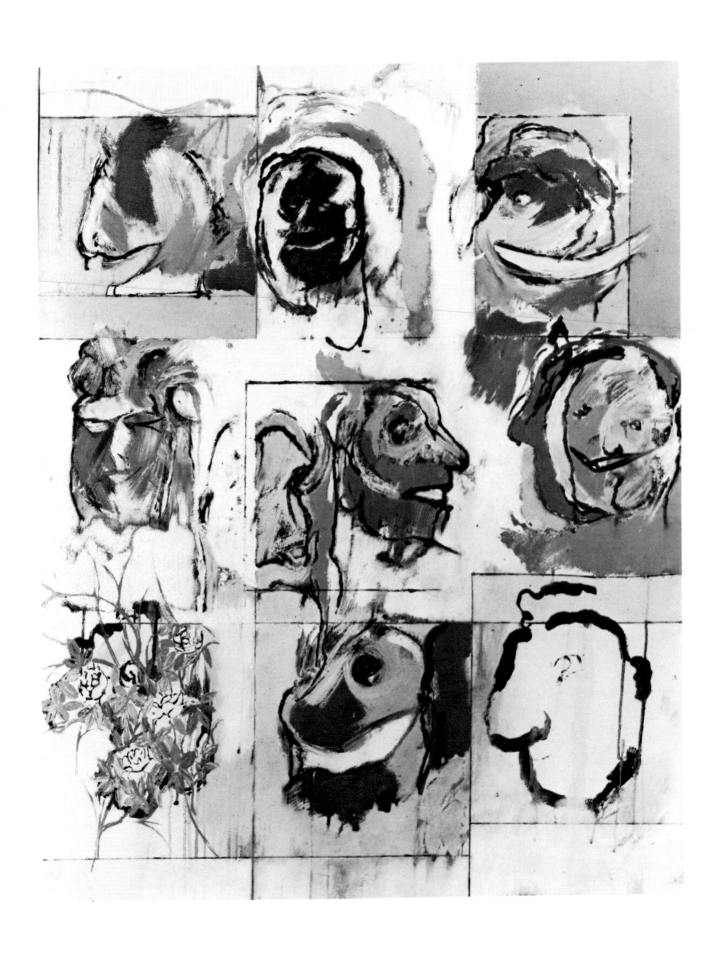

20 **Erasmus,** 1958
Oil on canvas, 104.1 × 83.8 (41 × 33)
Private collection

21 **Tarot Variations,** 1958
Oil on canvas, 109.2 × 86 (43 × 33⅞)
The High Museum of Art, Atlanta
J. J. Haverty Collection

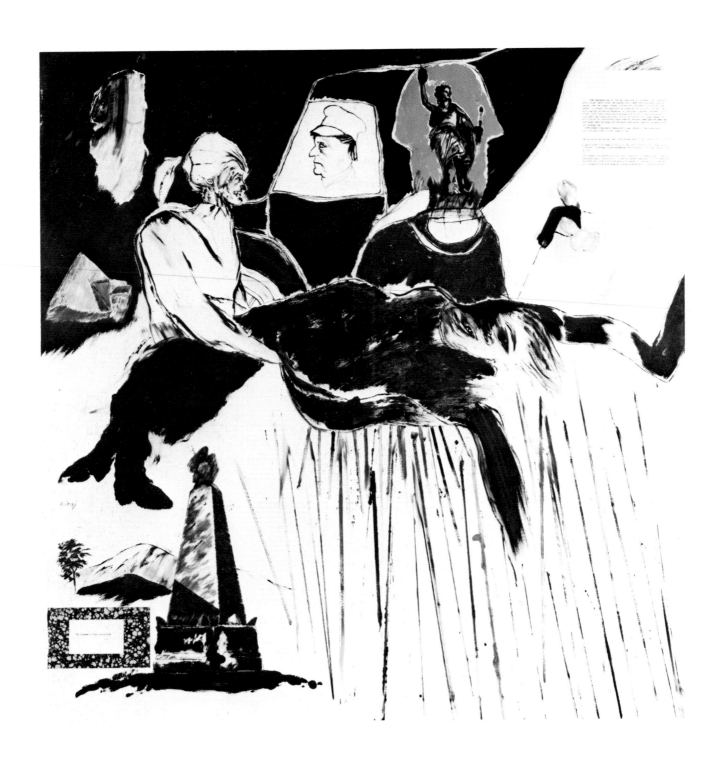

22 **The Murder of Rosa Luxemburg,** 1960
Oil and collage on canvas, 152.4 × 152.4 (60 × 60)
The Trustees of the Tate Gallery, London

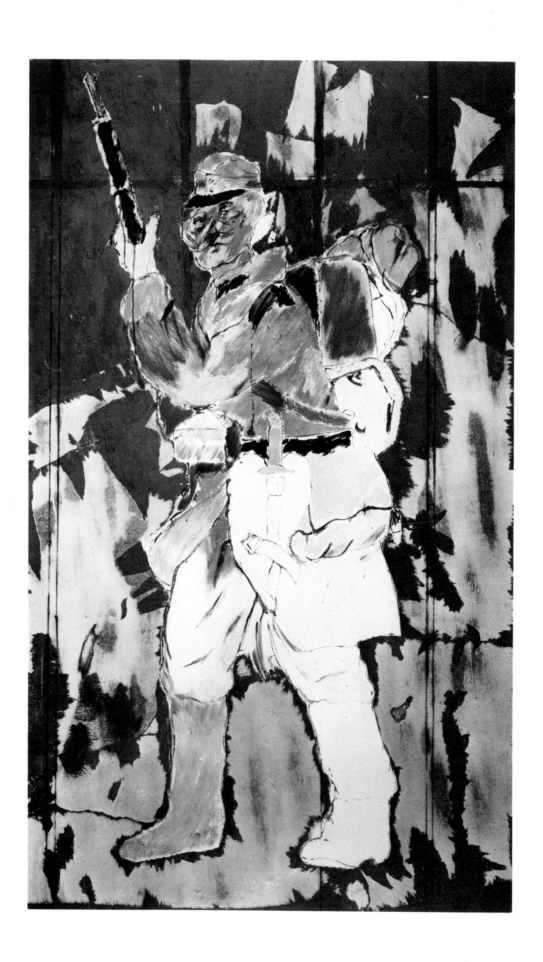

23 **Austro-Hungarian Foot Soldier,** 1961
Oil and collage on canvas, 152.5 × 91 cm
Ludwig Museum, Cologne

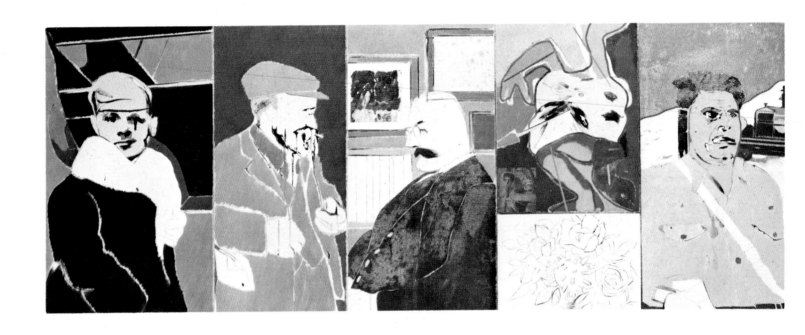

24 **Junta,** 1962
Oil and collage on canvas, 91.4 × 213.4 (36 × 84)
Private collection

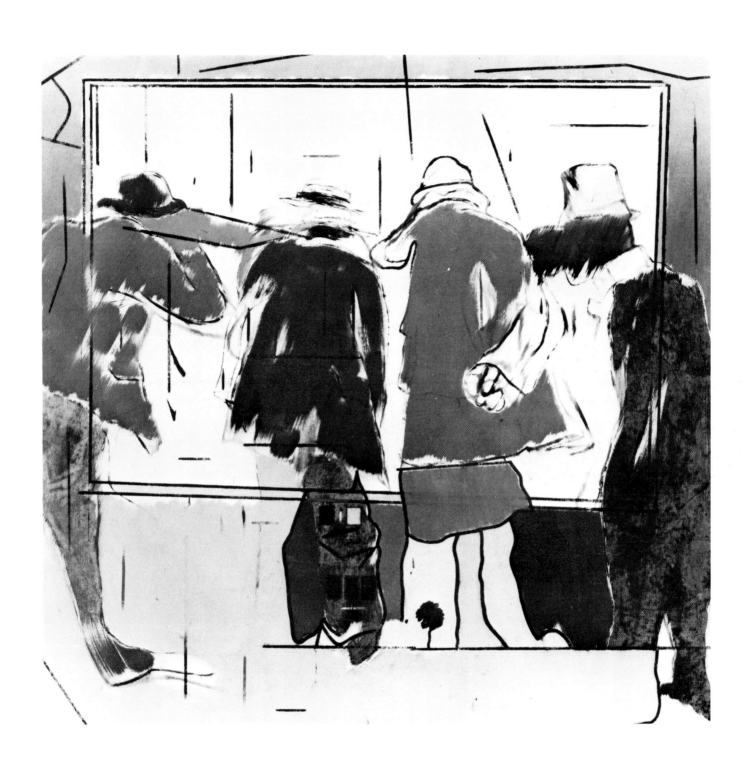

25 **Nietzsche's Moustache,** 1962
Oil on canvas, 121.9 × 121.9 (48 × 48)
Private collection

26 **Kennst Du das Land?,** 1962
Oil on canvas, 121.9 × 121.9 (48 × 48)
Marlborough Fine Art (London) Ltd.

27 **Reflections on Violence,** 1962
Oil on canvas, 152.4 × 152.4 (60 × 60)
Hamburger Kunsthalle, West Germany

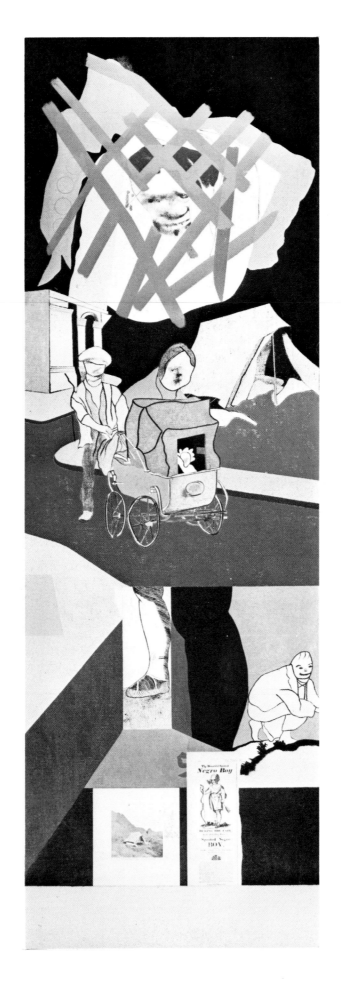

28 **The Baby Tramp,** 1963–64
Oil and collage on canvas, 183 × 61 (72 × 24)
Haags Gemeentemuseum, The Netherlands

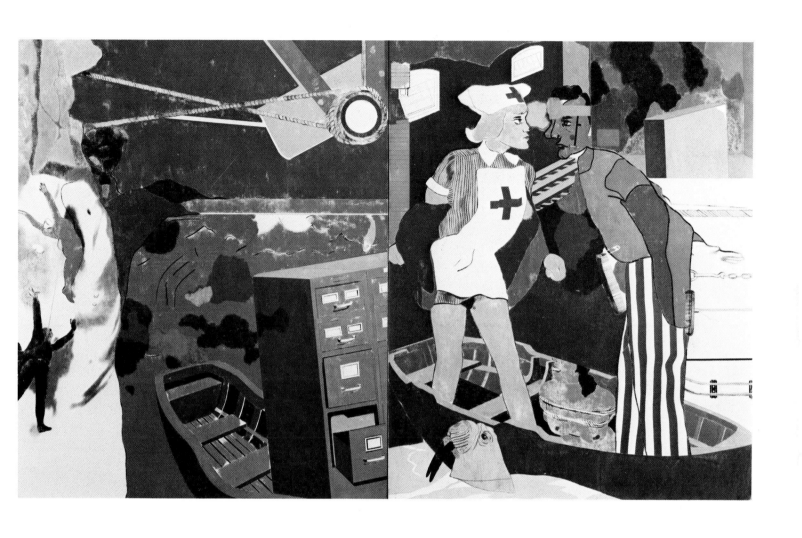

29 **Erie Shore,** 1966
Oil on canvas, 183 × 305 (72 × 121)
Nationalgalerie Berlin Staatliche Museen
Stiftung Preussischer Kulturbesitz, West Germany

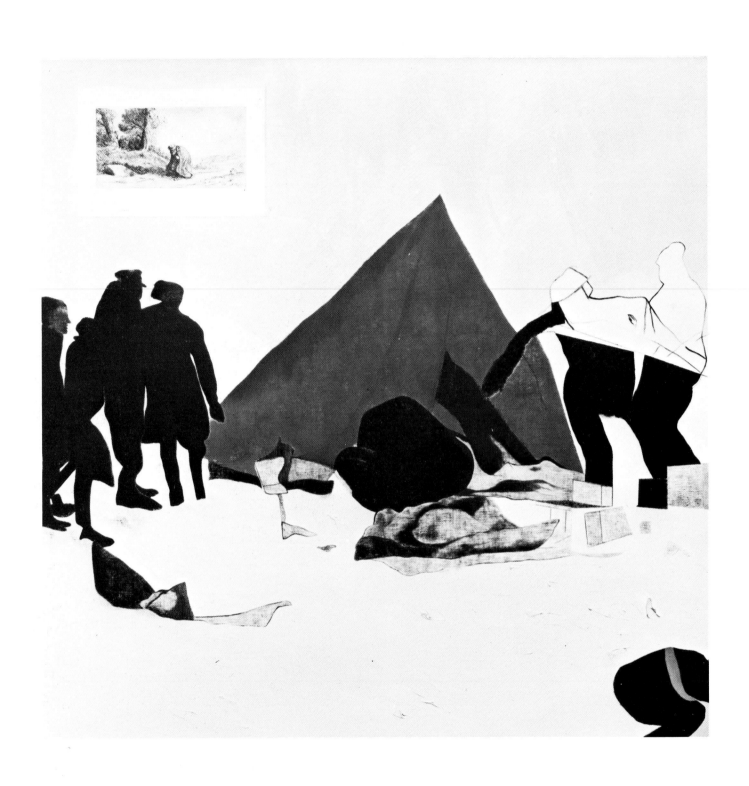

30 **Dismantling the Red Tent,** 1964
Oil and collage on canvas, 121.9 × 121.9 (48 × 48)
Private collection

31 **Rival Poet,** 1965
Oil on canvas, 57.2 × 38.1 (22½ × 15)
Sheffield City Art Galleries, England

32 **Sisler and Schoendienst,** 1967
Oil on canvas, 25.4 × 35.2 (10 × 13⅞)
Private collection

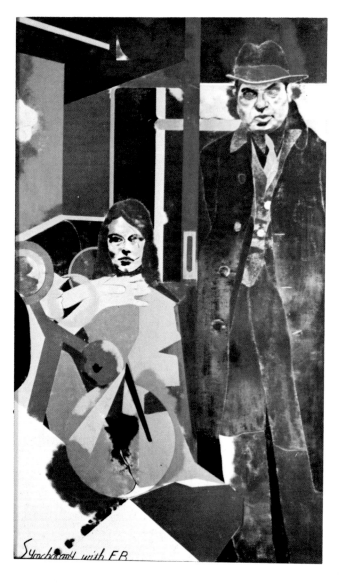

33 **Synchromy with F.B.—General of Hot Desire,** 1968
Oil on canvas, two panels, each 152.4 × 91.4 (60 × 36)
Private collection

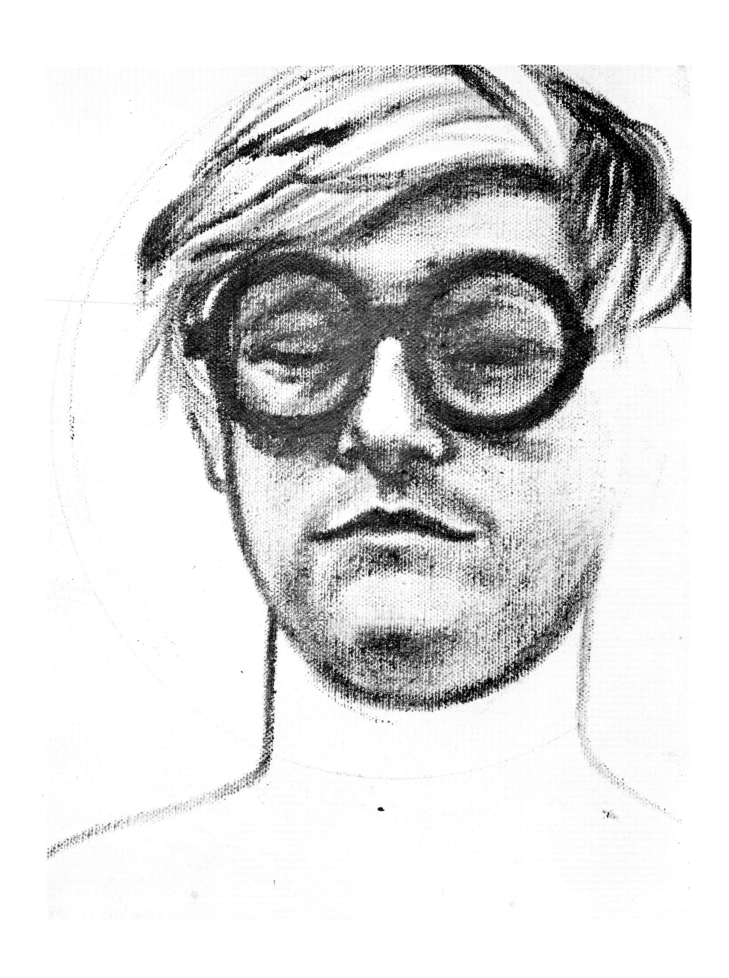

34 **David at Berkeley,** 1968
Oil on canvas, 25.4 × 20.5 (10 × 8)
Marlborough Fine Art (London) Ltd.

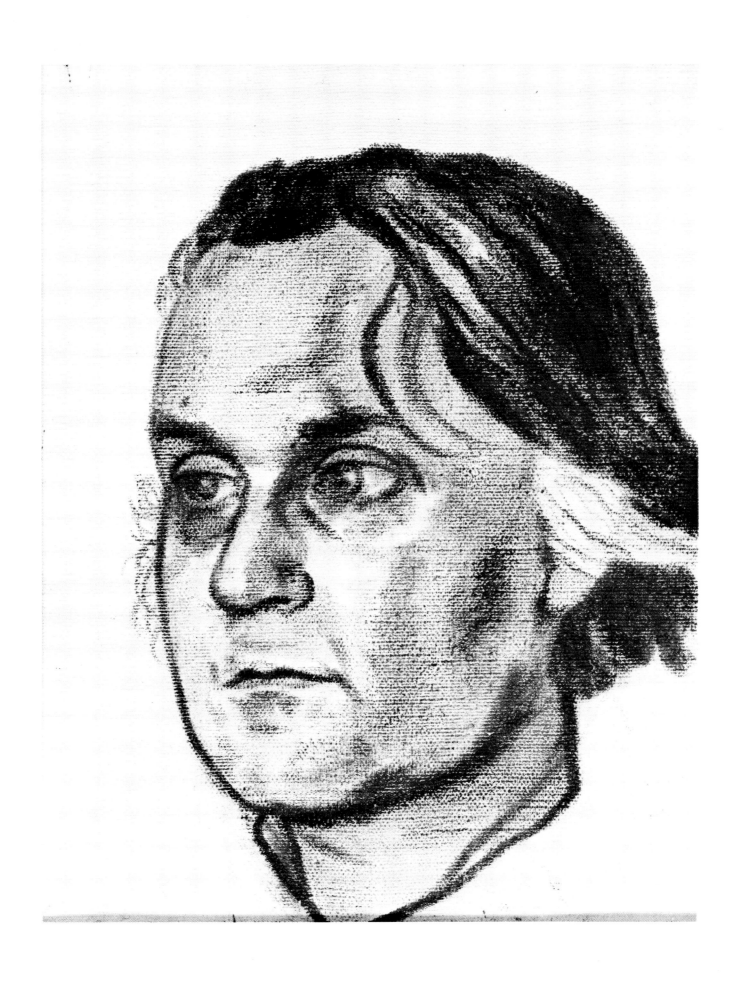

35 **Robert Duncan,** 1968
Oil on canvas, 30.5 × 30.5 (12 × 12)
Marlborough Fine Art (London) Ltd.

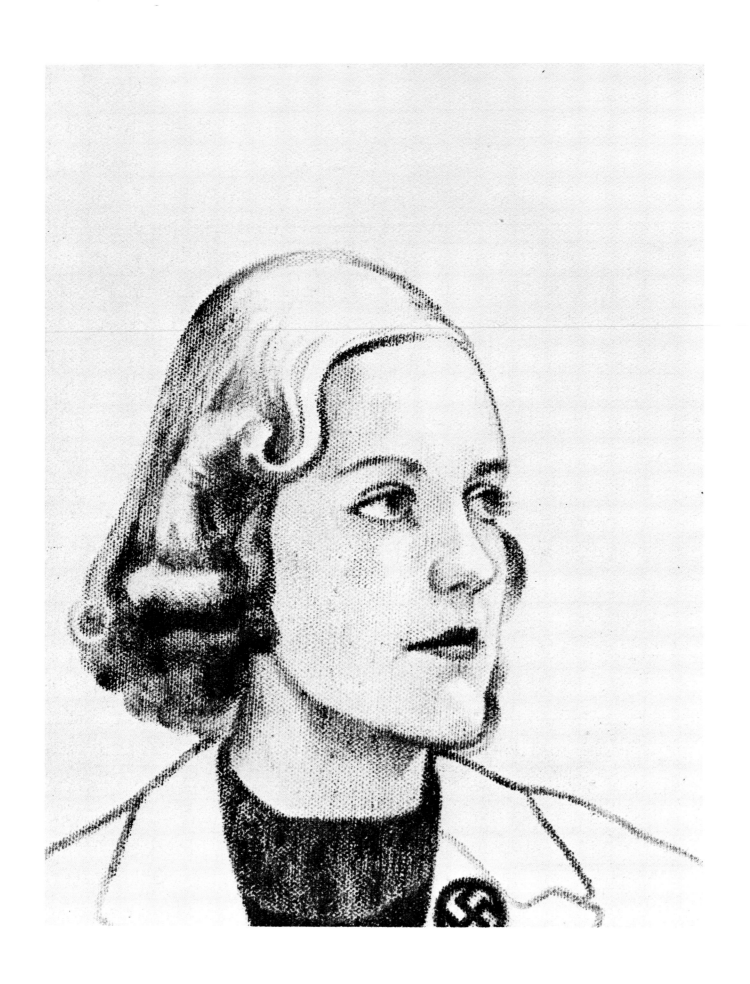

36 **Unity Mitford,** 1968
Oil on canvas, 25.4 × 20.5 (10 × 8)
Collection of the artist, London

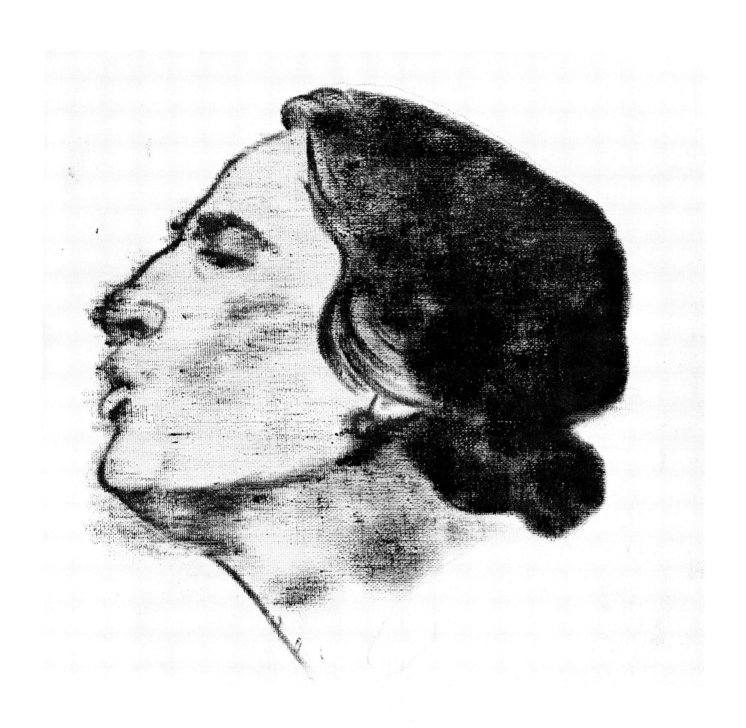

37 **Passionaria,** 1969
Oil on canvas, 30.5 × 30.5 (12 × 12)
Private collection

little
suicide
picture

Kitaj

38 **Little Suicide Picture,** 1969
Oil on canvas, 50.8 × 50.8 (20 × 20)
The Baltimore Museum of Art
Thomas Benesch Memorial Collection

39 **Little Slum Picture,** 1968–70
Oil on canvas, 76.2 × 61 (30 × 24)
Private collection

40 **The Third Department (A Teste Study),** 1970–77
Oil on canvas, 76.2 × 121.9 (30 × 48)
Marlborough Fine Art (London) Ltd.

41 **Arcades (After Walter Benjamin),** 1972–74
Oil on canvas, 152.4 × 152.4 (60 × 60)
Private collection

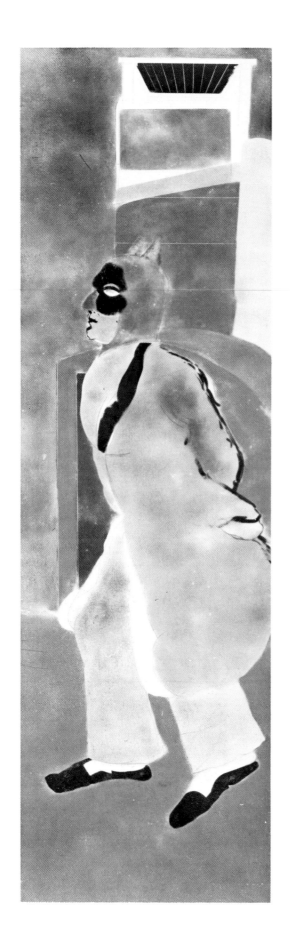

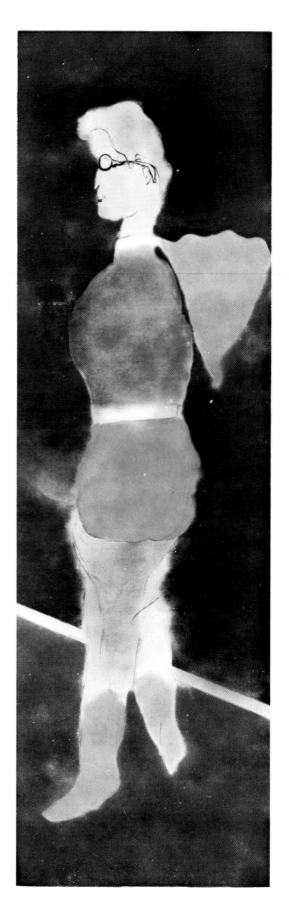

42 **Batman,** 1973
 Oil on canvas, 244 × 76.2 (96 × 30)
 Private collection, Cologne

43 **Superman,** 1973
 Oil on canvas, 244 × 76.2 (96 × 30)
 Private collection, Cologne

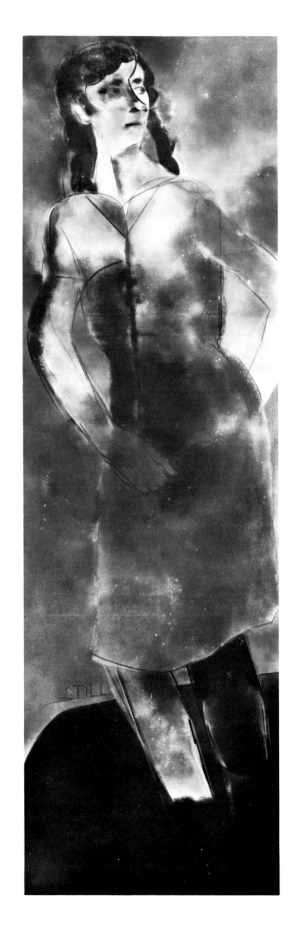

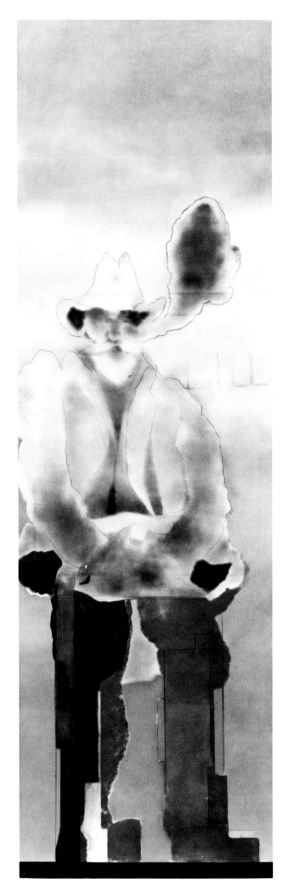

44 **Still (The Other Woman),** 1974
Oil on canvas, 243.8 × 76.2 (96 × 30)
Private collection

45 **Bill at Sunset,** 1973
Oil on canvas, 244 × 76.2 (96 × 30)
Marlborough Fine Art (London) Ltd.

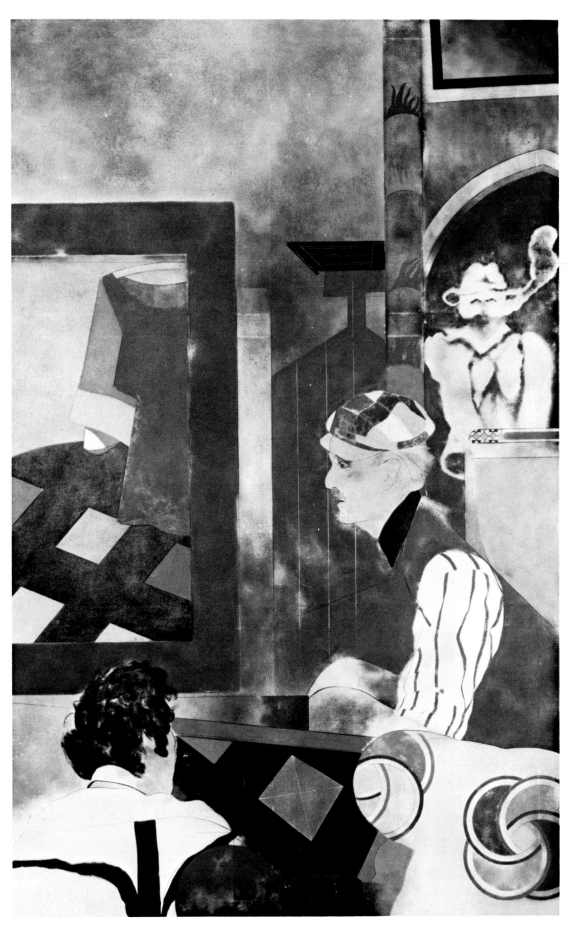

46 **Kenneth Anger and Michael Powell,** 1973
Oil on canvas, 244 × 152.4 (96 × 60)
Musée National d'Art Moderne, Centre Georges Pompidou, Paris
Lent by the Ludwig Collection, Aix-la-Chapelle

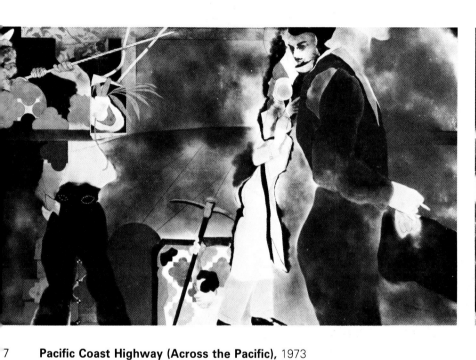

7 **Pacific Coast Highway (Across the Pacific),** 1973
Oil on canvas, two panels, left: 152.4 × 244 (60 × 96); right: 152.4 × 152.4 (60 × 60)
Private collection

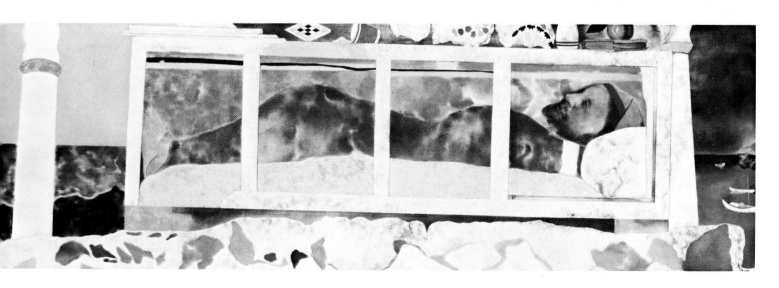

48 **Catalan Christ (Pretending to Be Dead),** 1976
Oil on canvas, 76.2 × 244 (30 × 96)
Louisiana Museum of Modern Art, Humlebaek, Denmark

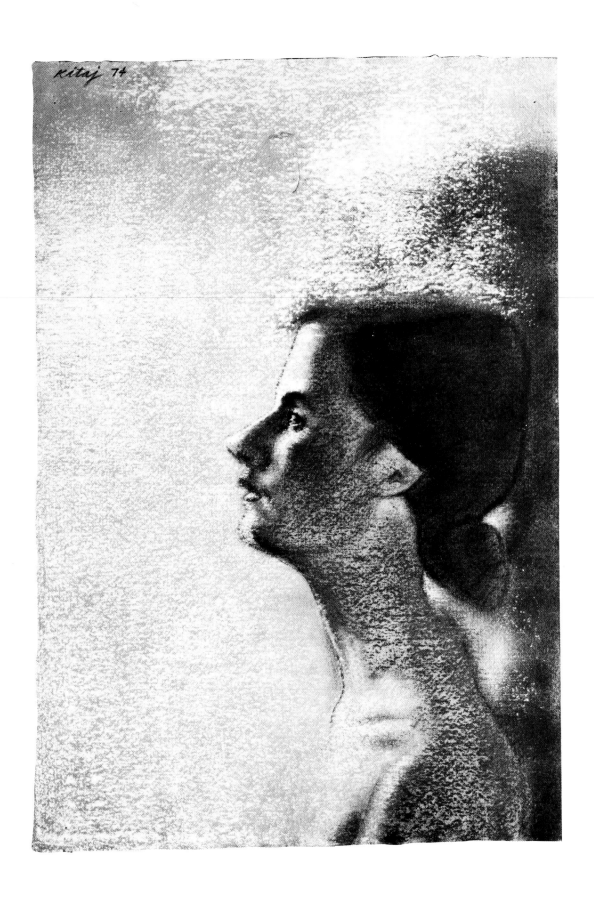

49 **Study for Miss Brooke,** 1974
Pastel on paper, 58 × 39 (22⅞ × 15⅜)
Museum Boymans-van Beuningen, Rotterdam

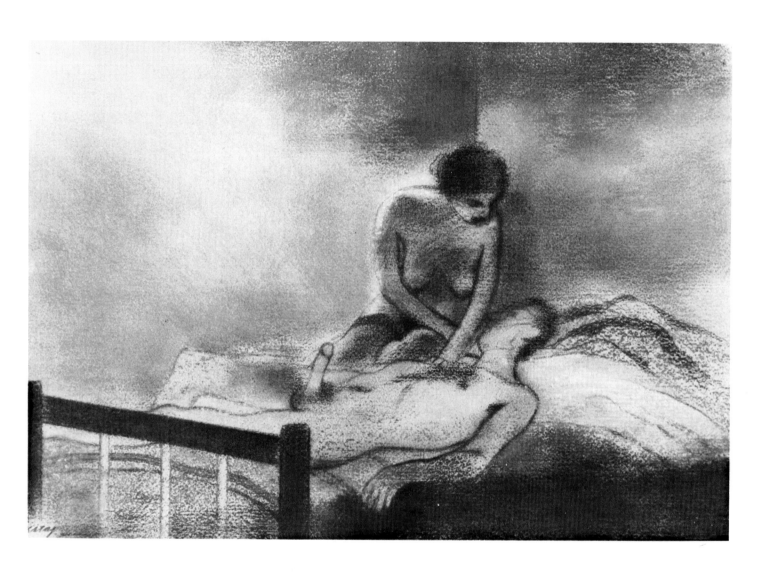

Communist and Socialist, 1975
Pastel on paper, 38.5 × 56.5 cm
Collection of the artist, London

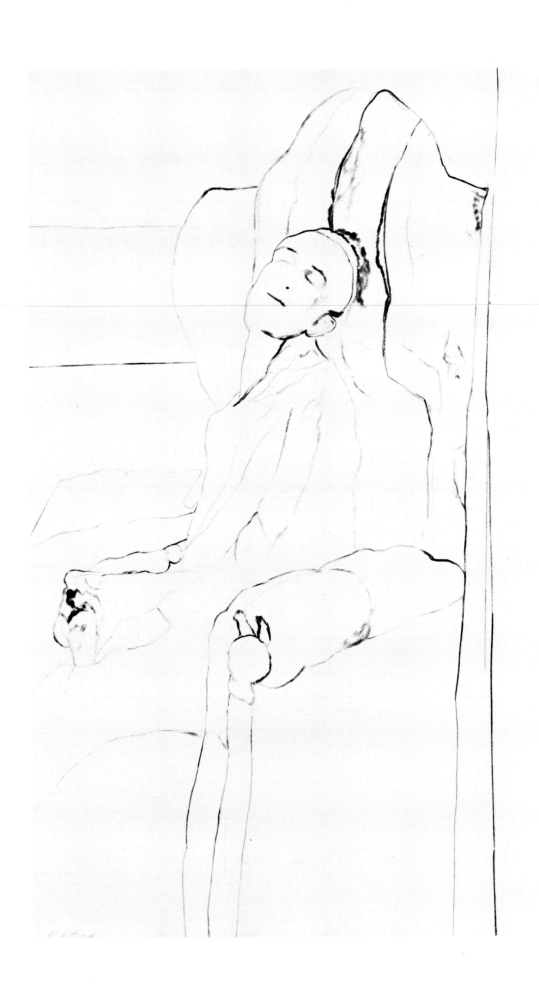

51 **The Stage-Life of the Dead,** 1974
Lithographic pencil on paper, 80 × 59.5 (31½ × 23⁷⁄₁₆)
Private collection

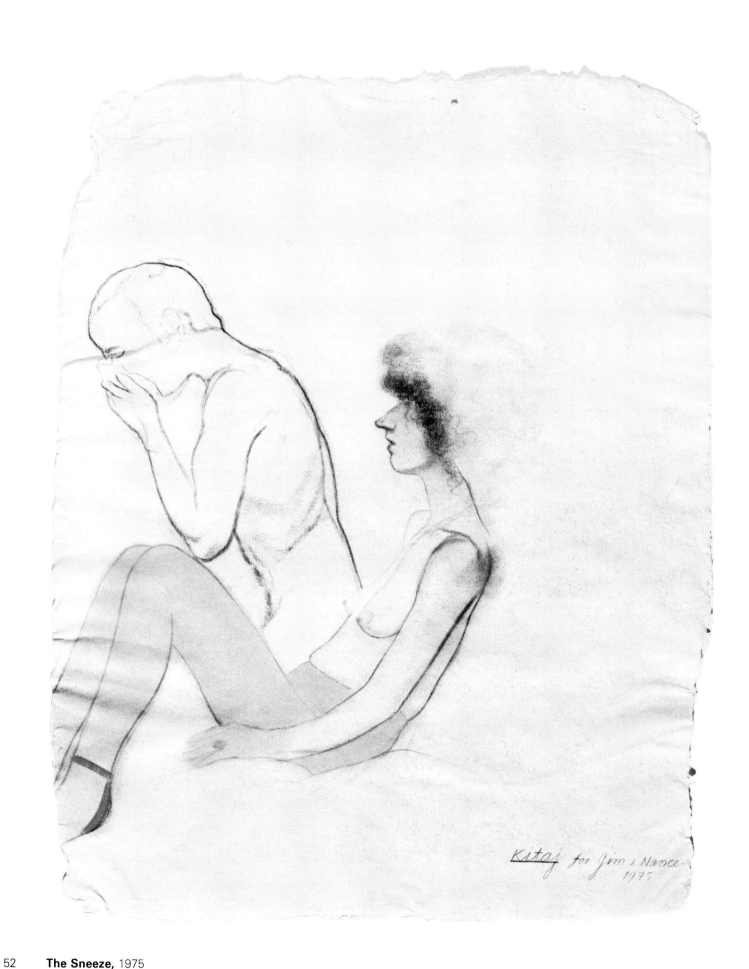

52 **The Sneeze,** 1975
Pastel, charcoal, and pencil on paper, 86.4 × 68.6 (34 × 27)
The Museum of Modern Art, New York
Gift of Nancy and Jim Dine

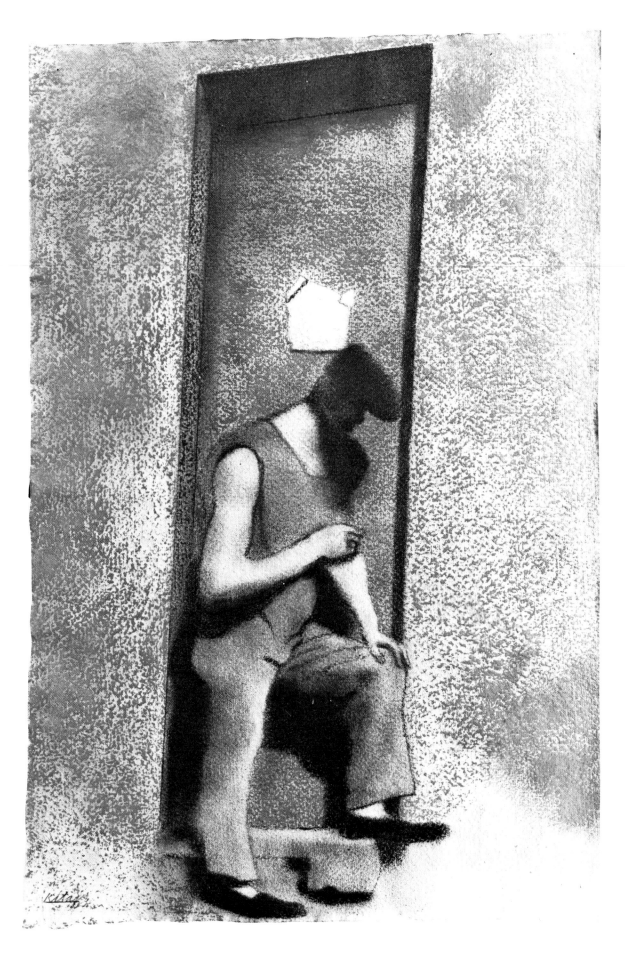

53 **In Catalonia,** 1975
Pastel on paper, 56.8 × 38.7 (22⅜ × 15¼)
Private collection

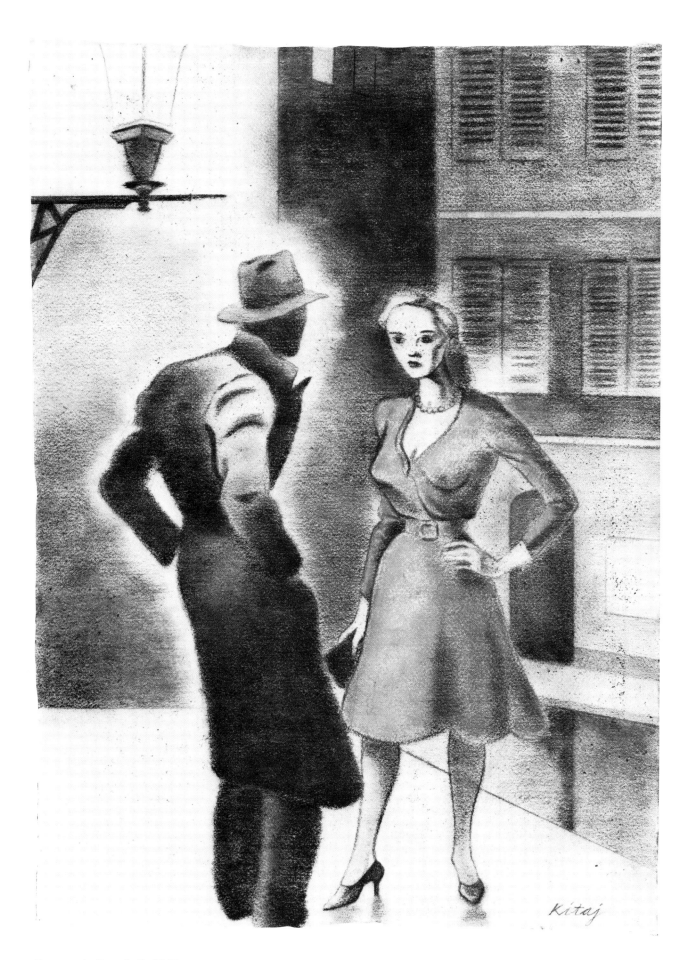

54 **Femme du Peuple II,** 1975
Pastel on paper, 77.2 × 55.9 (30⅜ × 22)
Private collection

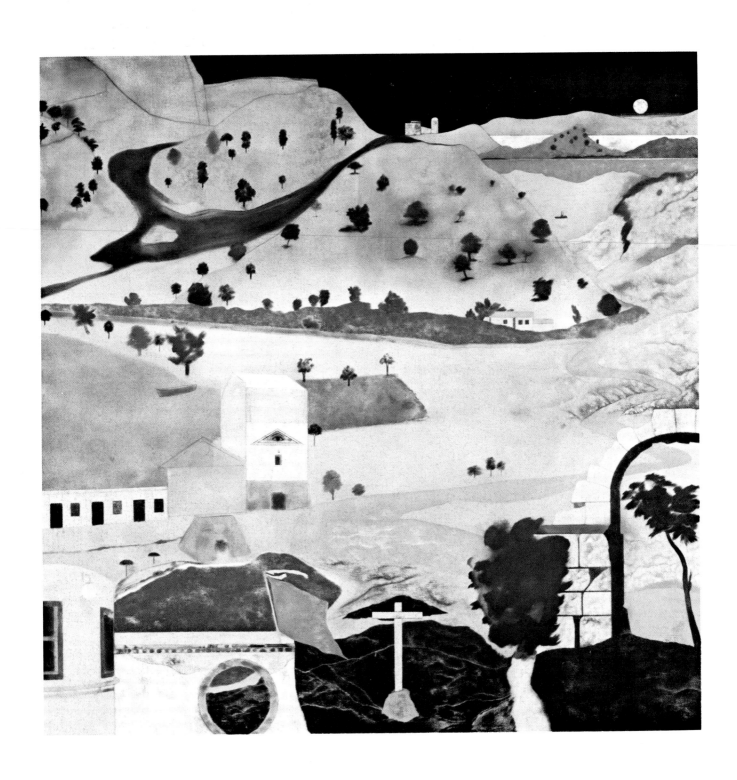

55 **Land of Lakes,** 1975–77
Oil on canvas, 152.4 × 152.4 (60 × 60)
Private collection

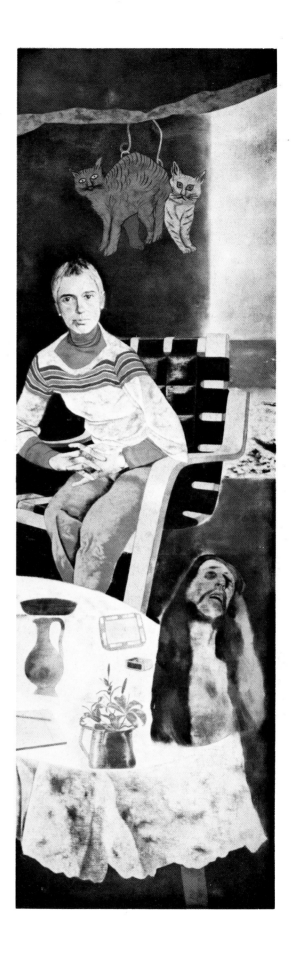

56 **Moresque,** 1975–76
Oil on canvas, 244 × 76.2 (96 × 30)
Museum Boymans-van Beuningen, Rotterdam

57 **The Hispanist (Nissa Torrents),** 1977
Oil on canvas, 244 × 76.2 (96 × 30)
Private collection

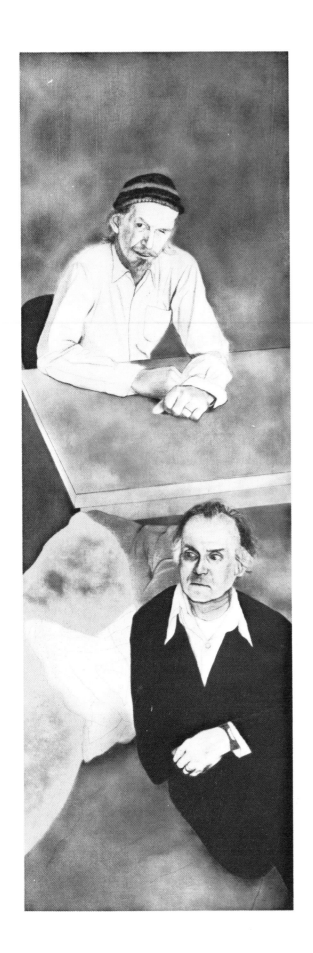

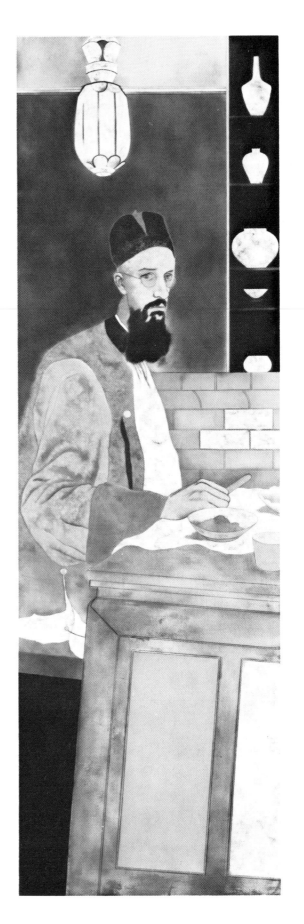

58 **A Visit to London (Robert Creeley and
Robert Duncan),** 1977
Oil on canvas, 182.9 × 61 (72 × 24)
Marlborough Fine Art (London) Ltd.

59 **The Orientalist,** 1976–77
Oil on canvas, 244 × 76.8 (96 × 30¼)
The Trustees of the Tate Gallery, London

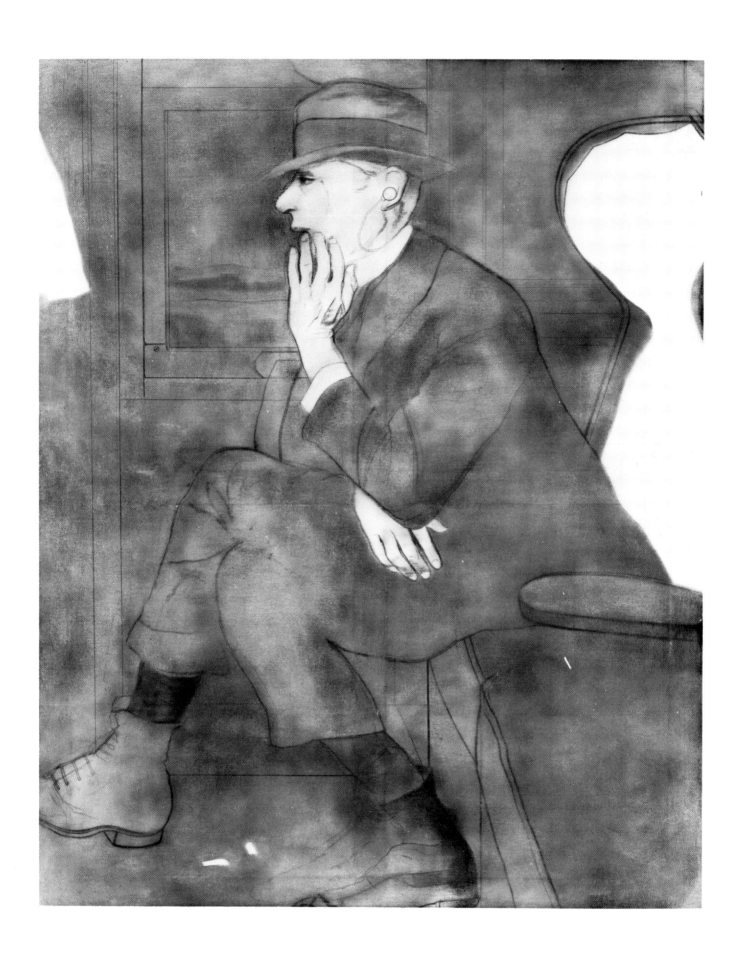

60 **The Jew, Etc.,** 1976
Oil and charcoal on canvas, 152.4 × 121.9 (60 × 48)
Marlborough Fine Art (London) Ltd.

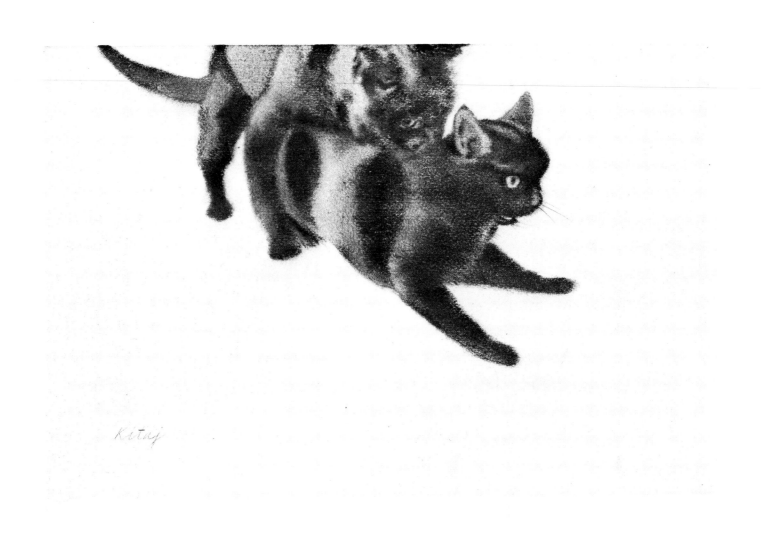

61 **My Cat and Her Husband,** 1977
Charcoal on paper, 38.1 × 55.9 (15 × 22)
Collection of the artist, London

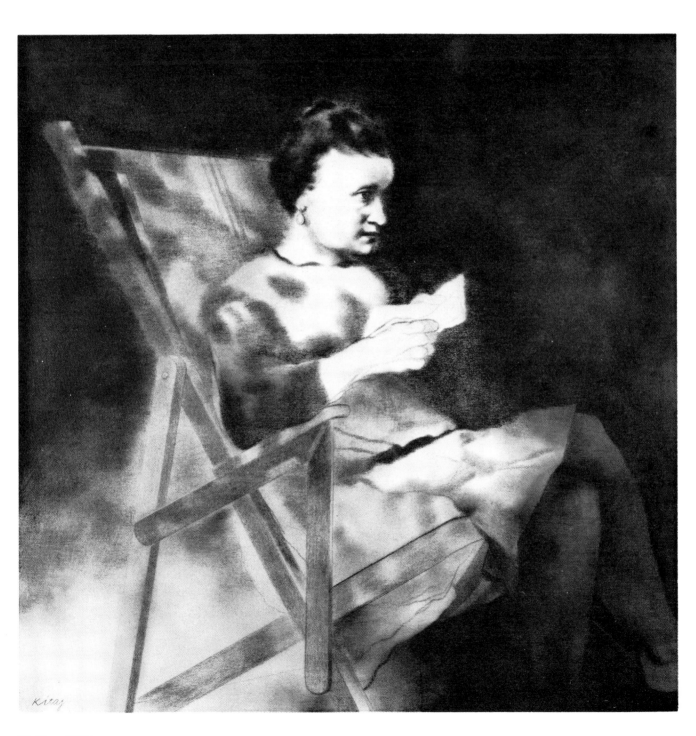

62 **Mother,** 1977
Oil and charcoal on canvas, 106.7 × 106.7 (42 × 42)
Collection of the artist, London

63 **Dominie (Sant Feliu),** 1978
Pastel and charcoal on paper, 54 × 39 (21⅜ × 15⅜)
Collection of the artist, London

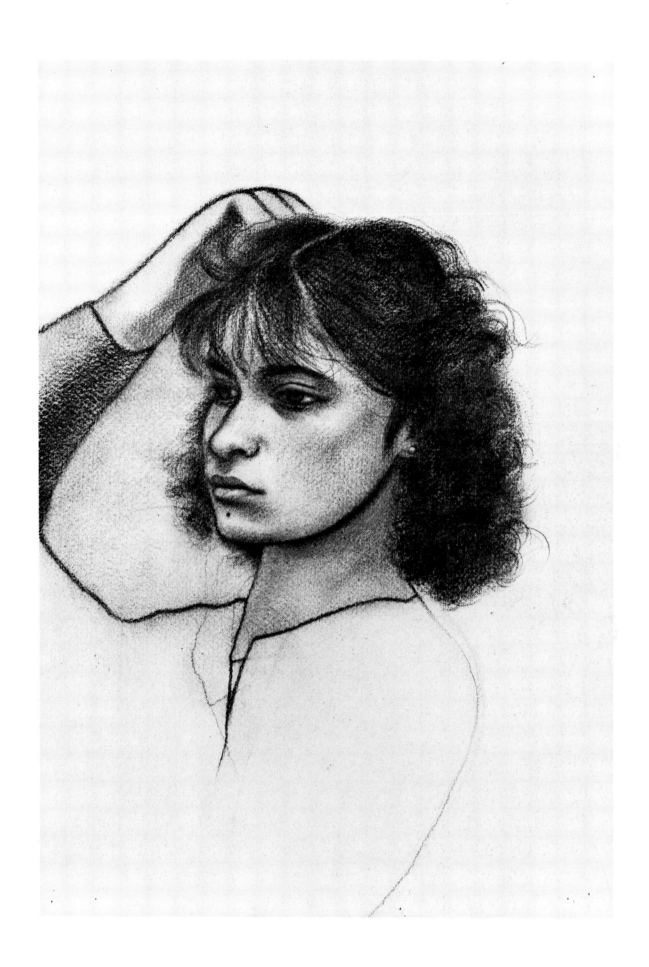

64 **Dominie (Dartmouth),** 1978
Pastel and charcoal on paper, 55.9 × 38.1 (22 × 15)
Collection of the artist, London

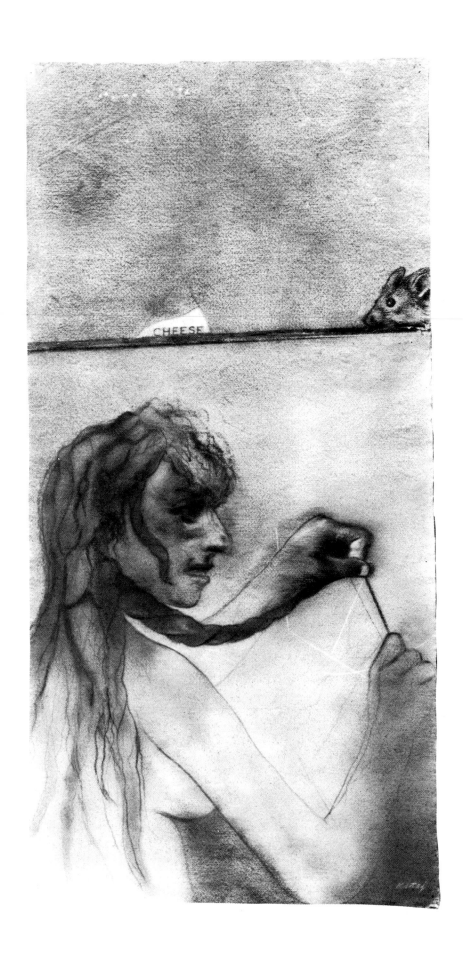

65 **Bad Faith (Gulag),** 1978
Pastel and charcoal on paper, 112.4 × 55.9 (44¼ × 22)
Jonathan Silver Collection at Art and Furniture, Manchester, England

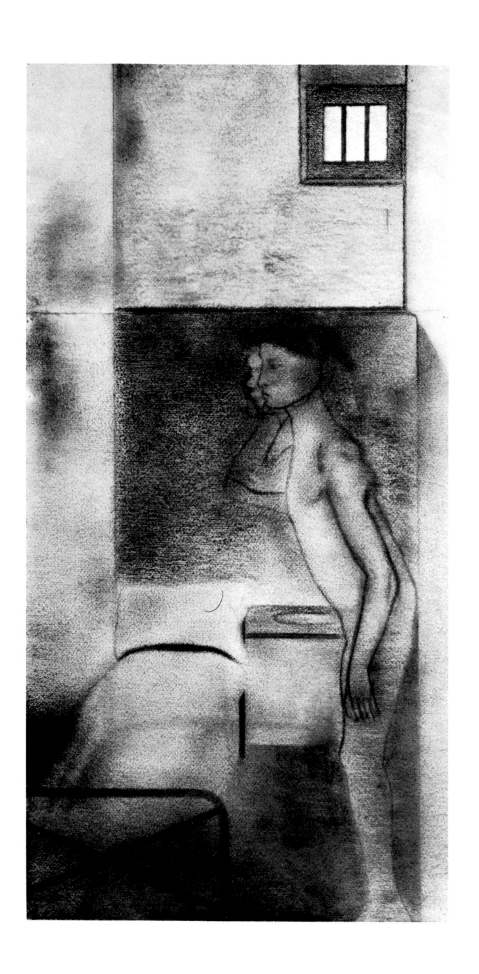

66 **Bad Faith (Warsaw),** 1978
Pastel and charcoal on paper, 109.9 × 56.8 (43½ × 22⅜)
Collection of the artist, London

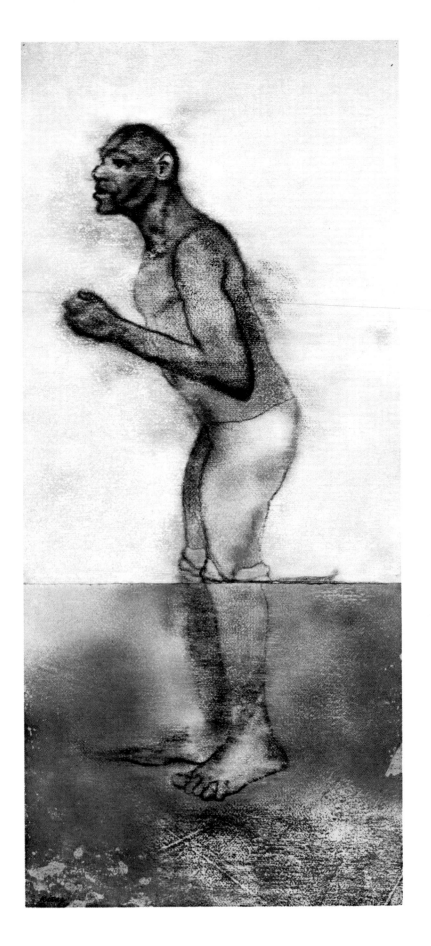

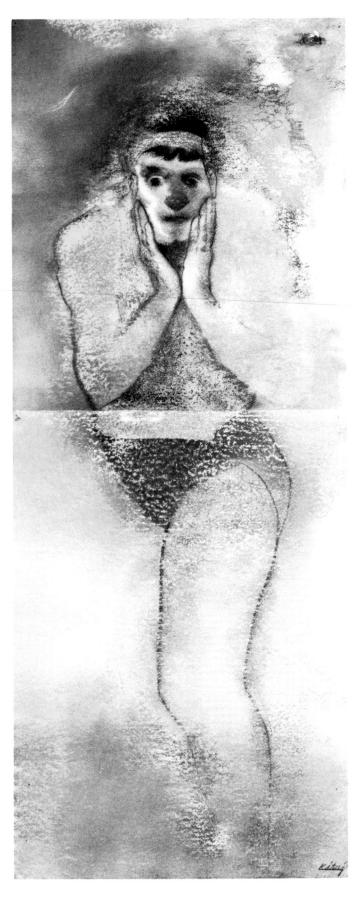

67 **Bather (Wading),** 1978
Pastel and charcoal on paper, 121.3 × 56.8 (47¾ × 22⅜)
Private collection, London

68 **Bather (Torsion),** 1978
Pastel and charcoal on paper, 137.8 × 56.8 (54¼ × 22⸍
Sovereign American Arts Corporation, New York

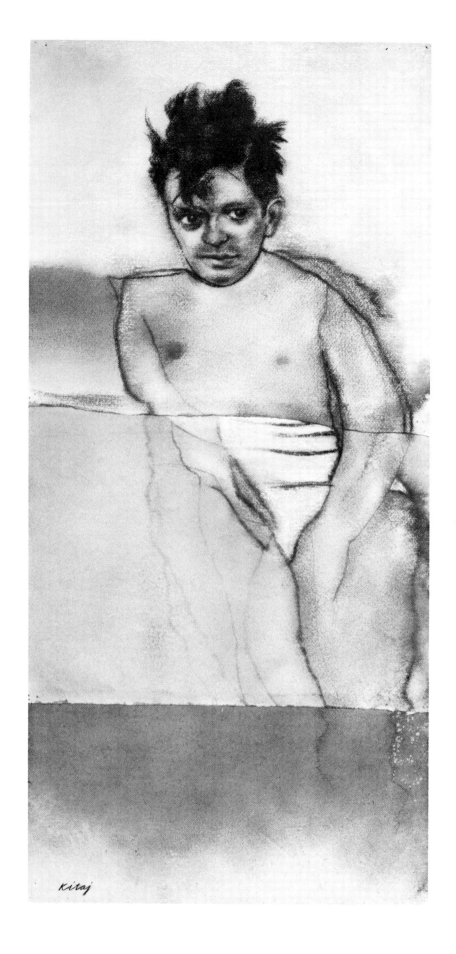

69 **Bather (Tousled Hair),** 1978
Pastel and charcoal on paper, 121.3 × 56.8 (47¾ × 22⅜)
Private collection

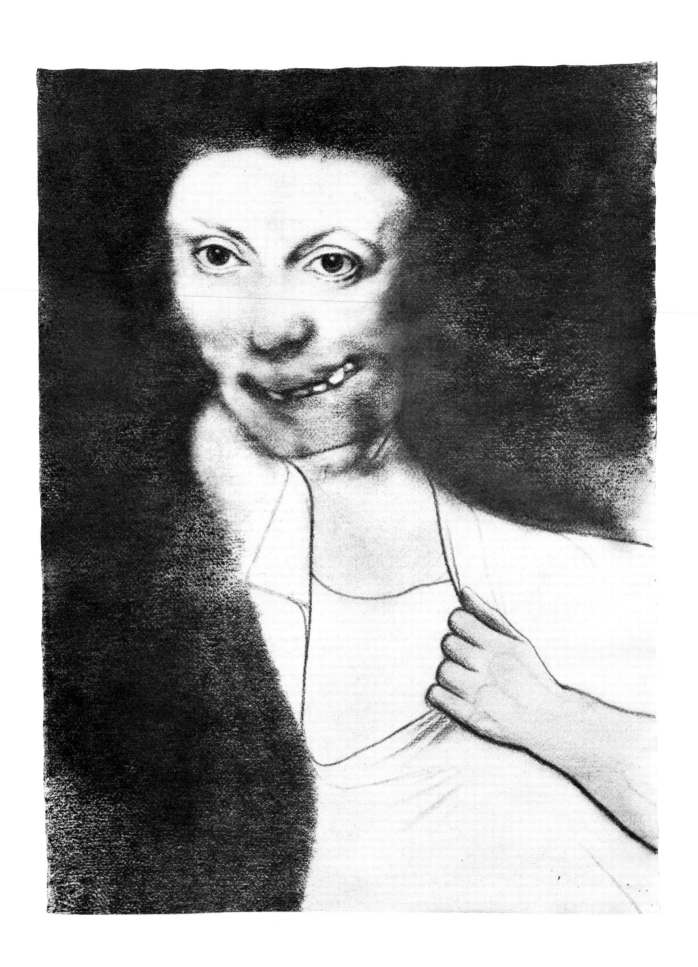

70 **His New Freedom,** 1978
Pastel and charcoal on paper, 76.8 × 55.9 (30¼ × 22)
Collection of the artist, London

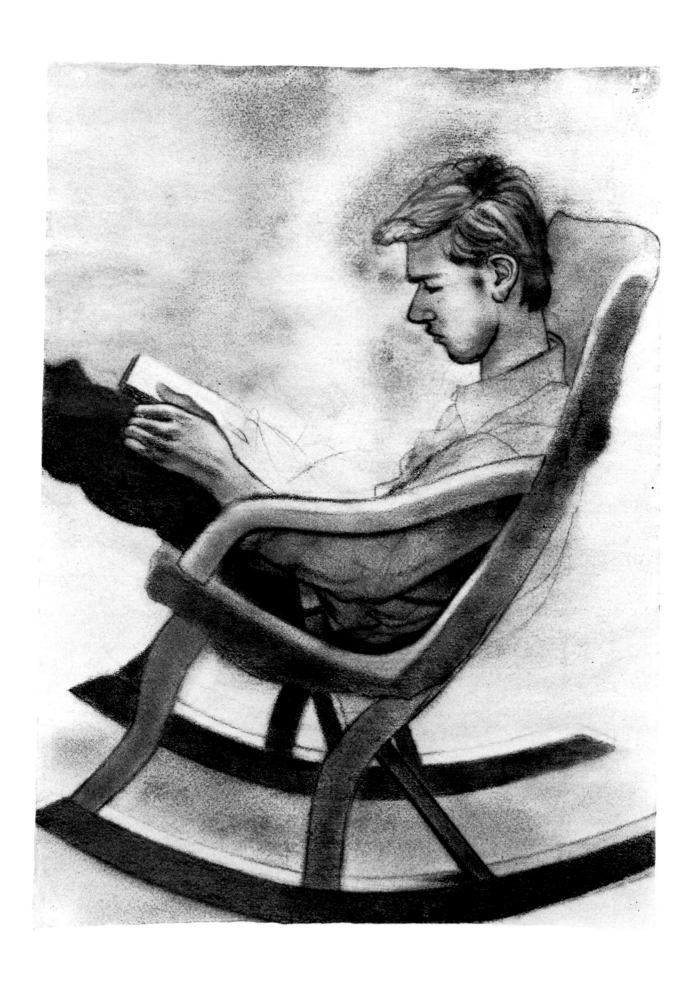

71 **Lem (Sant Feliu),** 1978
Pastel and charcoal on paper, 76.8 × 55.9 (30¼ × 22)
Collection of the artist, London

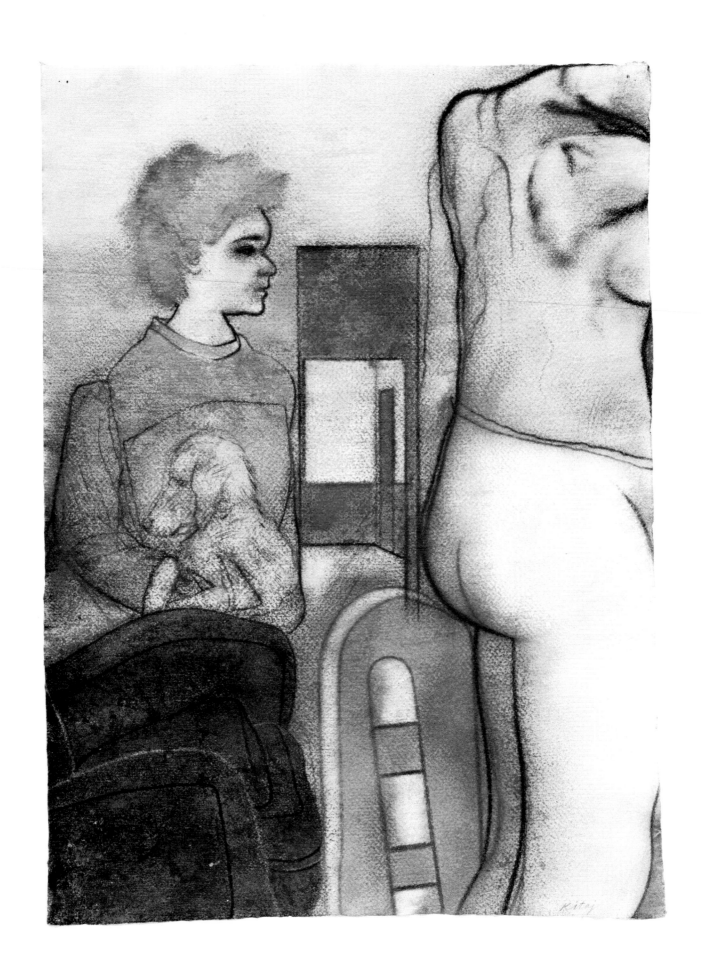

72 **Mother and Child,** 1978
Pastel on paper, 76.8 × 55.9 (30¼ × 22)
Private collection

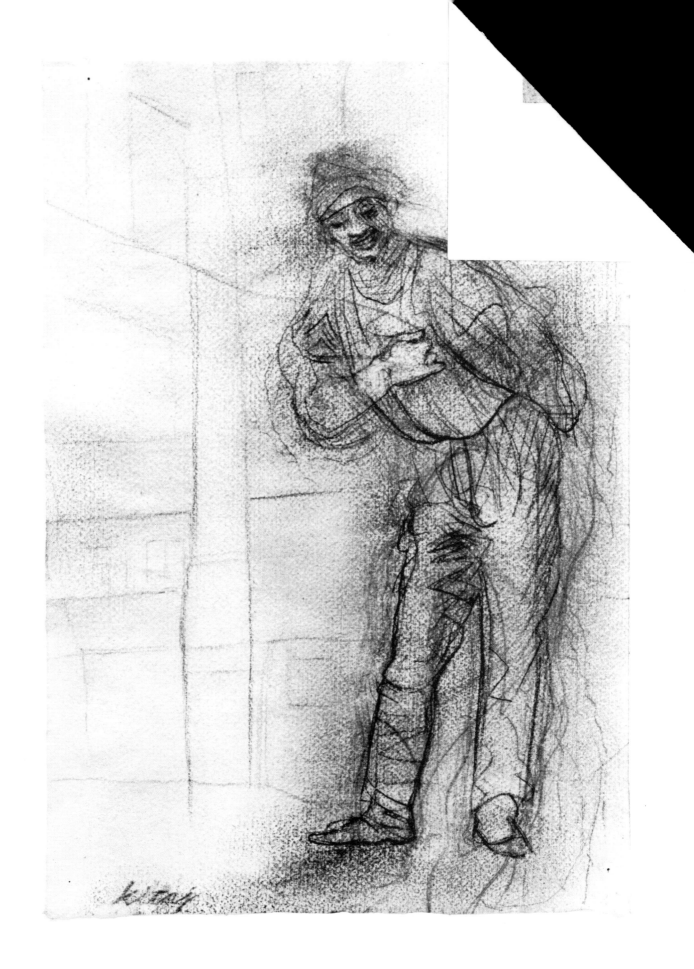

73 **New York Madman,** 1978
Pastel and charcoal on paper, 55.9 × 38.7 (22 × 15¼)
Private collection

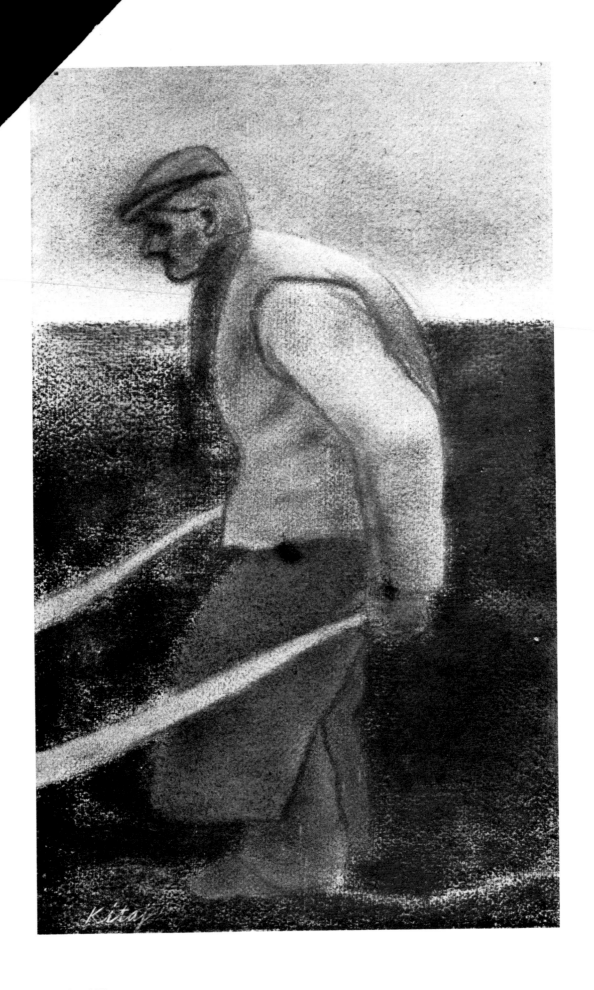

74 **Slovak,** 1978
Pastel and charcoal on paper, 56.8 × 35.2 (22⅜ × 13⅞)
Private collection

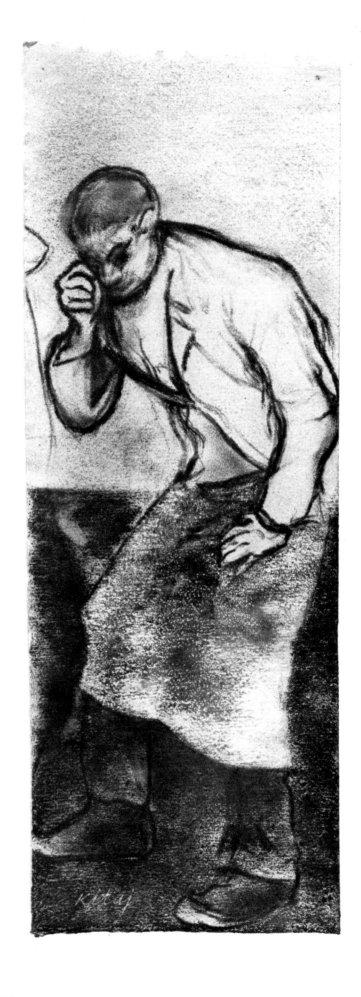

75 **The Yellow Apron,** 1978
Pastel and charcoal on paper, 78.4 × 28.9 (30⅞ × 11⅜)
Jonathan Silver Collection at Art and Furniture, Manchester, England

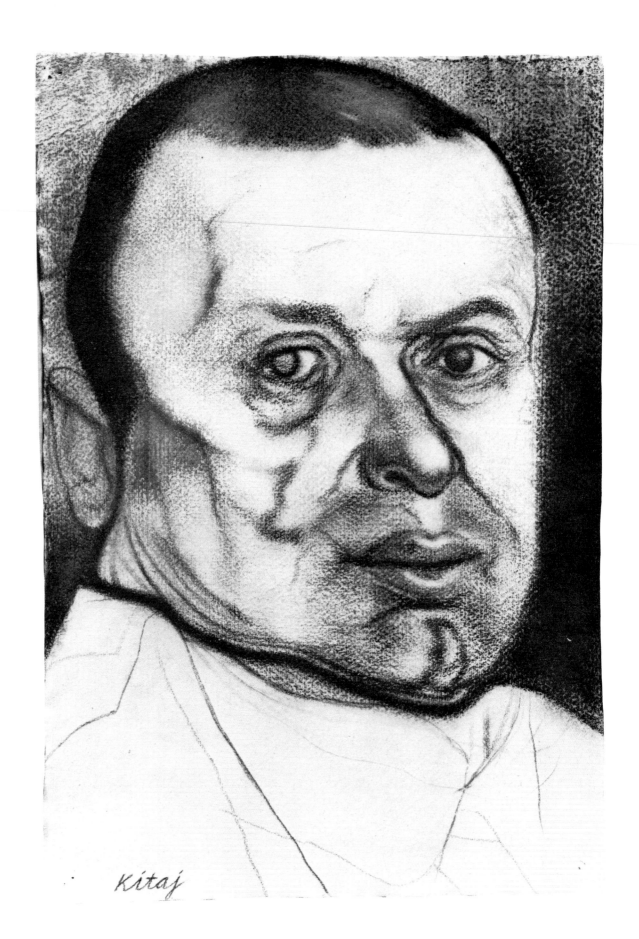

Kitaj

76 **Doctor Kohn,** 1978
Pastel and charcoal on paper, 55.9 × 38.1 (22 × 15)
Collection of the artist, London

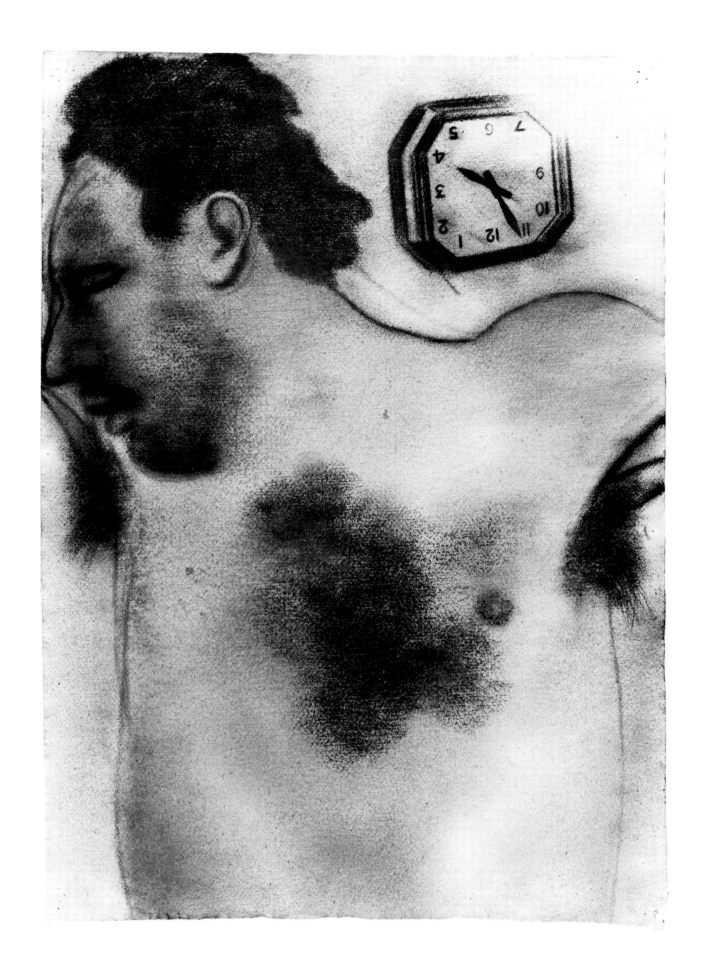

77 **Bad Faith (Chile),** 1978
Pastel and charcoal on paper, 76.8 × 57 (30¼ × 22½)
Jonathan Silver Collection at Art and Furniture, Manchester, England

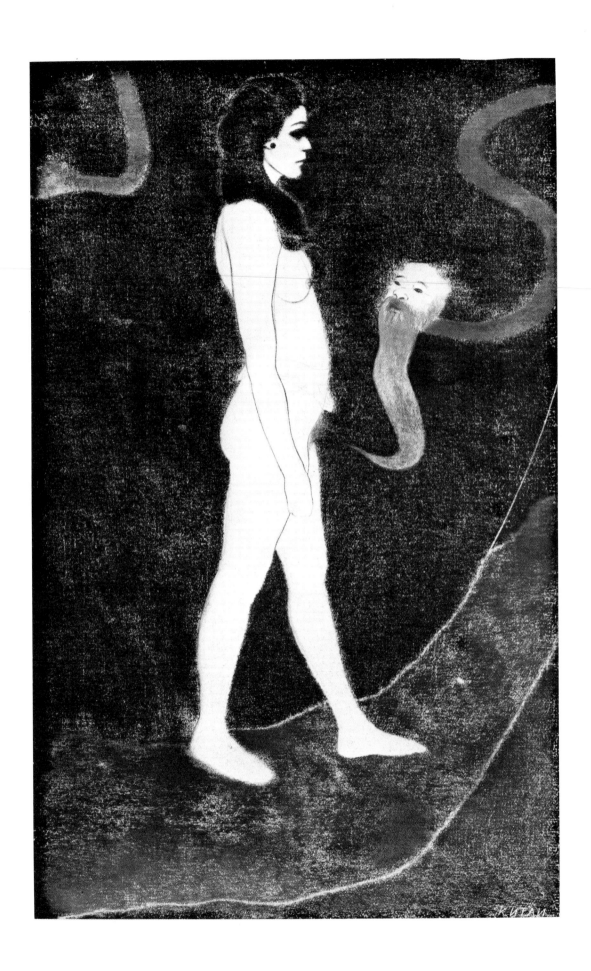

78 **The Symbolist,** 1978
Pastel and oil crayon on paper, 100 × 65 (39⅜ × 25½)
Private collection

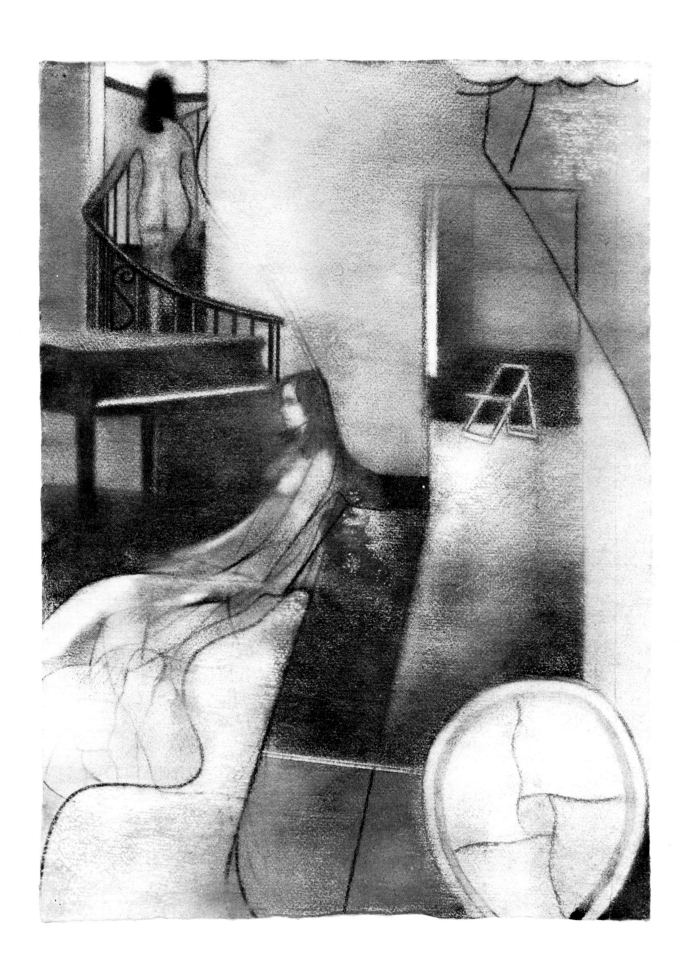

79 **The Philosopher—Queen,** 1978–79
Pastel and charcoal on paper, 76.8 × 55.9 (30¼ × 22)
Collection of the artist, London

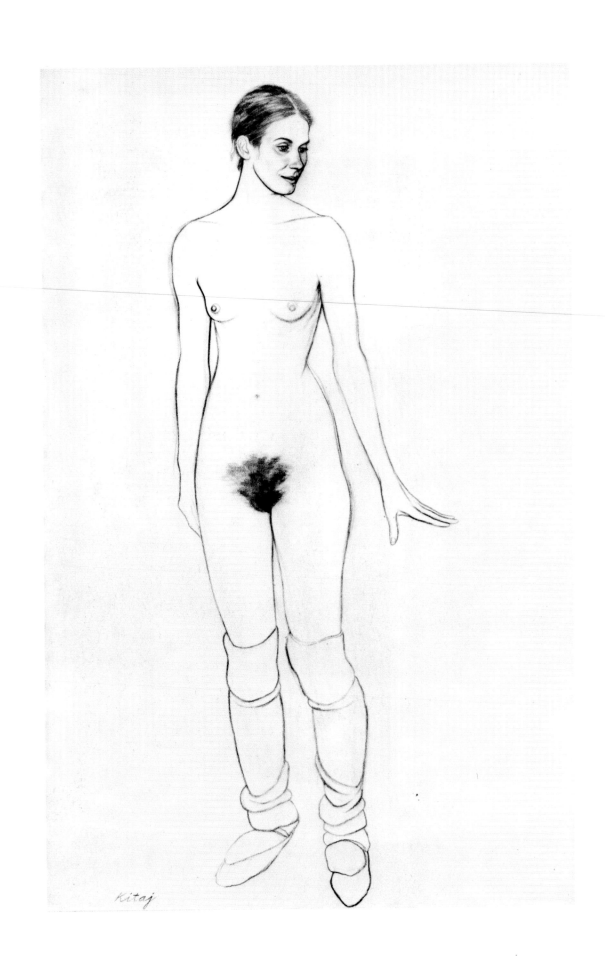

80 **The Dancer (Margaret),** 1979
Pencil on paper, 100 × 64.8 (39⅜ × 25½)
Private collection

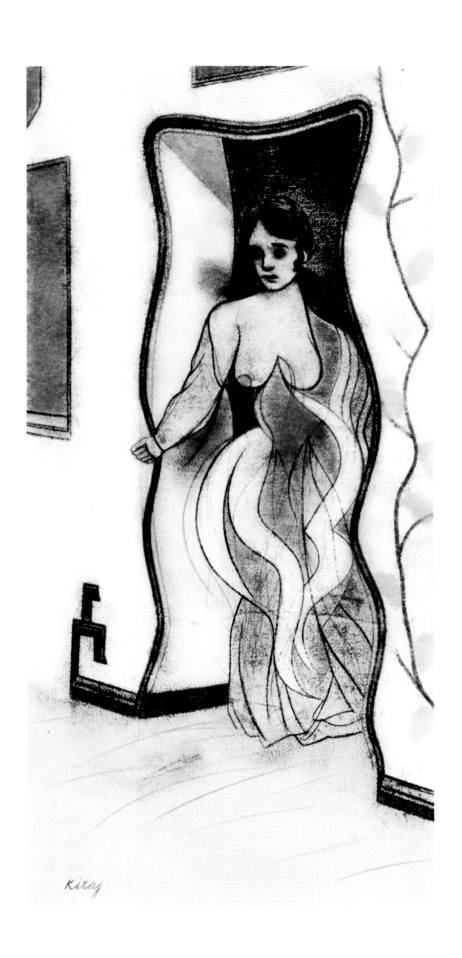

81 **Manchu Decadence,** 1979
Pastel on paper, 115 × 55.9 (45¼ × 22)
Private collection

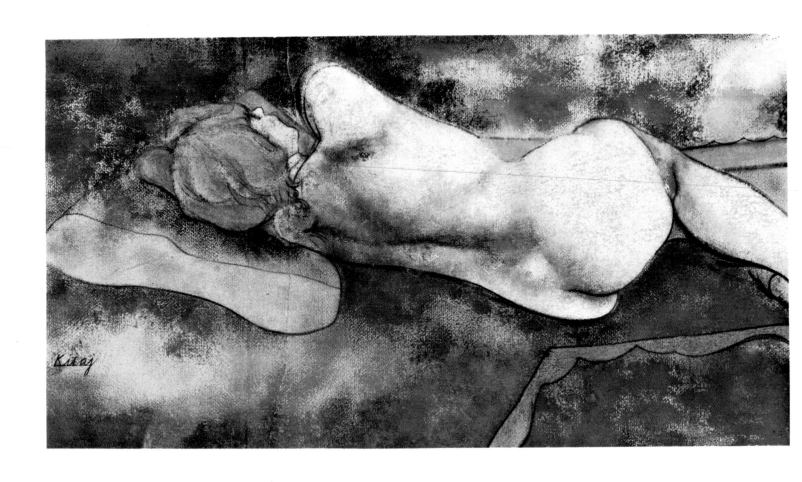

82 **Marynka,** 1979
 Pastel on paper, 56.5 × 106 (22¼ × 41¾)
 Private collection

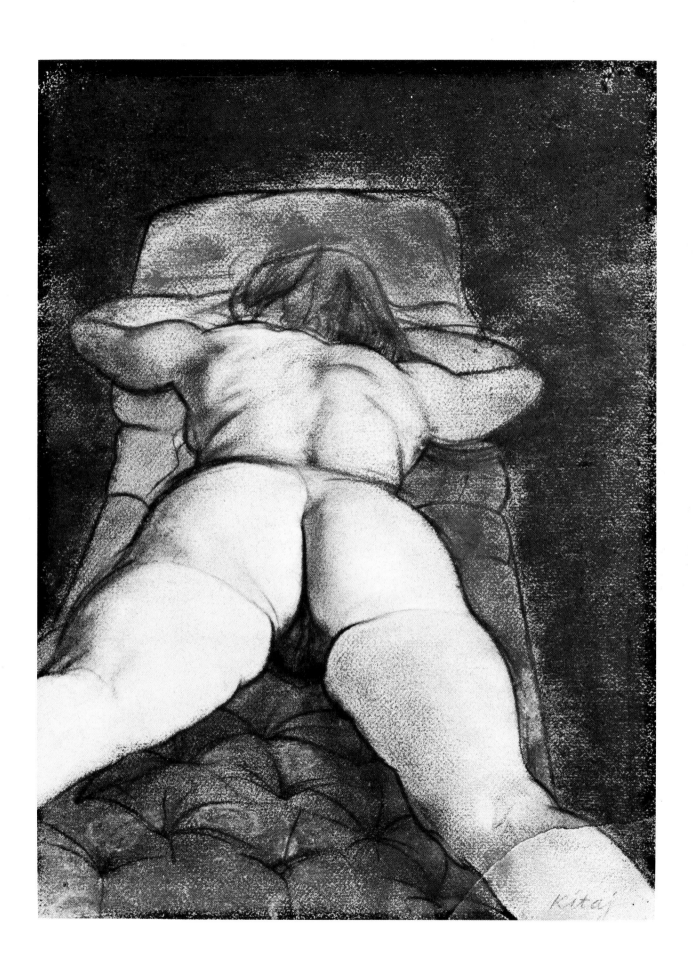

83 **Marynka on Her Stomach,** 1979
Pastel and charcoal on paper, 77.2 × 56.6 (30⅜ × 22¼)
Collection of the artist, London

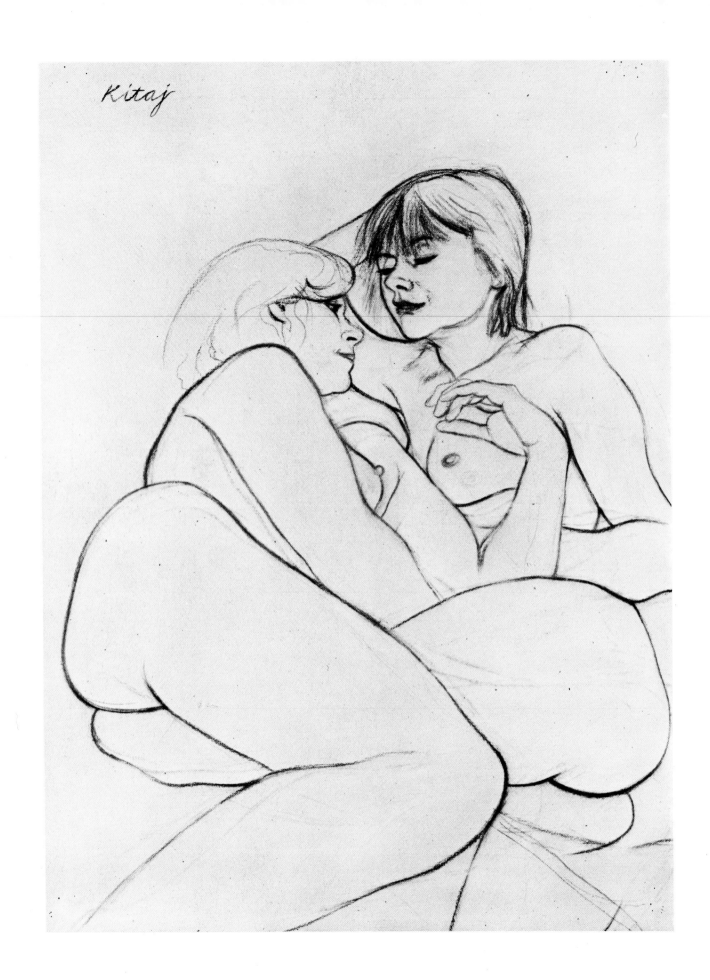

Kitaj

84 **Marynka and Janet,** 1979
Charcoal on paper, 77.2 × 56.6 (30⅜ × 22¼)
Collection of the artist, London

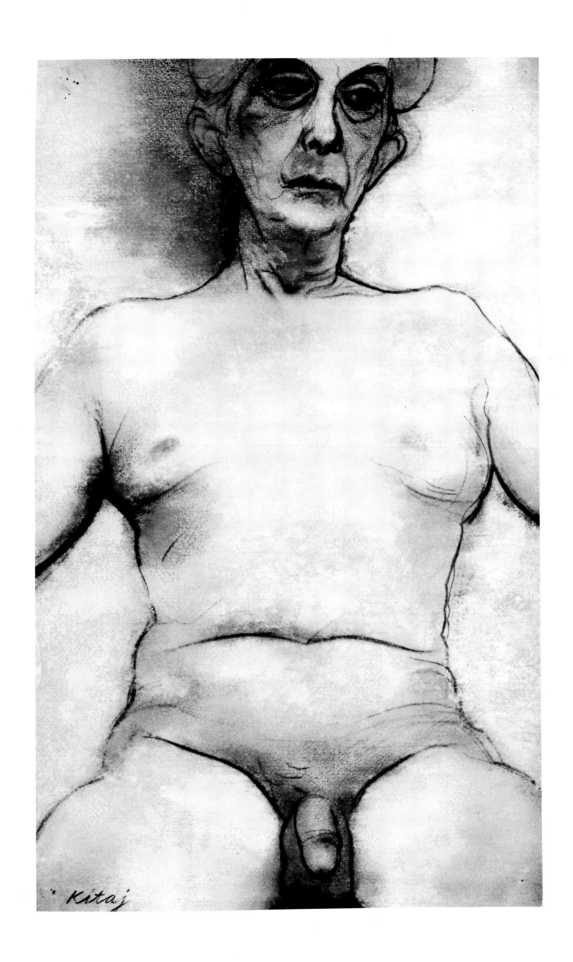

85 **Quentin,** 1979
Pastel and charcoal on paper, 65.4 × 40 (23¾ × 15¾)
Collection of the artist, London

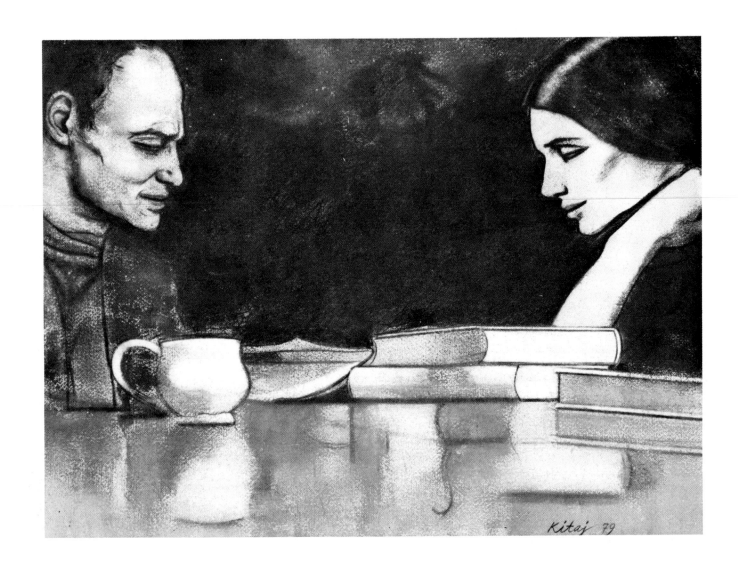

86 **Two London Painters: Frank Auerbach and Sandra Fisher,** 1979
Pastel and charcoal on paper, 55.9 × 76.8 (22 × 30¼)
Private collection

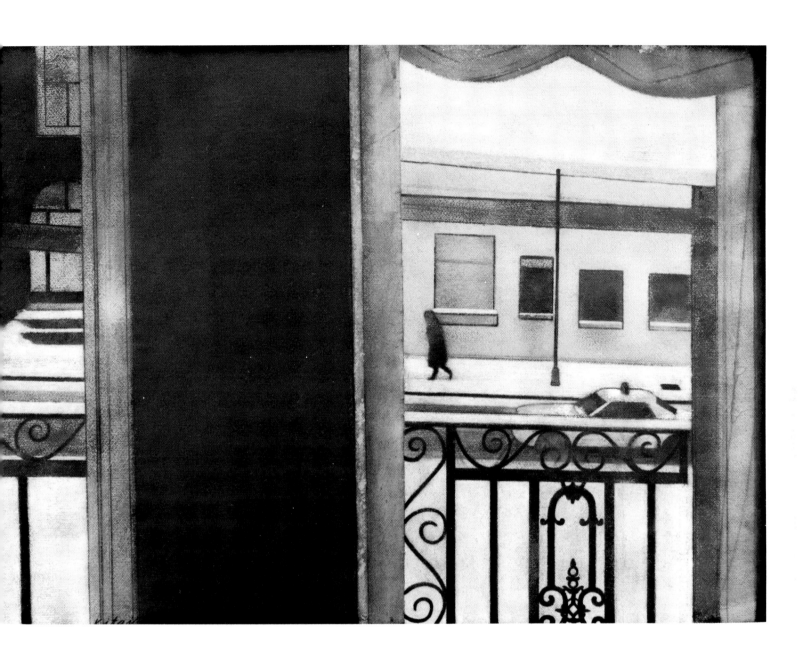

87 **Ninth Street under Snow,** 1979
Pastel on paper, 76.8 × 111.8 (30¼ × 44)
Odyssia Gallery, New York

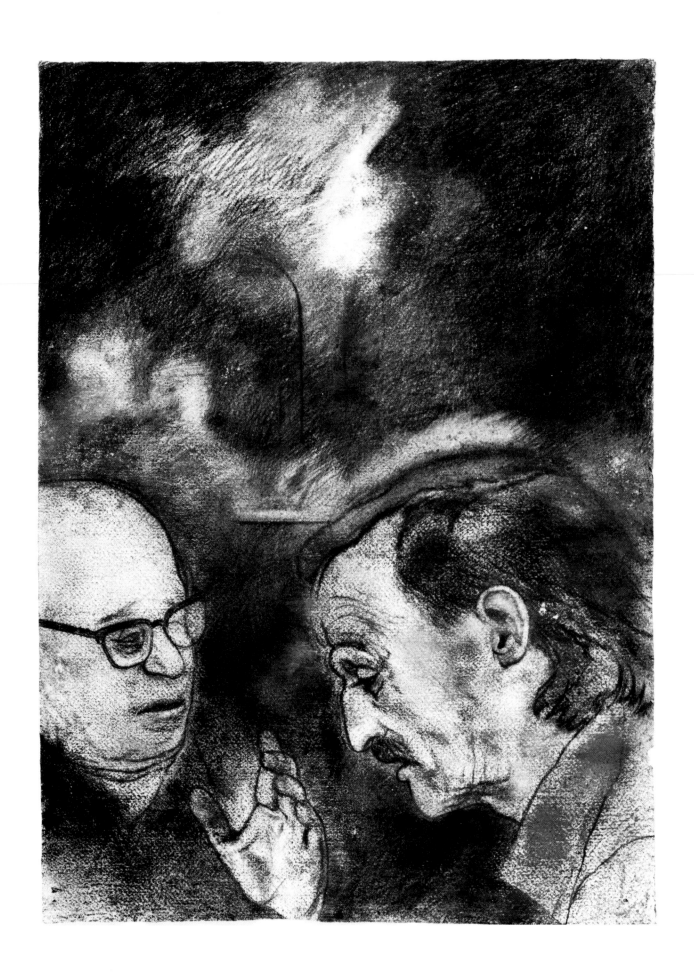

88 **Communist and Socialist (Second Version),** 1979
Pastel and charcoal on paper, 76.8 × 55.9 (30¼ × 22)
Collection of the artist, London

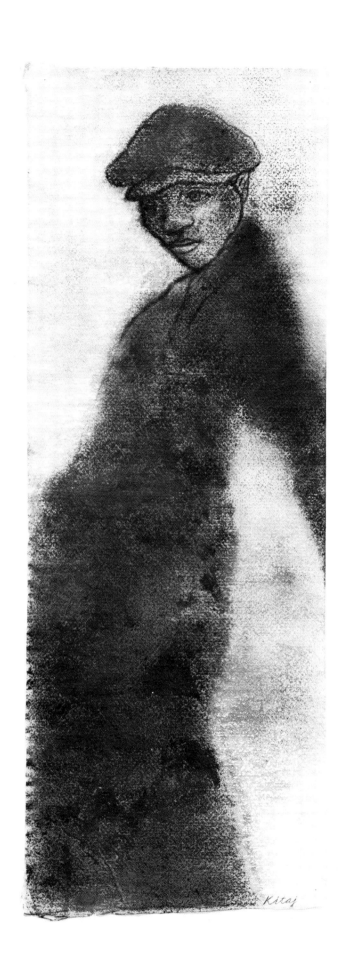

89 **Sixth Avenue Madman,** 1979
Pastel and charcoal on paper, 76.8 × 27.9 (30¼ × 11)
Private collection

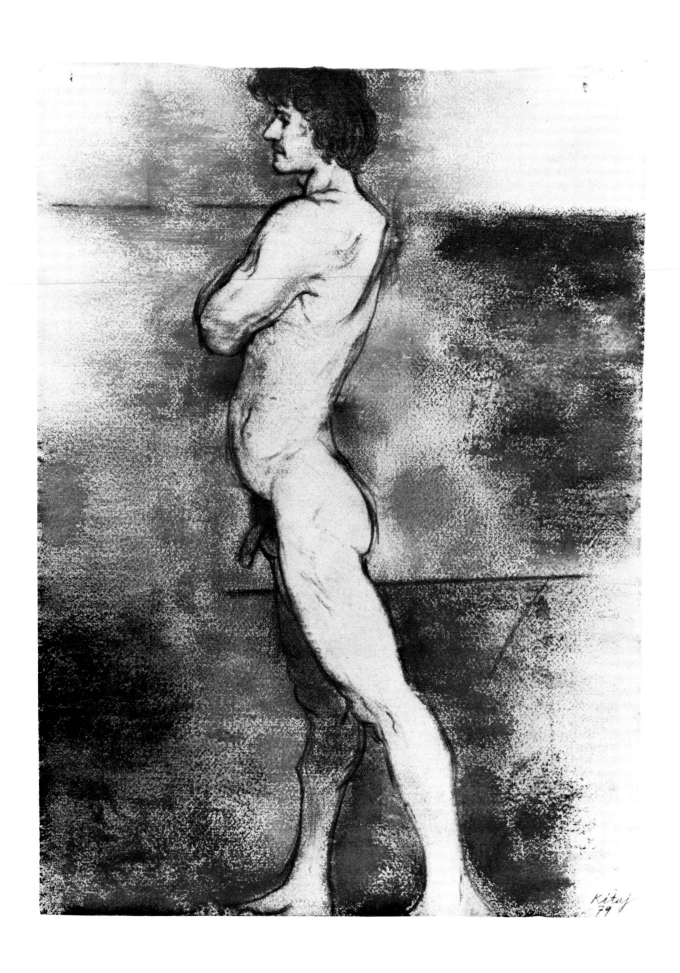

90 **Richard,** 1979
Pastel and charcoal on paper, 76.8 × 55.9 (30¼ × 22)
Private collection

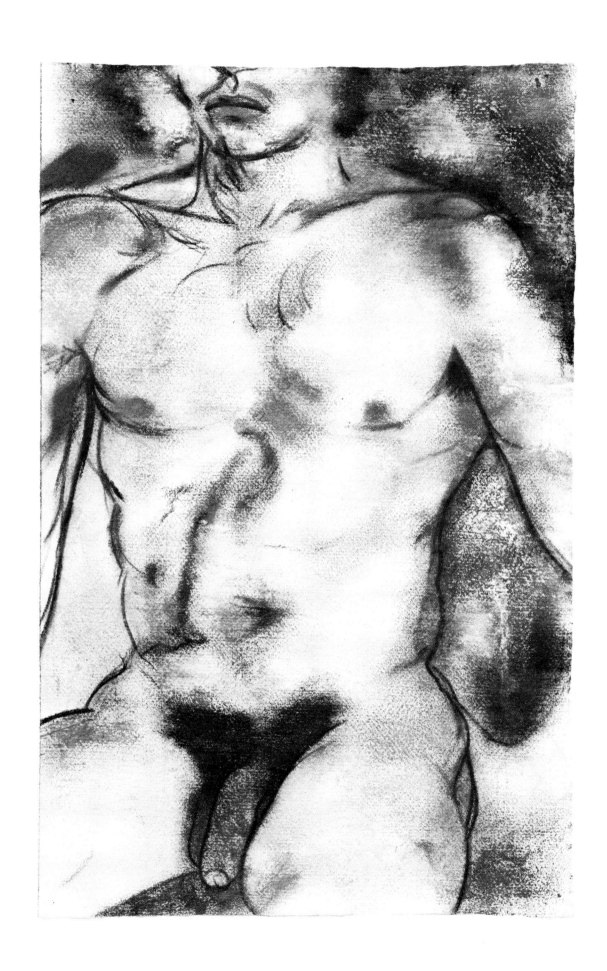

91 **Actor (Richard),** 1979
Pastel and charcoal on paper, 76.8 × 49.2 (30¼ × 19⅜)
Collection of the artist, London

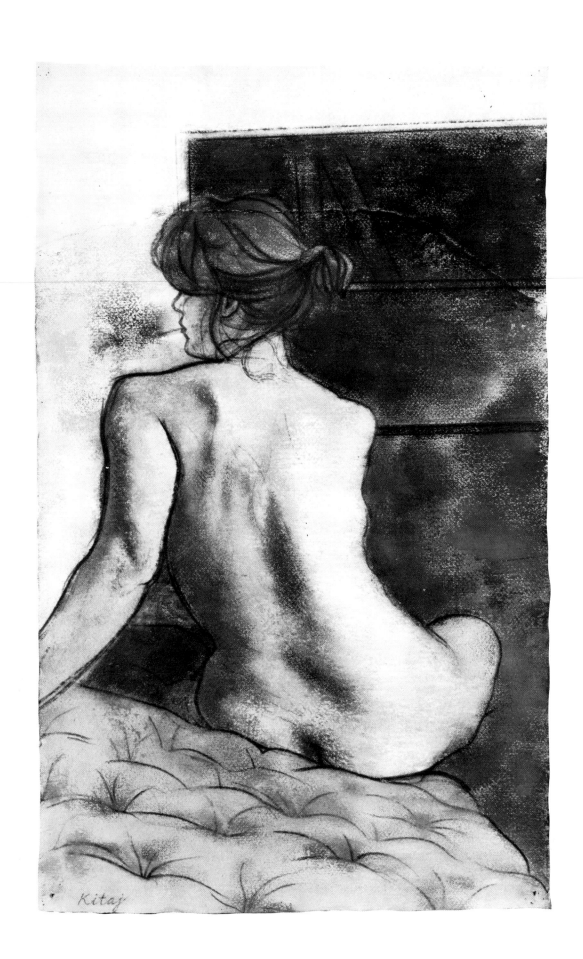

92 **Marynka Smoking,** 1980
Pastel and charcoal on paper, 90.8 × 56.5 (35¾ × 22¼)
Collection of the artist, London

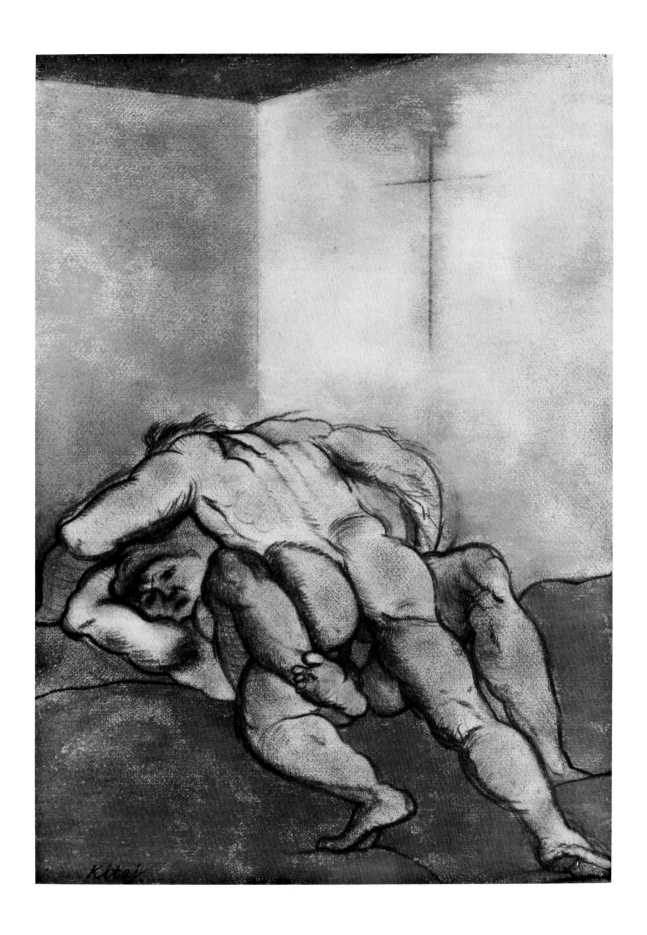

93 **Form and Content,** 1979
Pastel on paper, 73 × 52.1 cm
Marlborough Fine Art (London) Ltd.

94 **The Waitress,** 1980
Pastel and charcoal on paper, 77.5 × 69.8 (30½ × 27½)
Private collection

95 **Degas,** 1980
Pastel and charcoal on paper, 73 × 50.8 (28¾ × 20)
Collection of the artist, London

96 **Self-Portrait in Saragossa,** 1980
Pastel and charcoal on paper, 147.3 × 85.1 (58 × 33½)
Collection of the artist, London

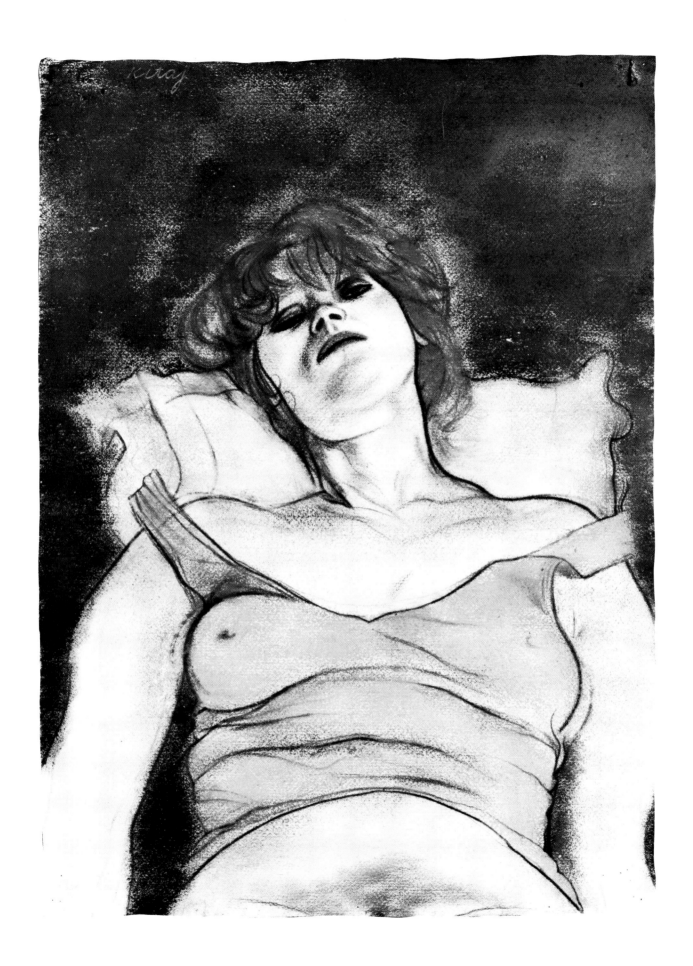

97 **Mary-Ann,** 1980
Pastel and charcoal on paper, 77.5 × 55.9 (30½ × 22)
Private collection

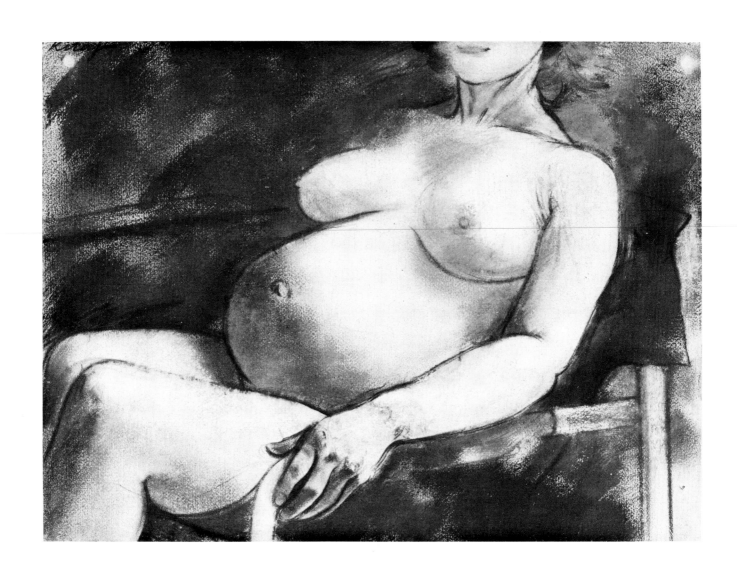

98 **Marynka Pregnant II,** 1981
Pastel and charcoal on paper, 56.5 × 77.2 cm
Marlborough Fine Art (London) Ltd.

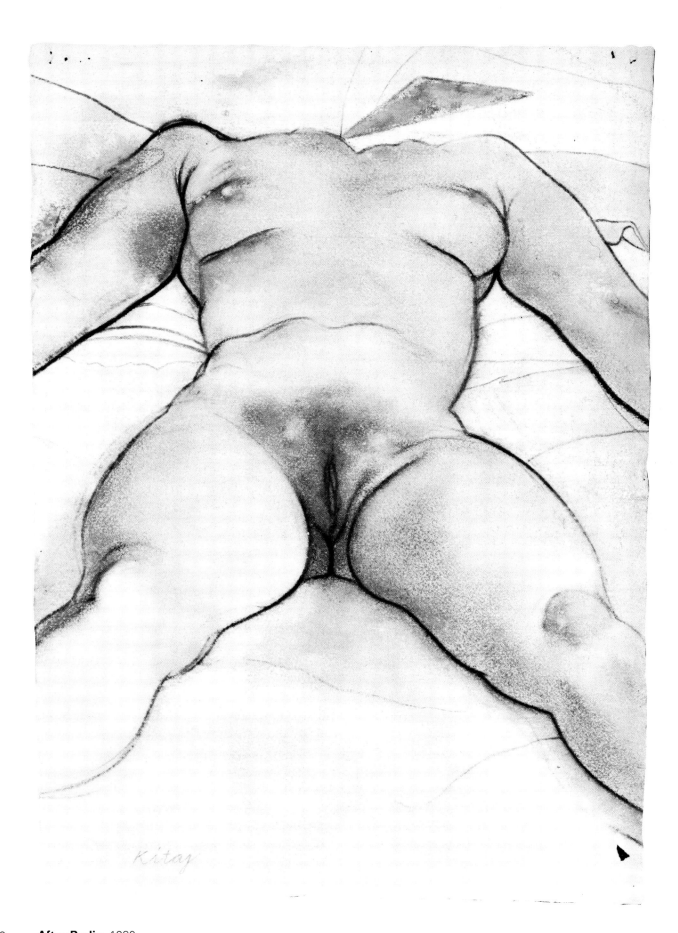

99 **After Rodin,** 1980
 Pastel and charcoal on paper, 77.5 × 57.2 (30½ × 22½)
 Collection of the artist, London

100 **Red Eyes,** 1980
Pastel and charcoal on paper, 76.2 × 55.9 (30 × 22)
Private collection

101 **Sacha and Gabriel,** 1981
Charcoal on paper, 72.2 × 56.5 cm
Marlborough Fine Art (London) Ltd.

102 **Bather (Psychotic Boy),** 1980
Pastel and charcoal on paper, 134 × 57.2 (52¾ × 22½)
Private collection

103 **Two Famous Writers,** 1980
Charcoal on paper, 151.1 × 55.9 (59½ × 22)
Collection of the artist, London

104 **The Listener (Joe Singer in Hiding),** 1980
Pastel and charcoal on paper, 103.2 × 108.2 (40⅝ × 42⅝)
Private collection

105 **Study for the Jewish School (Joe Singer as a Boy),** 1980
Pastel and charcoal on paper, 77.5 × 56.5 (30½ × 22¼)
Collection of the artist, London

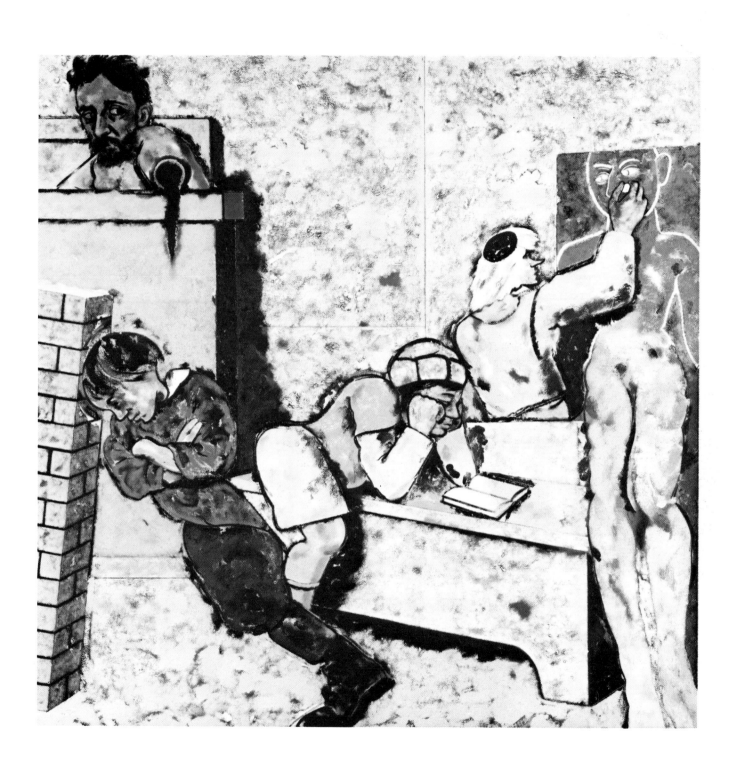

106 **The Jewish School (Drawing a Golem),** 1980
Oil on canvas, 152.4 × 152.4 (60 × 60)
Private collection

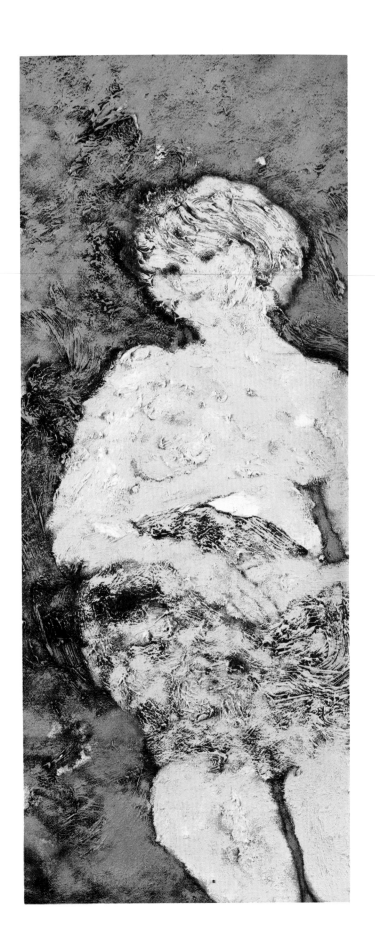

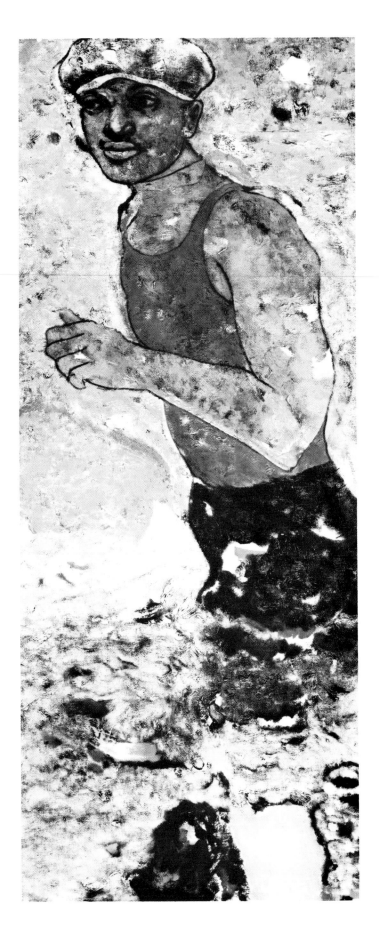

107 **Grey Girl,** 1981
Oil on canvas, 76.2 × 30.5 cm
Marlborough Fine Art (London) Ltd.

108 **The Sailor (David Ward),** 1979–80
Oil on canvas, 152.4 × 61 (60 × 24)
Private collection

Selected Exhibitions

Selected Bibliography

Selected Exhibitions

Exhibitions are arranged chronologically. Entries in brackets are unconfirmed.

Solo Exhibitions

ANNA BROOKE

1963 R. B. Kitaj: Pictures with Commentary, Pictures without Commentary, Marlborough New London Gallery, February–March 9, catalog, 22 works.

1965 R. B. Kitaj: Paintings, Marlborough-Gerson Gallery, New York, February 2–March 6, catalog, 70 works.

R. B. Kitaj: Paintings and Prints, Los Angeles County Museum of Art, August 11–September 12, catalog introduction by Maurice Tuchman, 40 works.

1967 Work of Ron Kitaj, Cleveland Museum of Art, March 7–April 2, checklist, 15 works.

Kitaj: Tekeningen en Serigrafiëen, Stedelijk Museum, Amsterdam, May 11–June 18, catalog introduction by John Russell, 49 works.

R. B. Kitaj, University of California, Berkeley, October 7–November 12, brochure, 29 works.

1969 R. B. Kitaj: Complete Graphics 1963–1969, Galerie Mikro, Berlin, May 10–June 15, catalog introduction by Werner Haftmann, 27 works (tour: Württembergischer Kunstverein, Stuttgart, July–August; Galerie van de Loo, Munich, September 12–October 25; Galerie Niepel, Düsseldorf, January 23–March 7, 1970; Overbeck Gesellschaft, Lübeck, March 22–April 19; Städtische Kunstmuseum, Bonn, May–June).

1970 R. B. Kitaj, Kestner-Gesellschaft, Hanover, January 23–February 22, catalog introduction by Wieland Schmied, 40 works (tour: Museum Boymans-van Beuningen, Rotterdam, February 28–April 5).

R. B. Kitaj: Pictures from an Exhibition Held at the Kestner-Gesellschaft, Hannover, and the Boymans Museum, Rotterdam, 1970, Marlborough New London Gallery, April 23(?)–May 23, catalog, 67(?) works.

1971 Kitaj, Graphics Gallery, San Francisco, April 1–May 1.

1973 R. B. Kitaj, In Our Time: Mappenwerk und Grafik aus den Jahren 1969–1973, Amerika Haus, Berlin, April 14–May 19, brochure text by R. B. Kitaj, 17 works.

1974 R. B. Kitaj: Pictures, Marlborough Gallery, New York, February 2–23, catalog introduction by Frederic Tuten, 28 works.

1975 R. B. Kitaj: Pictures, New 57 Gallery, Edinburgh, August 18–September 12, catalog, 29 works.

R. B. Kitaj: Lithographs, Petersburg Press, New York, September, checklist, 8 works.

1976 R. B. Kitaj: The Rash Act A, B1, B2, B3, Petersburg Press, March, checklist, 1 work, 4 states.

Ron B. Kitaj, Mala Galerija, Ljubljana, Yugoslavia, March 24–April 18, catalog text by R. B. Kitaj, 20 works.

1977 R. B. Kitaj: Graphics, Ikon Gallery, Birmingham, England, February, checklist, 42 works.

R. B. Kitaj: Pictures/Bilder, Marlborough Fine Art, London, April–June 4, catalog introduction by Robert Creeley, 47 works (tour: Marlborough Galerie, Zurich, June 14–July 22).

1978 R. B. Kitaj, Beaumont-May Gallery, Hopkins Center, Hanover, N.H., April 6–May 14, 21 works.

1979 R. B. Kitaj: Fifty Drawings and Pastels, Six Oil Paintings, Marlborough Gallery, New York, April 3–28, catalog introduction by Timothy Hyman, 50 works.

1980 *R. B. Kitaj: Pastels and Drawings,* Marlborough Fine Art, London, October 8–November 7, catalog introduction by Stephen Spender, 44 works.

Group Exhibitions

1958 *Young Contemporaries 1958,* RBA Galleries, London, February 19–March 10, catalog foreword by Michael Chalk, no. 92.

1960 *Young Contemporaries 1960,* RBA Galleries, March 14–April 2, catalog nos. 238–41.

1961 *Young Contemporaries 1961,* Royal College of Art, London, February 8–25, catalog preface by Peter Phillips, nos. 105–8.

 Recent Developments in Painting IV, Arthur Tooth & Sons, London, October 3–21, catalog, nos. 3, 11.

 The John Moores Liverpool Exhibition 1961, Walker Art Gallery, Liverpool, November 16–January 14, 1962, catalog preface by Walter Clark, no. 61.

1962 *Prizewinners of the John Moores Liverpool Exhibition 1961,* Institute of Contemporary Art, London, March 29–April 28, 1 work.

 European Community Contemporary Painting Exhibition Marzotto Award, Club Unione, Valdagno, September 8–30, catalog foreword by Edoardo Soprano, nos. 51, 52 (tour: Staatliche Kunsthalle, Baden-Baden, October 27–November 21; Stedelijk van Abbemuseum, Eindhoven, December 15–January 27, 1963; Whitechapel Art Gallery, London; Galerie Raymond Creuze, Paris, June 7–July 6, 1963).

 Kompass 2: Contemporary Paintings in London, Stedelijk van Abbemuseum, October 21–December 9, catalog text by Ronald Alley, nos. 41–45.

1963 *Towards Art?,* Arts Council Gallery, Cambridge, May 18–June 6, catalog introduction by Carel Weight, no. 30 (tour: Graves Art Gallery, Sheffield, June 15–July 6; Laing Art Gallery, Newcastle, July 13–August 3; Municipal College of Art, Bournemouth, August 10–31).

 British Painting in the Sixties, Tate Gallery and Whitechapel Art Gallery, London, June 1–30, catalog foreword by Whitney Straight, nos. 163–65.

 Premio internacional di pintura, Instituto Torcuato di Tella, Buenos Aires, August 12–September 8, catalog essay by Jorge Romero Brest.

 Dunn International: An Exhibition of Contemporary Painting Sponsored by the Sir James Dunn Foundation, Beaverbrook Art Gallery, Fredericton, New Brunswick, Canada, September 7–October 6, catalog preface by M. Beaverbrook, no. 42 (tour: Tate Gallery, November 15–December 22).

 The John Moores Liverpool Exhibition, Walker Art Gallery, November 14–January 12, 1964, catalog preface by Ben Shaw, no. 79.

1964 *Guggenheim International Award 1964,* Solomon R. Guggenheim Museum, New York, January 16–March 9, catalog introduction by Lawrence Alloway, no. 71 (tour: Honolulu Academy of Arts, May 14–July 5; Akademie der Künste, Berlin, August 21–September

5; National Gallery of Canada, Ottawa, October 5–November 9; John and Mable Ringling Museum of Art, Sarasota, Fla., January 16, 1965–March 14; Museo Nacional de Bellas Artes, Buenos Aires, April 20–May 20).

Study for an Exhibition of Violence in Contemporary Art, Institute of Contemporary Art, London, February 20–March 26.

Painting and Sculpture of a Decade 54–64, Tate Gallery, April 22–June 28, catalog preface by the Calouste Gulbenkian Foundation, nos. 340, 341, 341a, 341b.

Britische Malerei der Gegenwart, Kunstverein für die Rheinlande und Westfalen, Düsseldorf, May 25–July 5, catalog introduction by Ronald Alley, nos. 45, 46 (tour: Haus am Waldsee, Berlin, October 30–December 5).

XXXII Biennale, Venice, June 20–October 18, catalog introduction by G. A. Dell'Acqua, "Arte d'Oggi nei Musei: Tate Gallery, London" section, no. 7.

Nieuwe Realisten, Haags Gemeentemuseum, June 24–August 30, catalog essay by L. J. F. Wijsenbeek, nos. 130–33.

Documenta III: Malerei Skulptur, Alte Galerie, Museum Fridericianum, Orangerie im Auepark, Kassel, June 27–October 5, catalog introduction by Werner Haftmann, 4 works.

Pop, etc., Museum des 20 Jahrhunderts, Vienna, September 19–October 31, catalog foreword by Werner Hofmann, nos. 71–74.

Contemporary British Painting and Sculpture from the Collection of the Albright-Knox Art Gallery and Special Loans, Albright-Knox Art Gallery, Buffalo, New York, October 27–November 29, catalog preface by Samuel Clifford Miller, no. 58.

The 1964 Pittsburgh International Exhibition of Contemporary Painting and Sculpture, Museum of Art, Carnegie Institute, Pittsburgh, October 30–January 10, 1965, catalog foreword by Gustave von Groschwitz, no. 330.

Pick of the Pops, National Museum of Wales, Cardiff, November 7–December 13, brochure essay by John Ingamells, no. 16.

1965 *Pop Art; Nieuwe Figuratie; Nouveau Réalisme*, Palais des Beaux-Arts, Brussels, February 5–March 1, catalog text by Jean Dypréau, no. 72.

La figuration narrative dans l'art contemporain, Galerie Raymond Creuze, Paris, October 1–29, catalog text by Gérald Gassiot-Talabot, 1 work.

The English Eye, Marlborough-Gerson Gallery, New York, November–December, catalog introduction by Robert Melville and Bryan Robertson, nos. 42, 43.

[*Marlborough Prints*, Marlborough New London Gallery, November 16–December 23, catalog, nos. 21–25.]

John Moores Liverpool Exhibition, Walker Art Gallery, November 18–January 16, 1966, catalog, no. 40.

1965 Annual Exhibition of Contemporary American Painting, Whitney Museum of American Art, New York, December 8 –January 30, 1966, catalog, no. 68.

1966 *Nieuwe Stromingen in de Britse Grafiek*, Museum Boymans-van Beuningen, Rotterdam, April 6–May 22, catalog introduction by M. L. Wurfbain, nos. 43–49.

Five Americans in Britain, U.S.I.S., American Embassy, London, April 20–May 6, catalog introduction by Max Wykes-Joyce, nos. 32–41.

Seven Decades: 1895–1965; Crosscurrents in Modern Art, for the benefit of the Public Education Association, Cordier and Ekstrom, New York, April 26–May 21, catalog text by Peter Selz, no. 370.

Englische Graphik, Galerie der Spiegel, Cologne, May 28–June 28, catalog foreword by Helmut Leppien, 3 works.

Erotic Art, Sidney Janis Gallery, New York, October 3–29, catalog foreword by Sidney Janis, no. 10.

The First Flint Invitational, Flint [Mich.] Institute of Arts, November 4–December 31, catalog foreword by G. Stuart Hodge, no. 67.

1967 *Contemporary American Painting and Sculpture 1967*, Krannert Art Museum, Champaign, Ill., March 5–April 9, catalog essay by Allen S. Weller, no. 56.

Color, Image, and Form: An Exhibition of Painting and Sculpture Presented by the Friends of Modern Art of the Founders Society, Detroit Institute of Arts, April 11–May 21, catalog introduction by Gene Baro, nos. 38–40.

Visage de l'homme dans l'art contemporain, Musée Rath, Geneva, June 30–September 17, catalog text by Charles Goerg, no. 64.

Recent Acquisitions, Marlborough Fine Art, London, July–August, catalog, no. 12.

Amerikanische Druckgraphik: Eine neue Formensprache (New Expressions in Fine Printmaking), catalog foreword by Una E. Johnson, nos. 17, 18, circulated by the International Art Program, National Collection of Fine Arts, Smithsonian Institution, Washington, D.C., September 15, 1967–January 9, 1970.

Pictures to Be Read/Poetry to Be Seen, Museum of Contemporary Art, Chicago, October 24–December 3, catalog introduction by Jan van der Marck, nos. 42–48.

Pittsburgh International Exhibition of Contemporary Painting and Sculpture, Museum of Art, Carnegie Institute, October 27–January 7, 1968, catalog foreword by Gustave von Groschwitz, United States section, no. 273.

Recent British Painting: Peter Stuyvesant Foundation Collection, Tate Gallery, November 15–December 22, catalog introduction by Alan Bowness, no. 69.

John Moores Liverpool Exhibition 6, Walker Art Gallery, November 23–January 21, 1968, catalog preface by John Moores, no. 18.

Marlborough Graphics, Marlborough New London Gallery, December–January 15, 1968, catalog, nos. 53–60.

1967 Annual Exhibition of Contemporary Painting, Whitney Museum of American Art, December 13–February 4, 1968, catalog, no. 72.

Aawinsten uit het Stedelijk, Groninger Museum, The Netherlands, December 20–January 28, 1968, catalog, no. 6.

1968 *Ars multiplicata: Vervielfältigte Kunst seit 1945*, Kunsthalle, Cologne, January 13–April 15, catalog foreword by Gert von der Osten, nos. 226–29.

Social Comment in America, Museum of Modern Art Circulating Exhibition, brochure essay by Dore Ashton, no. 20 (tour: Lawrence University, Appleton, Wis., February 25–March 15; Andrew Dickson White Museum of Art, Cornell University, Ithaca, April 9–30; Museum of Art, Bowdoin College, Brunswick, Maine, June 13–July 7; Bloomsburg [Pa.] State College, September 22–October 31 (?); College of Wooster [Ohio], November 1–22; Municipal University of Omaha [Neb.], January 3–31, 1969; De Pauw University, Greencastle, Ind., February 21–March 16; Sloan Galleries of American Painting, Valparaiso [Ind.] University, April 8–28; Mankato [Minn.] State College, May 19–June 9).

Britische Kunst Heute, Kunstverein in Hamburg, March 30–May 12, catalog introduction by Hans Platte, no. 26.

American Paintings on the Market Today V, Cincinnati Art Museum, April 9–May 12, catalog introduction by Richard J. Boyle, no. 48.

The Obsessive Image 1960–1968, Institute of Contemporary Art, London, April 10–May 29, catalog essay by Mario Amaya, nos. 46, 47.

Junge Generation grossbritannien, Akademie der Künste, Berlin, April 28–June 9, catalog introduction by Alan Bowness, 6 works.

Paintings from the Albright-Knox Art Gallery, National Gallery of Art, Washington, D.C., May 19–July 21, catalog introduction by Gordon MacKintosh Smith, 1 work.

Graphik des XX Jahrhunderts: Neuer Werbungen des Berliner Kupferstichkabinetts 1958–1968, Kupferstichkabinett, Staatliche Museen Preussischer Kulturbesitz, Berlin, May 30–October 13, catalog foreword by Hans Möhle, no. 81.

From Kitaj to Blake: Non-Abstract Artists in Britain, Bear Lane Gallery, Oxford, June 8–29, checklist, nos. 27–32.

Critici Kiezen Grafiek, Gemeentemuseum, The Hague, June 15–August 4, catalog foreword by H. J. Reinink, nos. 249–52.

4. Documenta Internationale Ausstellung, Galerie an der Schönen Aussicht, Museum Fridericianum, Orangerie im Auepark, June 27–October 6, catalog one (painting and sculpture), essay by Werner Spies, 5 works; catalog two (graphics and objects), essay by Arnold Bode, 5 works.

Recent Acquisitions 1968, Marlborough Fine Art, London, July–August, catalog, no. 19.

Menschenbilder, Kunsthalle, Darmstadt, September 14–November 17, catalog foreword by L. Engel, no. 126.

British Printmakers, Konstfrämjandet, Stockholm, autumn, catalog introduction by Michael Compton, nos. 71–77.

Peintres européens d'aujourd'hui, Musée des Arts Décoratifs, Paris, September 27–November 17, catalog introduction by François Mathey, no. 50 (tour: Jewish Museum, New York, January 21–March 16, 1969; National Collection of Fine Arts, Washington, D.C., April 9–June 1; Museum of Contemporary Art, Chicago, July 5–September 8; High Museum of Art, Atlanta, September 28–October 26; Dayton [Ohio] Art Institute, November 17–December 14).

Prints from London: Hamilton/Kitaj/Paolozzi/Tilson, Walker Art Center, Minneapolis, October 2–November 10, brochure introduction by Christopher Finch, nos. 15–20 (tour: Santa Barbara [Calif.] Museum of Art, March 21–April 20, 1969; Akron [Ohio] Art Institute, July 2–August 3; J. B. Speed Art Museum, Louisville, Ky., September 7–October 5; Colorado Springs Fine Arts Center, November 2–30; Krannert Art Museum, Champaign, Ill., February 8–March 1, 1970; Cranbrook Academy of Art/Museum, Bloomfield Hills, Mich., March 15–April 12).

6e International Biennale of Prints, National Museum of Modern Art, Tokyo, November 2–December 15, catalog preface by Nobusuke Kishi, 2 works (tour: National Museum of Modern Art, Kyoto, January 4–February 16, 1969).

British International Print Biennale, Bradford [England] City Art Gallery and Museum, November 23–January 19, 1969, catalog introduction by Rosemary Simmons, nos. 354, 355.

1969 *Ars '69*, Ateneumin Taidemuseo, Helsinki, March 8–April 13, catalog introduction by Anne Lindström, no. 79 (tour: Nykytaiteen Museo and Tampereen Taidemuseo, Tampere, April 20–May 11).

Arts Council Collection 1967–68: Paintings Bought by Alan Bowness and Robyn Denny, catalog introduction by Alan Bowness, no. 12, circulated by the Arts Council of Great Britain (tour: Birmingham Museum and Art Gallery, April 19–May 10; Laing Art Gallery and Museum, Newcastle, June 14–July 5; Museum of Modern Art, Oxford, July 12–August 2; City of Bristol Museum and Art Gallery, August 9–23; Southampton City Art Galleries and Museum, September 6–27; Oldham Art Galleries and Museum, October 4–25; Winchester School of Art, November 1–22; Reading Museum and Art Gallery, November 29–December 27; Royal Albert Memorial Museum, Exeter, January 3–24, 1970; Royal Institution of Cornwall County Museum and Art Gallery, Truro, January 31–February 21; Art Gallery and Museum, Folkestone, April 25–May 16; Castle Museum, Norwich, June 20–July 11; Gordon Maynard Gallery, Welwyn Garden City, August 15–September 5; Huddersfield Art Gallery, October 10–31; Nottingham University Art Gallery, November 7–28; City Art Gallery, York, December 5–January 2, 1971).

A Selection of 20th Century British Art, Cunard Marlborough London Gallery on board *Queen Elizabeth II*, May, catalog, 3 works.

Mednarodna grafična Razstava, Moderne Galerija, Ljubljana, Yugoslavia, June 6–August 31, catalog foreword by Miha Košak, no. 306.

Grafiek van Gene Davis, R. B. Kitaj, E. Paolozzi, Museum Boymans-van Beuningen, Rotterdam, June 15–August 3, catalog nos. 13–24.

Information: Tilson, Phillips, Jones, Paolozzi, Kitaj, Hamilton, Kunsthalle Basel, June 15–July 20, catalog preface by Peter F. Althaus, nos. 44–56 (tour: Badischer Kunstverein, Karlsruhe, August 1–September 14).

Pop Art, Hayward Gallery, London, July 9–September 3, catalog introduction by John Russell and Suzi Gablik, no. 78.

The Gosman Collection: Forty-five Paintings from the Collection of Dr. and Mrs. Joseph Gosman of Toledo, Ohio, Art Gallery, University of Pittsburgh Department of Fine Arts, September 14–October 10, catalog text by Aaron Sheon, no. 24.

109 Obras de Albright-Knox Art Gallery, Museo Nacional de Bellas Artes, Buenos Aires, October 23–November 30, catalog introduction by Gordon M. Smith, no. 62.

1970 *Zeitgenossen: Das Gesicht unserer Gesellschaft im Spiegel der heutigen Kunst*, Städtische Kunsthalle Recklinghausen, West Germany, May 6–July 16, catalog foreword by Thomas Grochowiak, no. 111.

Kunst und Politik, Badischer Kunstverein, May 31–August 16, catalog preface by G. Bussmann, nos. 64–68 (tour: Kunsthalle Basel, January 24–February 21, 1971).

Kelpra Prints, Hayward Gallery, June 17–July 7, catalog introduction by Ronald Alley, nos. 23, 36–40, 64–78, 83–95.

Keuze uit de Verzameling van het Stedelijk Museum, Stedelijk Museum, Amsterdam, summer, catalog foreword by E. de Wilde, nos. 319, 807.

XXXV Biennale, Venice, June 24–October 25, catalog introduction by Umbro Apollonio, United States section, nos. 31, 32.

Pop Art, Nieuwe Figuratie, Nouveau réalisme, Gemeentelijk Casino, Knokke, Belgium, June 27–September 9, catalog essay by John Russell, nos. 64, 65.

Contemporary British Art, National Museum of Modern Art, Tokyo, September 9–October 25, catalog introduction by Andrew Causey, 3 works.

Inaugural Exhibition: 19th and 20th Century Art from Collections of Alumni and Friends, Elvehjem Art Center, University of Wisconsin, Madison, September 11–November 8, catalog introduction by Arthur R. Blumenthal, no. 129.

3→∞: New Multiple Art, Whitechapel Art Gallery, London, November 19–January 13, 1971, catalog essay by Janet Daley, nos. 299–304.

1971 *Expo Stedelijk*, Ateneumin Taidemuseo, April 1–May 9, catalog text by E. de Wilde, no. 69.

Vår tids scenebilde, Sonja Henie og Niels Onstads Kunstsenter, Høvikodden, Norway, April 17–June 6, catalog, 1 work.

De Metamorfose van het Object: Kunst en anti-Kunst 1910–1970, Musées Royaux des Beaux-Arts de Belgique, Brussels, April 22–June 6, catalog essay by Werner Haftmann, no. 117 (tour: Museum Boymans-van Beuningen, June 25–August 15; Nationalgalerie, Berlin, September 11–November 7; Palazzo Reale, Milan, December 15–February 10, 1972; Kunsthalle Basel, March 4–April 22; Musée des Arts Décoratifs, May–June).

Art and Technology, Los Angeles County Museum of Art, May 11–August 29, report introduction by Maurice Tuchman, 20 illustrations.

Kunst des 20 Jahrhunderts, Städtische Kunsthalle Düsseldorf, June 25–August 15, catalog, no. 107.

The Artist as Adversary: Works from the Museum Collection, Museum of Modern Art, New York, July 1–September 27, catalog introduction by Betsy Jones, nos. 152, 153.

Graphik der Welt; Internationale Druckgraphik der letzten 25 Jahre, Kunsthalle, Nuremberg, August 28–November 28, catalog text by Wolf Stubbe, nos. 287–99.

Celebrate Ohio, Akron Art Institute, September 27–November 7, catalog foreword by Orrel E. Thompson, 7 works.

Stedelijk '60–'70: Les collections 1960–1970, Palais des Beaux-Arts, Brussels, Art étranger, October 20–November 21, catalog introduction by E. de Wilde, no. 24.

Oversize Prints, Whitney Museum of American Art, November 2–December 12, catalog introduction by Elke M. Solomon, no. 16.

Silkscreen: History of a Medium, Philadelphia Museum of Art, December 17–February 27, 1972, brochure essay by Richard S. Field, nos. 129–33.

1972 *Amerikanische Graphik seit 1960*, Büdner Kunsthaus, Chur, May 6–June 18, catalog fore-word by Hans Hartmann, nos. 76–78 (tour: Kunstverein Solothurn, August 26–September 24; Musée d'Art et d'Histoire, Geneva, October 5–November 5; Kunsthaus Aarau, January 26, 1973–February 25; Ulmer Museum, April 1–May 12; Städelsches Kunstinstitut, Frankfurt, May 26–July 8; Kunsthalle Bremen, July 20–September 2; Kunsthalle Basel, January 19, 1974–March 17).

Third British International Print Biennale, Bradford City Art Gallery, July–September, catalog foreword by John Thompson, no. 497.

Contemporary Art: The Collection of Dr. and Mrs. Joseph Gosman, University of Michigan Museum of Art, Ann Arbor, September 13–October 15, catalog introduction by Charles H. Sawyer, no. 19.

1973 *Amerikanische und englische Graphik der Gegenwart*, Staatsgalerie Stuttgart, February 17–March 18, catalog foreword by Gunther Theim, nos. 37–39d.

Selection 3: Contemporary Graphics from the Museum's Collection, Rhode Island School of Design, Providence, April 5–May 6, catalog introduction by Diana Johnson, no. 33.

Dine, Kitaj, Cincinnati Art Museum, April 12–May 13, catalog essay by Richard J. Boyle, nos. 18–45.

Selected European Masters of the 19th and 20th Centuries, Marlborough Fine Art, London, June 16–September 7, catalog, no. 34.

Hommage à Picasso, Nationalgalerie, Berlin, July 11–August 27, catalog essay by Werner Haftmann, 1 work, circulated by Propyläen Verlag (tour: six European locations).

A Selection of American and European Paintings from the Richard Brown Baker Collection, San Francisco Museum of Art, September 14–November 11, catalog essay by Suzanne Foley, no. 30 (tour: Institute of Contemporary Art, University of Pennsylvania, Philadelphia, December 7–January 27, 1974).

1974 *Contemporary British Painters and Sculptors*, Lefevre Gallery, London, April 18–May 18, catalog, nos. 17, 18.

Mini-retrospective of Graphics by Eduardo Paolozzi, Victor Pasmore, Tom Phillips, R. B. Kitaj; Fünfte Internationale Kunstmesse Basel, Marlborough Graphics Stand, Hallen der Schweizer Mustermesse, Basel, June 19–24, catalog foreword by Frederic P. Walthard.

Masterpieces of the 19th and 20th Centuries, Marlborough Fine Art, London, summer.

Fourth British International Print Biennale, Bradford City Art Gallery and Museum, July–September, catalog, no. 161.

British Painting '74, Hayward Gallery, September 26–November 17, catalog introduction by Andrew Forge, nos. 117, 118.

1975 *The British Are Coming! Contemporary British Art*, De Cordova Museum, Lincoln, Mass., April 12–June 8, catalog essay by Eva Jacob, nos. 37–39.

Basel Art Fair 1975: Dine, Johns, Kitaj, Hockney, Moore . . ., Petersburg Press, New York, July 7–August 29, 5 works.

European Painting in the Seventies: New Work by Sixteen Artists, Los Angeles County Museum of Art, September 30–November 23, catalog introduction by Maurice Tuchman, nos. 47–50 (tour: St. Louis Art Museum, March 16–May 9, 1976; Elvehjem Art Center, June 8–August 1).

1976 *Arte inglese oggi 1960–76*, Palazzo Reale, Milan, February–May, catalog introduction by Guido Ballo, 7 works.

Pop Art in England: Anfänge einer neuen Figuration 1947–63/Beginnings of a New Figuration 1947–63, Kunstverein in Hamburg, February 7–March 21, catalog text by Uwe Schneede, nos. 43–47 (tour: Städtische Galerie im Lenbachhaus, Munich, April 3–May 16; York City Art Gallery, May 29–July 11).

John Moores Liverpool Exhibition 10, Walker Art Gallery, May 6–August 8, catalog preface by John Moores, no. 11.

Peter Blake, Richard Hamilton, David Hockney, R. B. Kitaj, Eduardo Paolozzi, Museum Boymans-van Beuningen, May 20–July 4, catalog introduction by Toni del Renzio, nos. 66–84.

[*Summer Exhibition: Important Works by Contemporary Artists*, Marlborough Fine Art, London, June 10–July 31.]

The Human Clay: An Exhibition Selected by R. B. Kitaj, Hayward Gallery, August 5–30, catalog introduction by R. B. Kitaj, no. 61, circulated by the Arts Council of Great Britain and the British Council (tour: Gardner Centre Gallery, University of Sussex, Brighton, September 28–October 28; Preston Polytechnic, November 16–December 11; Leeds Polytechnic, February 5–27, 1977; Middlesbrough Art Gallery, March 5–26; Scottish National Gallery of Modern Art, Edinburgh, April 2–May 2; Carlisle Museum and Art Gallery, May 7–June 5; Derby Museum and Art Gallery, June 11–July 9; Ikon Gallery, Birmingham, July 16–August 6; Bangor Museum and Art Gallery, University College of North Wales, August 13–September 11; Herbert Art Gallery and Museum, Coventry, September 17–October 16; Sainsbury Center for Visual Arts, University of East Anglia, Norwich, October 22–November 20; Palais des Beaux-Arts, Charleroi, Belgium, December 10–January 8, 1978; Provinciaal Museum, Hasselt, Belgium, February 10–March 5).

Recent Work: Arikha, Auerbach, Bacon, Botero, Genovés, Grooms, Katz, Kitaj, Lopez-Garcia, Rivers, Marlborough Gallery, New York, November 30–December 31, catalog, 2 works.

1977 *1977 Hayward Annual*, Hayward Gallery, part 1: May 25–July 4, part 2: July 20–September 4, catalog introduction by Michael Compton; Kitaj's work appeared in part 2, nos. 159–71.

Papiers sur nature: Festival d'automne à Paris 77, Fondation National pour les Arts Graphiques et Plastiques, Paris, October 14–November 27, catalog essay by Jean Clair, nos. 87–92.

1978 *The Mechanised Image: An Historical Perspective on 20th Century Prints*, catalog text by Pat Gilmour, no. 215, circulated by the Arts Council of Great Britain (tour: Portsmouth City Museum and Art Gallery, February 25–April 9; Graves Art Gallery, Sheffield, April 22–June 4; Ferens Art Gallery, Kingston-upon-Hull, June 17–July 30; Camden Arts Centre, London, August 17–September 24; Hatton Gallery, University of Newcastle upon Tyne, October 7–November 19; Aberdeen Art Gallery and Museum, December 2–January 13, 1979; Ulster Museum, Belfast, February 15–March 25).

20th Century Portraits, National Portrait Gallery, London, June 9–September 17, catalog introduction by Robin Gibson, no. 42.

1979 *Lives: An Exhibition of Artists Whose Work Is Based on Other People's Lives*, Serpentine Gallery, London, March 7–April 1, catalog introduction by Derek Boshier, 1 work.

Verbiage: An Exhibition of Words, Cambridge University, Kettle's Yard, Cambridge, May 12–June 10, catalog, five artist's proofs.

[*Narrative Paintings*, Arnolfini, Bristol, September 1–October 20 (tour).]

SI/25: A Sports Illustrated Retrospective, Spectrum Fine Art, New York, October 3–November 2, catalog introduction by Bill Goff, no. 48.

This Knot of Life: Paintings and Drawings by British Artists, L.A. Louver Gallery, Venice, Calif., part 2, November 27–December 22, catalog foreword by Peter Goulds, 6 works.

1980 *The Artist's Eye: An Exhibition Selected by R. B. Kitaj*, National Gallery, London, May 21–July 21, catalog introduction by R. B. Kitaj, nos. 35, 36.

Kelpra Studio: An Exhibition to Commemorate the Rose and Chris Prater Gift, Tate Gallery, July 9–August 25, catalog introduction by Pat Gilmour, nos. 106–20.

The First Twenty Years of the Scottish National Gallery of Modern Art, Scottish National Gallery of Modern Art, Edinburgh, August 8–September, 1 work.

Obra gràfica britànica, Fundació Joan Miró, Barcelona, September 18–October 26, catalog introduction by Julie Lawson, no. 48.

1981 *A New Spirit in Painting*, Royal Academy of Arts, London, January 15–March 18, catalog essay by Christos M. Joachimides, nos. 73–76.

Drawings and Watercolors by 13 British Artists, Marlborough Fine Art, London, March–April, catalog, nos. 22–24.

Drawings from Georgia Collections: 19th and 20th Centuries, High Museum of Art, Atlanta, May 14–June 28, catalog foreword by Peter Morrin and Eric Zafran, no. 96 (tour: Georgia Museum of Art, Athens, July 12–August 23).

Selected Bibliography

Entries are arranged chronologically. Exhibition catalogs are listed under Selected Exhibitions.

Writings, Interviews, and Films

ANNA BROOKE

Kitaj, R. B. "Two Paintings with Notes." *Gazette* (London) 2 (1961): 3.

Kitaj, R. B. "Round the Art Galleries [letters to the editor]." *Listener* (London) 69 (February 28, 1963): 383.

Kitaj, R. B. "On Associating Texts with Paintings." *Cambridge Opinion* 37 (January 1964): 52–53.

Kitaj, R. B., and Finch, Christopher, narrators; Scott, James, director. *R. B. Kitaj* (film). London, Arts Council of Great Britain, 1967.

Glazebrook, Mark. "Why Do Artists Make Prints? Answers by Printmakers to Questions Put by Mark Glazebrook." *Studio International* 173 suppl. (June 1967): 1–3.

Kitaj, R. B. "Mainly about Using Photos: Re: The Prints." *Art and Artists* 4 (November 1969): 25.

Moore, Ethel, ed. "Letters from 31 Artists to the Albright-Knox Art Gallery." *Gallery Notes* 31–32 (Spring 1970): 18.

McNay, Michael. "R. B. Kitaj in an Interview with Michael McNay." *Manchester Guardian*, May 8, 1970, p. 8.

Kitaj, R. B. *Wings (Recent Sculpture and Buildings): A Collection of Works Produced at the Facilities of Lockheed—California, U.S.A., in Collaboration with Los Angeles County Museum of Art*. Photographs by Malcolm Lubliner. Edition of five. 1971(?).

"Painters Reply . . ." *Artforum* 14 (September 1975): 26–36.

Faure Walker, James. "R. B. Kitaj Interviewed by James Faure Walker." *Artscribe* 5 (February 1977): 4–5.

"R. B. Kitaj and David Hockney Discuss the Case for a Return to the Figurative . . ." *New Review* (February 1977): 75–77.

Kitaj, R. B.; Hamilton, Richard; and Hockney, David. "Letters to the Editor: Censorship of Erotic Art." *Sunday Times* (London), February 20, 1977, p. 32.

Kitaj, R. B. "TLS Commentary: Word and Image." *Times Literary Supplement* (London), March 18, 1977, p. 306.

MacBeth, George. "R. B. Kitaj and George MacBeth in Dialogue." *Art Monthly* 6 (April 1977): 8–10.

Kitaj, R. B. "Dine . . . Some Historical Notes Apropos." In *Jim Dine: Works on Paper 1975–1976*, exhibition catalog. London: Waddington and Tooth Galleries II, 1977.

Berthoud, Roger. "A Love for Pictures and an Enthusiasm for Life; Roger Berthoud Interviews R. B. Kitaj." *Times* (London), May 7, 1977, p. 8.

Kitaj, R. B. "Chris . . . a Note Apropos." *Arts Review* 29 (August 16, 1977): 506.

Kitaj, R. B. " 'The Horror! The Horror!'—Conrad." In *Irving Petlin Rubbings . . . The Large Paintings and the Small Pastels*, exhibition catalog. Purchase, N.Y.: Neuberger Museum, 1978.

Kitaj, R. B., and Szarkowski, John. *Open Photography 1978*, exhibition catalog. Nottingham: Midland Group, 1978.

Kitaj, R. B. "The Autumn of Central Paris (After Walter Benjamin), 1971." *Art International* 22 (March 1979): 19–20.

Kitaj, R. B. "A Return to London: R. B. Kitaj Replies to Some Questions Put to Him by Timothy Hyman . . ." *London Magazine*, n.s. 19 (February 1980): 15–27.

Kitaj, R. B. Introduction to *The Artist's Eye: An Exhibition Selected by R. B. Kitaj*, exhibition catalog. London: National Gallery, 1980.

Kitaj, R. B.; Golding, John; and others. "Letters to the Editor: Glasgow Sale of Whistlers." *Times* (London), July 12, 1980, p. 13.

Kuhn, Joy. "Natural Passage Towards the Other Shore . . . Joy Kuhn Talks to Him about His Work." *Antique Dealer and Collectors Guide*, October 1980, pp. 68–71.

Kitaj, R. B. Introduction to *Leland Bell: Paintings*, exhibition catalog. London: Theo Waddington, 1980.

Periodicals

Reichardt, Jasia. "Verso il figurativo? Un'altra strada davvero impensata, R. B. Kitaj. A Return to the Figurative? A New Direction, Indeed Unforeseen." *Metro* 6 (1962): 94–97.

Farr, Dennis. "The John Moores Liverpool Exhibition 3." *Burlington Magazine* 104 (January 1962): 30.

Russell, John. "London: Liverpool 'Biennale.'" *Art News* 60 (January 1962): 48.

Butcher, George. "The Anatomy of Pop Art." *Guardian* (London), June 21, 1962, p. 6.

Hodin, J. P. "Expositions: Londres." *Quadrum* 14 (1963): 161–64.

Reichardt, Tony. " 'Pop Art' in England: [Letter] to the Editor." *Arts Magazine* 37 (January 1963): 7.

"An Eagerly Awaited First Exhibition." *Times* (London), February 7, 1963, p. 16.

Richardson, John. "World of Art." *Evening Standard* (London), February 8, 1963, p. 11.

Shepherd, Michael. "Kitaj: New London Gallery." *Arts Review* 15 (February 9–23, 1963): 6.

Gosling, Nigel. "The Shapes of the Sixties." *Observer* (London), February 10, 1963, p. 21.

[Robertson, Bryan. "R. B. Kitaj: A Fantastic Conspiracy."*Sunday Times Magazine* (London), February 10, 1963, pp. 23–25.]

Russell, John. "The Polemical Painter." *Sunday Times* (London), February 10, 1963, p. 33.

Newton, Eric. "Kitaj Exhibition at the New London Gallery." *Manchester Guardian*, February 12, 1963, p. 9.

"Things Seen: Literary References in the New Figurative Painting, from a Correspondent." *Times* (London), February 12, 1963, p. 14.

Lucie-Smith, Edward. "A Village Explainer." *Listener* (London) 69 (February 21, 1963): 342.

Sutton, Denys. "Two Attitudes: Kitaj and Kossoff." *Financial Times* (London), February 26, 1963, p. 20.

Mullins, Edwin. "Other Exhibitions." *Apollo* 77 (March 1963): 230–31.

Roberts, Keith. "Current and Forthcoming Exhibitions." *Burlington Magazine* 105 (March 1963): 135–41.

Russell, John. "Art News from London: Kitaj." *Art News* 62 (March 1963): 46, 60–61.

Spira, Robert. "Londoner Ausstellungen: Kitaj in der Londoner (Marlborough) Galerie." *Weltkunst* 33 (March 15, 1963): 14.

Lynton, Norbert. "London Letter." *Art International* 7 (March 25, 1963): 55–59, 64.

Harrison, Jane. "Kitaj in London." *Arts Magazine* 37 (April 1963): 26–27.

Rykwert, Joseph. "La mostra di Kitaj, a Londra." *Domus* 401 (April 1963): 29–30.

Whittet, G. S. "Australians, Originals and the Young Ones: London Commentary." *Studio* 165 (April 1963): 168–70.

Horovitz, Michael. "London Report." *Kunstwerk* 16 (May 1963): 63–65.

Reichardt, Jasia. "Les expositions à l'étranger: Londres." *Aujourd'hui* 7 (May 1963): 50–51.

Melville, Robert. "One Man Show at the New London Gallery." *Architectural Review* 133 (June 1963): 437–39.

Reichardt, Jasia. "Kitaj's Drawings from Life." *Connoisseur* 154 (October 1963): 112–16.

Russell, John. "England: The Advantage of Being Thirty." *Art in America* 51 (December 1963): 92–97.

Melville, Robert. "English Pop Art." *Quadrum* 17 (1964): 23–38.

Burr, James. "Round the Galleries: Londoners to Liverpool." *Apollo* 79 (January 1964): 85–87.

Melville, Robert. "Fear of the Banal." *Architectural Review* 135 (April 1964): 291–93.

Baro, Gene. "The British Scene: Hockney and Kitaj." *Arts Magazine* 38 (May–June 1964): 94–101.

"To Greece with Kokoschka." *Times* (London), December 12, 1964, p. 4.

Gassiot-Talabot, Gérald. "La figuration narrative dans la peinture contemporaine." *Quadrum* 18 (1965): 5–40.

Melville, Robert. "Images and Titles." *Architectural Review* 137 (February 1965): 141–43.

Preston, Stuart. "Encyclopedic Pop." *New York Times*, February 7, 1965, sec. 2, p. 19.

Coates, Robert M. "The Art Galleries: Chaos." *New Yorker* 40 (February 13, 1965): 132–34.

Glueck, Grace. "Painter's Painter." *New York Times*, February 14, 1965, sec. 2, p. 19.

"Painting: Literary Collage." *Time* 85 (February 19, 1965): 72.

Judd, Donald. "In the Galleries: R. B. Kitaj." *Arts Magazine* 39 (March 1965): 62.

"Reviews and Previews: New Names This Month." *Art News* 64 (March 1965): 20–23.

Canaday, John. "The Bandwagon Toboggan." *New York Times*, March 7, 1965, p. 17.

Kozloff, Max. "Art: R. J. [*sic*] Kitaj." *Nation* 200 (March 8, 1965): 263–64.

Ashton, Dore. "R. B. Kitaj and the Scene." *Arts and Architecture* 82 (April 1965): 8–9, 34–35.

Lippard, Lucy R. "New York Letter." *Art International* 9 (April 1965): 48–64.

Russell, John. "London/NYC: The Two-way Traffic." *Art in America* 53 (April 1965): 126–36.

Tillim, Sidney. "Toward a Literary Revival?" *Arts Magazine* 39 (May–June 1965): 30–33.

Marmer, Nancy. "R. B. Kitaj, Los Angeles County Museum of Art." *Artforum* 4 (October 1965): 10–11.

Reichardt, Jasia. "R. B. Kitaj." *Billedkunst* 1 (1966): 12–19.

Kozloff, Max. "The Inert and the Frenetic." *Artforum* 4 (March 1966): 40–44.

Aldrich, Larry. "New Talent USA." *Art in America* 54 (July–August 1966): 22–69.

Kudielka, Robert. "R. B. Kitaj und die Schuld des Auges." *Kunstwerk* 20 (August–September, 1967): 3–12.

Russell, John. "London: Kitaj Komedy." *Art News* 66 (September 1967): 61–72.

Melville, Robert. "The Arresting Image." *Architectural Review* 142 (October 1967): 301–4.

Wasserman, Emily. "New York." *Artforum* 6 (October 1967): 56–57.

Rykwert, Joseph. "From London: Mostre a Londra." *Domus* 458 (January 1968): 53–54.

Boyle, Richard J. "Paintings of the Later Twentieth Century." *Cincinnati Art Museum Bulletin* 8 (October 1968): 13–19.

Tuten, Frederic. "Art and Technology in California." *Vogue* 153 (April 15, 1969): 36.

Glueck, Grace. "Coast Art—Industry Project Blossoms." *New York Times*, April 17, 1969, p. 54.

Ohff, Heinz. "R. B. Kitaj: Das gesamte graphische Werk." *Kunstwerk* 22 (June–July 1969): 85.

Miyagawa, Jun. "Ronald B. Kitaj." *Mizue* 777 (October 1969): 72–87.

Haftmann, Werner. "Kitaj's Graphics 1963–1969." *Art and Artists* 4 (November 1969): 24–29.

"Spotlight on Minds of Invention: R. B. Kitaj." *British Vogue* 126 (November 1969): 162–63.

Cusden, Norman. "John Moores Jury." *Art and Artists* 4 (December 1969): 38.

Siegfried, Joan C. "The Spirit of Comics . . ." *Art and Artists* 4 (December 1969): 18–21.

R. B. Kitaj: Three Sets. Marlborough Fine Arts, London, 1970 (announcement of three limited editions).

"Kitaj: Neue Alchimie." *Der Spiegel* 7 (February 9, 1970): 135–39.

Gilmour, Pat. "The Art Films of James Scott." *Art and Artists* 4 (March 1970): 16–19.

Russell, John. "Separate Directions." *Sunday Times* (London), April 19, 1970, p. 29.

Rouve, Pierre. "R. B. Kitaj." *Arts Review* 22 (April 25, 1970): 246, 261.

Gosling, Nigel. "Two Sides to Kitaj." *Observer* (London), April 26, 1970, p. 28.

Brett, Guy. "Kitaj's Spectres." *Times* (London), April 28, 1970, p. 7.

Vaizey, Marina. "R. B. Kitaj." *Financial Times* (London), April 29, 1970, p. 3.

Burr, James. "London Galleries: Philosopher Painter." *Apollo* 91 (May 1970): 393–95.

Melville, Robert. "Kitaj's Thoughts." *New Statesman* 79 (May 1, 1970): 637–38.

Robertson, Bryan. "Golden Oldies." *Spectator* (London) 224 (May 2, 1970): 594–95.

Russell, John. "Discoveries." *Sunday Times* (London), May 3, 1970, p. 32.

Hodgson, Simon. "Notes on Kitaj." *Listener* (London) 83 (May 7, 1970): 628.

Gilmour, Pat. "Ron Kitaj." *Arts Review* 22 (May 9, 1970): 281.

Reichardt, Jasia. "Kitaj's Pictures from an Exhibition." *Architectural Design* 40 (June 1970): 269.

Roberts, Keith. "Current and Forthcoming Exhibitions: London and Leeds." *Burlington Magazine* 112 (June 1970): 416–19.

Blok, Cor. "Holland." *Art International* 14 (Summer 1970): 116.

Russell, David. "London." *Arts Magazine* 44 (Summer 1970): 53.

Brett, Guy. "Artists and Printers." *Times* (London), June 23, 1970, p. 7.

Hofmann, Paul. "35th Art Biennale Beset by Problems at Venice Opening." *New York Times*, June 24, 1970, p. 38.

Willett, John. "Where to Stick It." *Art International* 14 (November 1970): 28–36.

Francis, Richard. " 'The Red Banquet' by R. B. Kitaj." *Annual Reports and Bulletin, Walker Art Gallery* (Liverpool) 2–4 (1971–74): 84–90.

Tuchman, Maurice. "An Introduction to 'Art and Technology.' " *Studio International* 181 (April 1971): 173–80.

"Art and Technology to Open." *Artweek* (May 1, 1971): 1.

Tarshis, Jerome. "San Francisco." *Artforum* 9 (June 1971): 89–92.

Burnham, Jack. "Corporate Art." *Artforum* 10 (October 1971): 66–71.

Mellow, James R. "Silkscreening: Any Number Can Play." *New York Times*, January 30, 1972, p. 30.

Loring, John. "Phoenix House Portfolio." *Arts Magazine* 47 (December 1972–January 1973): 70–71.

Phillips, Robert F. "Ronald B. Kitaj's Definition of Nobody." *Toldeo [Ohio] Museum of Art News*, n.s. 17, no.1 (1974): 19–22.

Russell, John. "John Russell Reports from New York: Dream of Perfection." *Sunday Times* (London), February 10, 1974, p. 27.

Tuten, Frederic. "New York: Kitaj." *Arts Magazine* 48 (March 1974): 70–71.

Derfner, Phyllis. "New York Letter." *Art International* 18 (April 1974): 50–51.

Henry, Gerrit. "Reviews and Previews: R. B. Kitaj." *Art News* 73 (April 1974): 96.

Ashbery, John. "Reviews of Exhibitions: R. B. Kitaj at Marlborough." *Art in America* 62 (May–June 1974): 103.

Roberts, Keith. "Current and Forthcoming Exhibitions: London." *Burlington Magazine* 116 (September 1974): 547–51.

Vaizey, Marina. "Didactic and Dramatic." *Art News* 73 (October 1974): 56–57.

Melville, Robert. "With Money to Spend." *Architectural Review* 156 (December 1974): 387–90.

Vaizey, Marina. "British Painting 74: Off Focus." *Art News* 73 (December 1974): 72–74.

Langmuir, Erika. "Letters (to the Editor): The Concert in European Art." *Burlington Magazine* 117 (January 1975): 52.

Overy, Paul. "Edinburgh Picks the Wrong Artists." *Times* (London), September 2, 1975, p. 7.

Daley, Janet. "Letters to the Editor: Paintings of Kitaj." *Times* (London), September 6, 1975, p. 13.

Overy, Paul. "Letters to the Editor: Paintings of Kitaj." *Times* (London), September 10, 1975, p. 15.

McCorquodale, Charles. "Edinburgh—Two Exhibitions." *Art International* 19 (November 1975): 26–29.

Simpson, David. "Letters [to the Editor]." *Artforum* 14 (November 1975): 8.

Tuchman, Maurice. "European Painting in the Seventies." *Art and Artists* 10 (November 1975): 44–49.

Ballatore, Sandy. "Contemporary European Painting." *Artweek* 6 (November 1, 1975): 1, 20.

Perlmutter, Elizabeth. "Los Angeles, European Painting: Masters and Mavericks." *Art News* 74 (December 1975): 84–86.

Nordland, Gerald. "Los Angeles Newsletter." *Art International* 19 (December 20, 1975): 29–37.

Pizzeoni, Atillio. "La presenza polemica di Kitaj nella situazione inglese." *Artecontro* 15 (1976): 14–15.

Plagens, Peter. "European Painting in LA: A Grab Bag of Well-Worn Issues." *Artforum* 14 (January 1976): 40–44.

Cork, Richard. "Now What Are Those English Up To?" *Evening Standard* (London), March 4, 1976, p. 24.

Frankman, Noel. "Arts Reviews: Group Show." *Arts Magazine* 50 (April 1976): 23.

Mereuță, Iulian. "Serigrafi de R. B. Kitaj." *Arta* (Bucharest) 23 (May 1976): 24.

del Renzio, Toni. "Style, Technique and Iconography." *Art and Artists* 11 (July 1976): 34–39.

Gosling, Nigel. "Well-behaved and British." *Observer* (London), August 15, 1976, p. 18.

Overy, Paul. "How Good Is Contemporary Art?" *Times* (London), August 17, 1976, p. 9.

Morris, Lynda. "The Human Clay." *Listener* (London) 96 (August 19, 1976): 218–19.

Russell, John. "A British Show Built of 'Human Clay.' " *New York Times*, September 5, 1976, sec. 2, p. 23.

Tarshis, Jerome. "The 'Fugitive Passions' of R. B. Kitaj." *Art News* 75 (October 1976): 40–43.

Hoffman, Donald. "Things about Modern Art Not Said in Public." *Kansas City Star*, October 24, 1976, sec. D, pp. 1, 6.

Melville, Robert. "The Poetry of Ordinariness." *Architectural Review* 160 (November 1976): 312–14.

Russell, John. "House Miscellany." *New York Times*, December 17, 1976, sec. C, p. 16.

Gablik, Suzi. "Human Clay." *Studio International* 193 (January 1977): 46–47.

"Nude Review." *Times* (London), February 20, 1977, p. 32.

Vaizey, Marina. "Life Classes." *Sunday Times* (London), February 20, 1977, p. 38.

Vaizey, Marina. "Private Moments." *Sunday Times* (London), April 24, 1977, p. 38.

Ackerman, M., and Ackerman, D. "Dear Kitaj and David—The Quality of the Creation Is More Important Than Its Content." *Arts Review* 29 (April 29, 1977): 285–87.

Daley, Janet. "R. B. Kitaj." *Arts Review* 29 (April 29, 1977): 289–91.

Shepherd, Michael. "Kitaj Observed." *Arts Review* 29 (April 29, 1977): 288–89.

Feaver, William. "Life Class Champion." *Observer* (London), May 1, 1977, p. 25.

Vaizey, Marina. "The Week When the Americans Took Over." *Sunday Times* (London), May 1, 1977, p. 39.

Overy, Paul. "Filibuster for the Figurative." *Times* (London), May 10, 1977, p. 12.

Butler, Christopher. "Figure-conscious." *Times Literary Supplement* (London), May 20, 1977, p. 618.

Morris, Lynda. "Popular Front." *Listener* (London) 97 (May 26, 1977): 692–93.

Burr, James. "Round the Galleries: Sky and Sculpture." *Apollo* 105 (June 1977): 504.

Roberts, Keith. "Current and Forthcoming Exhibitions: London." *Burlington Magazine* 119 (June 1977): 459–60.

Lucie-Smith, Edward. "In View: R. B. Kitaj." *Art and Artists* 12 (July 1977): 6.

"Zurich/Kitaj." *Oeil*, nos. 264–65 (July–August 1977), p. 54.

Delacroix, Nikolaus. "R. B. Kitaj." *Kunstwerk* 30 (August 1977): 72.

Melville, Robert. "A Mixture of Survivals." *Architectural Review* 162 (August 1977): 120–22.

Hyman, Timothy. "R. B. Kitaj: Avatar of Ezra." *London Magazine*, n.s. 17 (August–September 1977): 53–61.

Daval, Jean-Luc. "The Image of Culture." *Skira Annual* 4 (1978): 42–91.

Garrett, Robert. "Kitaj Lauds Revival of the Figurative Artist." *Boston Herald American*, May 30, 1978, pp. 11, 15.

Creeley, Robert. "Ecce Homo." *Art International* 22 (March 1979): 27–30.

Podro, Michael. "Some Notes on Ron Kitaj." *Art International* 22 (March 1979): 18–30.

Russell, John. "Campaigner for Figurative Art." *New York Times*, March 30, 1979, sec. C, p. 19.

Kramer, Hilton. "R. B. Kitaj." *New York Times*, April 6, 1979, sec. C, p. 23.

Ashbery, John. "Poetry in Motion." *New York* 12 (April 16, 1979): 94–96.

Stevens, Mark. "The Human Factor." *Newsweek* 93 (April 16, 1979): 79.

Hughes, Robert. "The Last History Painter: Expatriate R. B. Kitaj Brings Home the Bacon." *Time* 113 (April 23, 1979): 70–71.

Wilson, Colin St. John. "Reflections on the Relation of Painting to Architecture." *London Magazine*, n.s. 19 (April–May 1979): 36–40.

Crombie, Theodore. "Prodigal's Return." *Apollo* 110 (July 1979): 69.

Russell, John. "Art Gallery Season in Full Swing, with Something for Everyone: Drawings from Sports Illustrated." *New York Times*, October 26, 1979, sec. C, p. 20.

Pincus, Robert L. "Contemporizing the Figure." *Artweek* 10 (December 15, 1979): 16.

Wyndham, Francis. "The Dream Studio of R. B. Kitaj." *Sunday Times Magazine* (London), May 25, 1980, pp. 59–62, 67.

Bumpus, J. "As a Man Sees." *Art and Artists* 15 (July 1980): 12–15.

Livingstone, Marco. "Iconology as Theme in the Early Work of R. B. Kitaj." *Burlington Magazine* 122 (July 1980): 488–97.

McEwen, John. "In Principle." *Spectator* (London) 245 (July 12, 1980): 26–27.

Hyman, Timothy. "Kitaj: A Prodigal Returning." *Artscribe* 25 (October 1980): 37–41.

Packer, William. "Kitaj's Pastels." *Financial Times* (London), October 21, 1980, p. 23.

Lavell, Steven. "R. B. Kitaj/Marlborough Gallery." *Arts Review* 32 (October 24, 1980): 481.

McNay, Michael. "Marlborough: R. B. Kitaj." *Manchester Guardian*, October 24, 1980, p. 9.

Selwood, Sara. "Society Nudes." *Times Literary Supplement* (London), October 24, 1980, p. 1200.

McEwen, John. "Small Mercies." *Spectator* (London) 245 (November 1, 1980): 26.

Lucie-Smith, Edward. "London Letter." *Art International* 24 (November–December 1980): 174–77.

Cork, Richard. "Report from London: 'The Artist's Eye.' " *Art in America* 69 (February 1981): 43–55.